IMAGES
of America

KIRKWOOD

IMAGES
of America

KIRKWOOD

Vicki Berger Erwin
for the Kirkwood Public Library

ARCADIA
PUBLISHING

Copyright © 2013 by Vicki Berger Erwin for the Kirkwood Public Library
ISBN 978-1-5316-6786-3

Published by Arcadia Publishing
Charleston, South Carolina

Library of Congress Control Number: 2012955879

For all general information, please contact Arcadia Publishing:
Telephone 843-853-2070
Fax 843-853-0044
E-mail sales@arcadiapublishing.com
For customer service and orders:
Toll-Free 1-888-313-2665

Visit us on the Internet at www.arcadiapublishing.com

In memory of Janet Murphy Heyer, Kirkwood girl

CONTENTS

ACKNOWLEDGMENTS

Thank you to Kirkwood Public Library and Sarah Sorrells Erwin for bringing me into this project. All author royalties from the sale of the book will benefit the library. The research and writing of *Kirkwood* allowed me an opportunity to discover our town (where I've lived for 30 years!) in a new and enjoyable way. My family has always loved history, but we have often ignored that which is closest at hand, something that I have now remedied. And thanks to the Kirkwood Historical Society (KHS) for allowing us to use its photograph collection in this book. All photographs, unless otherwise noted, are from KHS. Sue Burkett, librarian, was especially helpful.

This book is not intended to be a comprehensive history of Kirkwood, and some things are not included, mainly because there was not a suitable photograph. It hopefully will provide a general overview of the history of our city and perhaps bring to light a few memories. I tried to be as accurate as possible, but any mistakes are solely my own.

Thanks also goes to my family, especially my husband, Jim, who after 40 years, still has infinite patience.

INTRODUCTION

When Hiram Leffingwell and Richard Elliott decided to auction off parcels of land along the newly built Pacific Railroad in 1853, it was an idea whose time had come. The city of St. Louis was overcrowded, disease loomed and struck often, and devastating fires were a constant threat. Even though land was available, people needed a convenient way to travel between outlying areas and the city where most worked and social activities were centered. The railroad provided the transportation, and Leffingwell and Elliott planned a city where people could live and still be within reach of St. Louis, naming it after the man who set the route for the new rail line. Leffingwell had experience planning additions to the city of St. Louis, and he put this to use making Kirkwood the first planned suburb west of the Mississippi.

Trains were essential to life in Kirkwood, as citizens traveled into the city to shop as well as work. The trip between Kirkwood and the city took 35 minutes, and trains ran frequently; the cost was 40¢. Trains continued to be the main form of transportation for the people living in Kirkwood until electric streetcars came along toward the end of the century, reducing train ridership. In turn, the streetcars were diminished by buses, and buses by the automobile as interstate highways wove their web around the city. The Kirkwood Train Station is still a center of activity, now run by volunteers and used as a symbol of the town. Many freight trains still travel through the city, and Kirkwood is still a stop for Amtrak passenger service.

The original Kirkwood Association dissolved in 1863, and the area was unincorporated until February 20, 1865, when the Missouri legislature granted charter to the town of Kirkwood. In the original charter, six trustees governed the town, headed by a chairman, not a mayor. The original trustees were Richard S. Elliott (partner in Leffingwell and Elliott), Albert G. Edwards, Francis Berg, William T. Essex (married into the Bodley family), Hiram Leffingwell (named chairman), and Lucius D. Morse. One of the first orders of business was to prohibit the sale of liquor within the city limits and to hire a marshal, Henry S. Allen, to enforce that ordinance. Taxes were one-fourth of one percent on all real and personal taxable property. There was a total assessed value in Kirkwood of $120,150, giving the city funds of $300.37 to operate—what a change today! During this early phase, Kirkwood tried to be named the seat of St. Louis County but failed. Today, Kirkwood is governed by a mayor and city council that oversee fire, police, streets, power and water, the library, and more. The population has grown along with assessed valuation (and taxes), and it is possible to buy a drink within the city limits.

Businesses developed after the upheaval of the Civil War, mainly along Kirkwood Road (then Webster Avenue) and Argonne Drive (then Main Street). There were and are many vibrant small businesses, but Kirkwood is still free of heavy industry. For a time, nurserymen and florists found the clean air and open spaces of the city a haven for their businesses, but this is no longer true. Commerce is still focused in the area around Kirkwood and Argonne as well as along Manchester Road.

Churches were one of the first orders of business for early settlers. The Catholic church, St. Peter's, predated the city of Kirkwood by 20 years. The cornerstone for the original church was laid in 1833 near where St. Peter Cemetery is today. The church was initially served by traveling pastors. Olive Chapel African Methodist Episcopal Church formed in 1853 with Rev. Jordan Winston as its circuit-riding preacher. In 1854, the Presbyterian Church of Kirkwood began meeting in homes of its members, and early on, it denoted the land on the southeast corner of Adams Avenue and Kirkwood Road as the home of the church. Leffingwell and Elliott were Episcopalian, as was another prominent early family, the Bodleys. In 1854, they formed a congregation, and the Bodleys continued to support the church for its first years. Today, Kirkwood is home to many faiths.

Early education was either provided in the home or students had to travel. Anna Sneed opened Kirkwood Seminary for young women in 1861. The student body quickly grew, and the school expanded, taking in boarders. After a dispute with neighbors and the city, Anna Sneed (by then Mrs. Cairns) closed the school in 1889. Other private schools such as Kirkwood Military Academy and parochial schools such as St. Peter and Concordia Lutheran also educated the young citizens of Kirkwood. In 1865, three days before the city was chartered, the Kirkwood School District incorporated, encompassing an area larger than that of the town (as it does today). The first school board was Albert G. Edwards, John W. Sutherland, Leonard B. Holland, William T. Essex, Augustus S. Mermod, and Henry T. Mudd. The school tax was one percent of assessed valuation of district property. School opened in a temporary building on September 24, 1866. There was no money to build a school for African American students, so the board rented space in a church. Initially, education was only through eighth grade, but Kirkwood added two years of high school, perhaps in 1873, and went to four years in 1896. High school was for white students only. Eventually, the school board agreed to pay for black students to go to high school in the city, but that was tuition only, and the students still had to pay for books and transportation. Plus, sometimes the payment was late, causing hardship for the students. African American parents fought hard for equal education and facilities, and finally schools were integrated with the decision in *Brown v. Board of Education*. Kirkwood School District now has a high school, two middle schools, five elementary schools, and an early childhood center.

Meramec Highlands provided a romantic episode in the history of Kirkwood. Marcus Bernheimer had the idea to build a summer resort, on par with those in other areas of the country, close by the city so people wouldn't have to travel. The Meramec Highlands was the result of that idea—an inn and all the amenities even the most pampered could enjoy. Unfortunately, the Highlands was never a completely successful enterprise and ultimately failed.

On February 7, 2008, tragedy struck in Kirkwood. A gunman entered the city hall chambers during a council meeting and shot four people. The gunman, Charles Lee "Cookie" Thornton, first shot police sergeant William Biggs outside the building, then proceeded inside, where he killed police officer Thomas Ballman, Councilwoman Connie Karr, Councilman Michael H.T. Lynch, and public works director Ken Yost. He wounded Mayor Mike Swoboda (who later died) and reporter Todd Smith before being killed himself. The shooter had a long-standing dispute with the city and frequently attended council meetings. This was a sad chapter in the history of our city.

Today, Kirkwood is a city with good schools, lovely homes, and shopping that lies within easy commuting distance of almost any point in the metropolitan area, although not by train as was originally pictured. It continues to reign as "Queen of the Suburbs."

One

EARLY KIRKWOOD

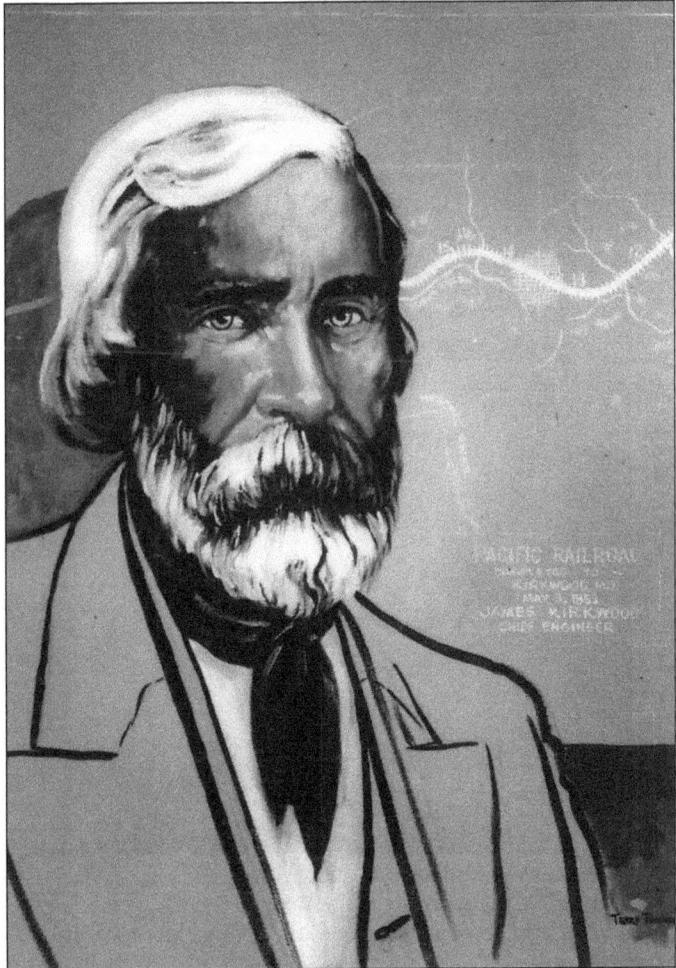

James P. Kirkwood was born in Edinburgh, Scotland, in 1807. After training as a civil engineer, he moved to New York in 1832. He was named chief engineer of the Pacific Railroad in 1850 and surveyed routes for the western expansion of the line from 1850 to 1852, recommending the route through what grew up to be the town named after him. James Kirkwood died in 1877.

Hiram Wheeler Leffingwell, born on May 3, 1809, in Massachusetts, is the acknowledged founder of Kirkwood, along with his real estate partner, Richard S. Elliott. They created the Kirkwood Association, purchased parcels of land along the new railroad, and offered them for sale in a planned community. Leffingwell was also an early resident of the community.

Harry Innes Bodley (1804–1883) served as the first president of the Kirkwood Association and was an important contributor to early Kirkwood in many capacities. He settled in the area in 1852 on a 60-acre estate named Homewood. He was also a founder of Grace Episcopal Church.

The Bodley family settled in Kirkwood in its early days and played a role in its growth and development. Pictured here are, from left to right, (seated) Mrs. William T. Essex (Effie Bodley Hensley), Sarah Bodley, Robert Hough (born 1873), Jessie Bledsoe Hough (born 1874), Mrs. Henry Wade Hough (Ella Cecil Bodley), and Bodley Hough (born 1876); (standing) Miriam G. Bodley, Harry Innes Bodley, Mrs. Anderson Gratz (Laura C. Bodley), and Katherine Howard Hensley (Effie Essex's daughter from her first marriage).

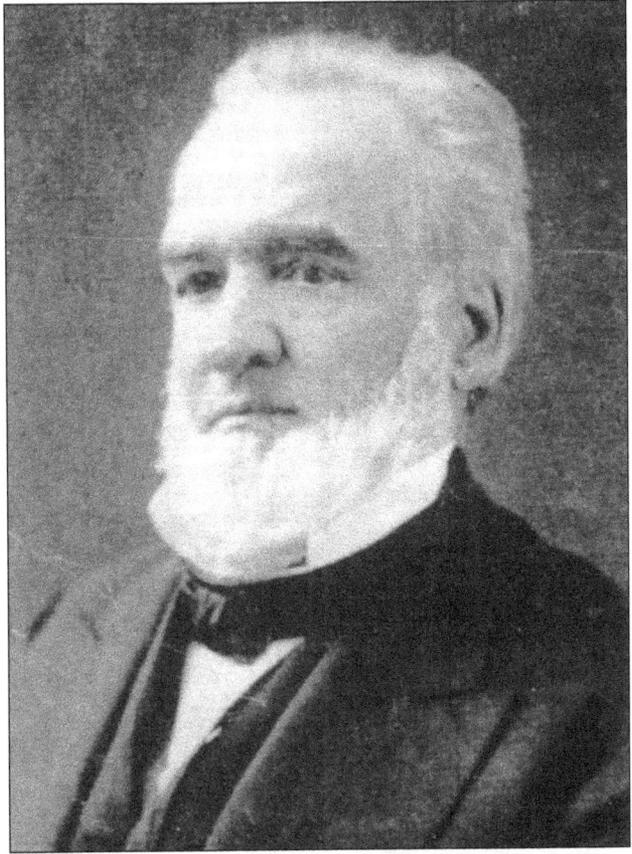

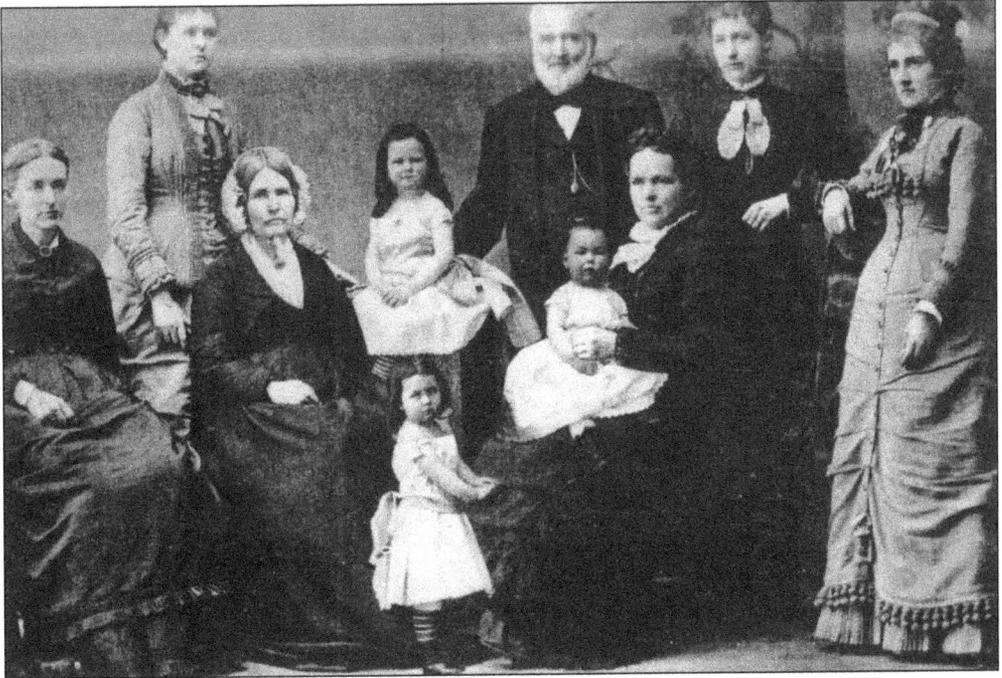

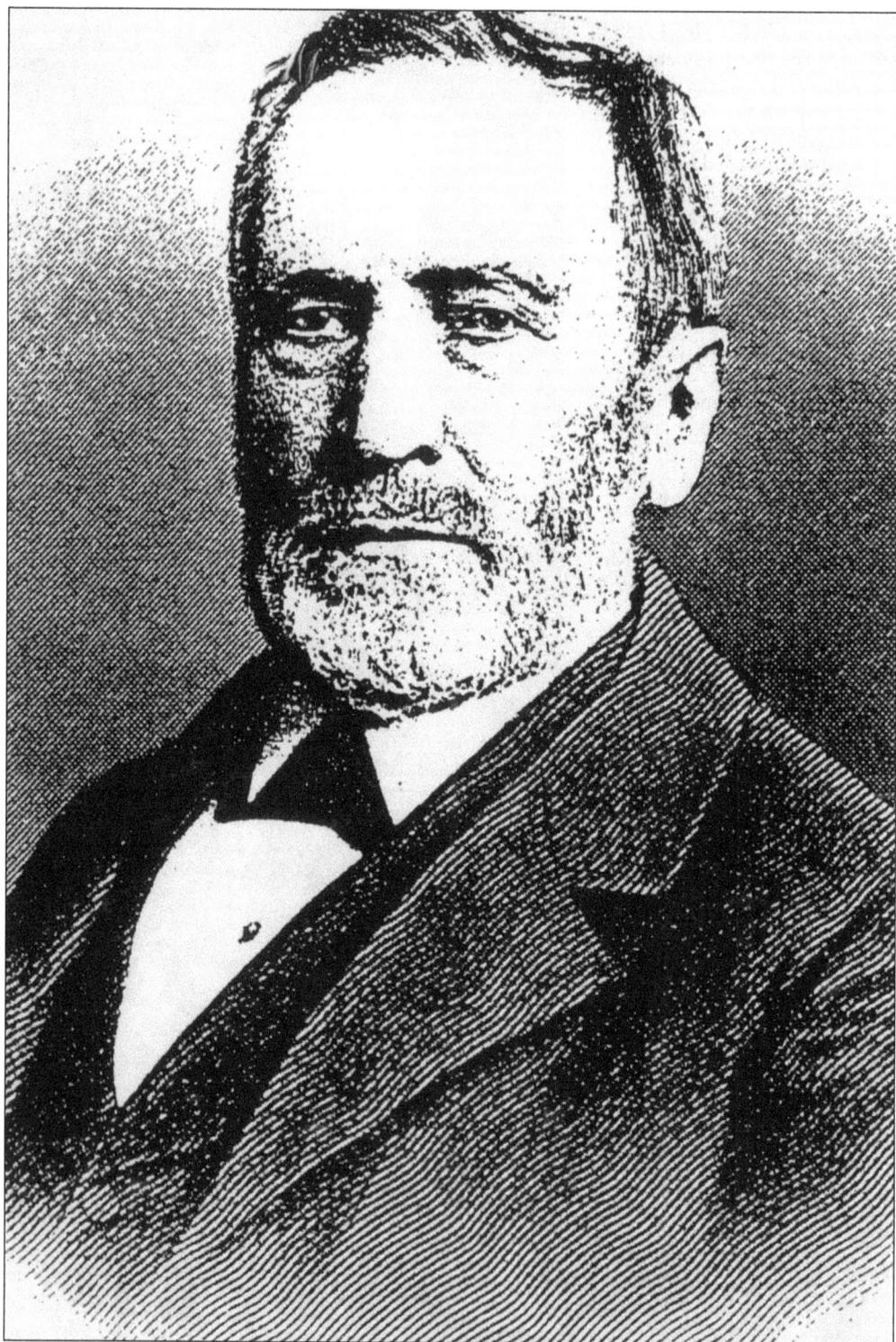

Henry Thomas Mudd lived at Mudd's Grove, the present home of the Kirkwood Historical Society, from 1865 to 1882. He was active in state and local government.

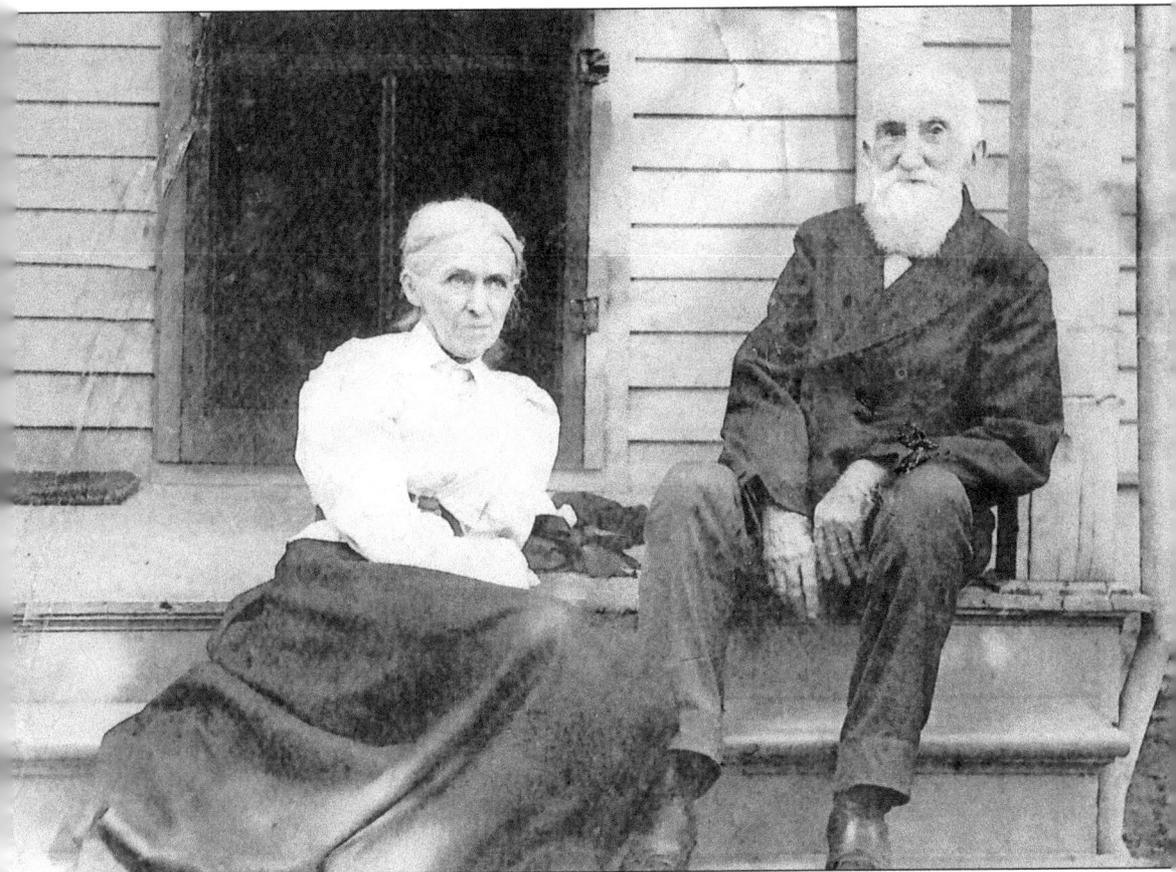

William and Euphemia "Effie" Bodley Hensley Essex, pictured here, were the first couple married at Grace Church. Effie Essex was the widow of Dr. Benjamin Hensley and the daughter of Sarah and Henry Innes Bodley. Effie Essex held a Sunday school for African Americans even before Grace Church was built. William Essex worked with his father-in-law in insurance and became a prime figure in Kirkwood government, civic, and community affairs.

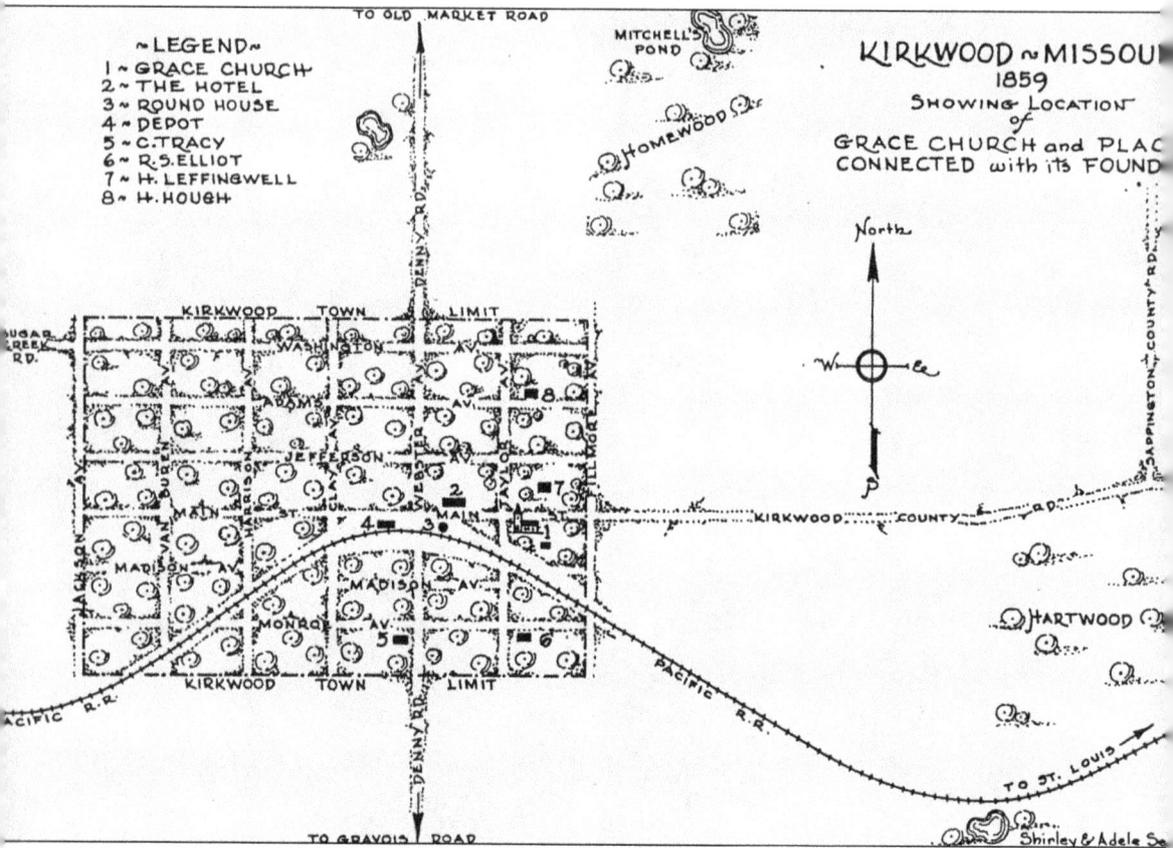

~LEGEND~
1 ~ GRACE CHURCH
2 ~ THE HOTEL
3 ~ ROUND HOUSE
4 ~ DEPOT
5 ~ C.TRACY
6 ~ R.S.ELLIOT
7 ~ H. LEFFINGWELL
8 ~ H.HOUGH

KIRKWOOD ~ MISSOU[RI]
1859
SHOWING LOCATION
of
GRACE CHURCH and PLAC[ES]
CONNECTED with its FOUND[ING]

This hand-drawn map shows the Kirkwood environs around 1859. The homes of Richard S. Elliott and Hiram Leffingwell, partners in the real estate company that led to the formation of Kirkwood, are marked as well as other early sites of interest.

Two

TRAINS AND
TRANSPORTATION

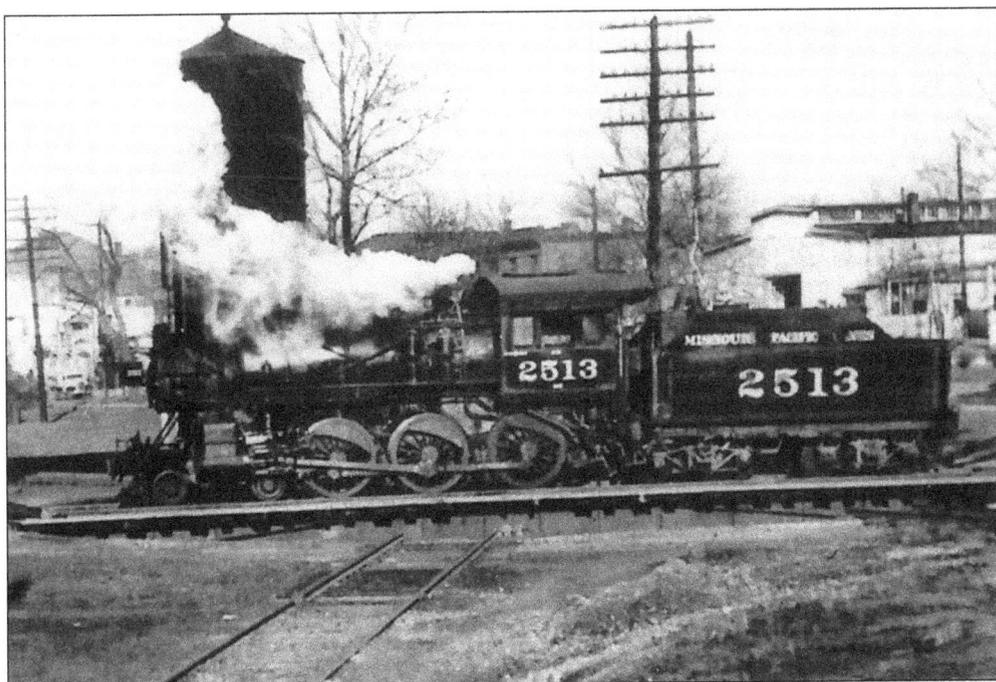

Trains were important in early Kirkwood. It was the end of the line for commuter trains from the city of St. Louis prior to the 1940s. The engine pictured would steam into Kirkwood from Union Station, roll onto a turntable, be turned around by hand by two workers, then head back into St. Louis. This photograph shows the turntable around 1900.

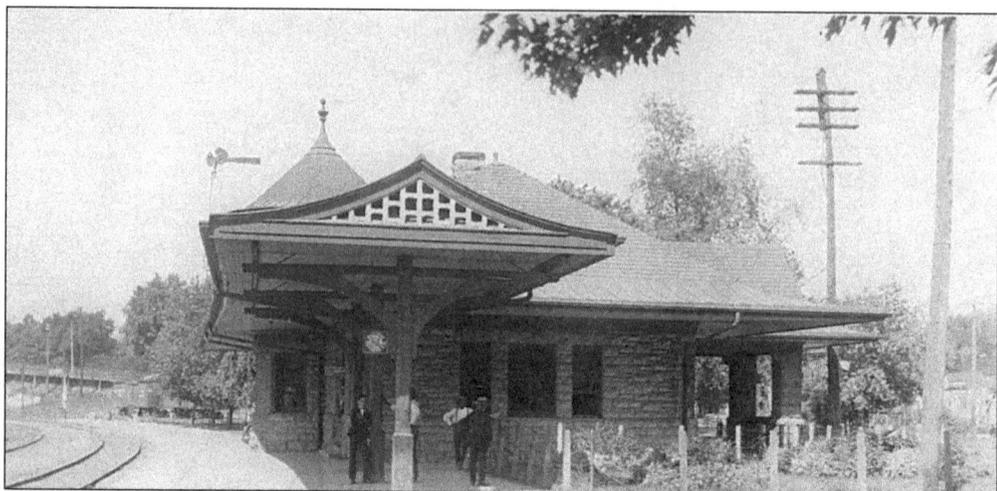

Kirkwood's iconic railroad station, built in 1893, is pictured here around 1905 with a view of the passenger canopy that was removed in a later renovation.

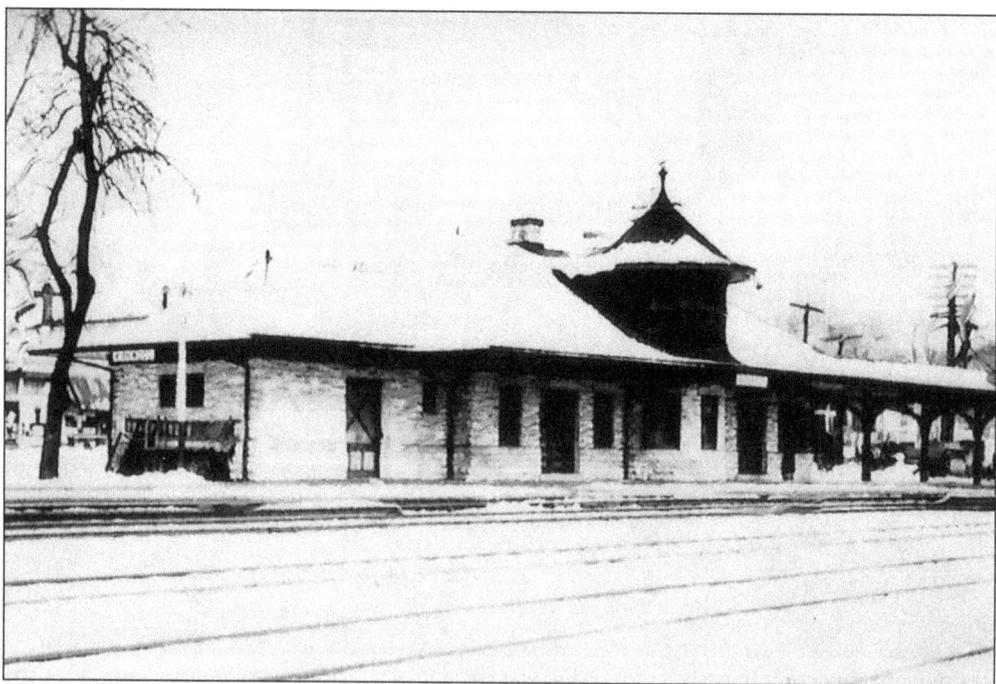

The Kirkwood Train Station is seen in this pre-1941 wintery view before the passenger canopy was removed. The railroad intended to completely redo the station, but the citizens of the town were so against it that the plans were modified.

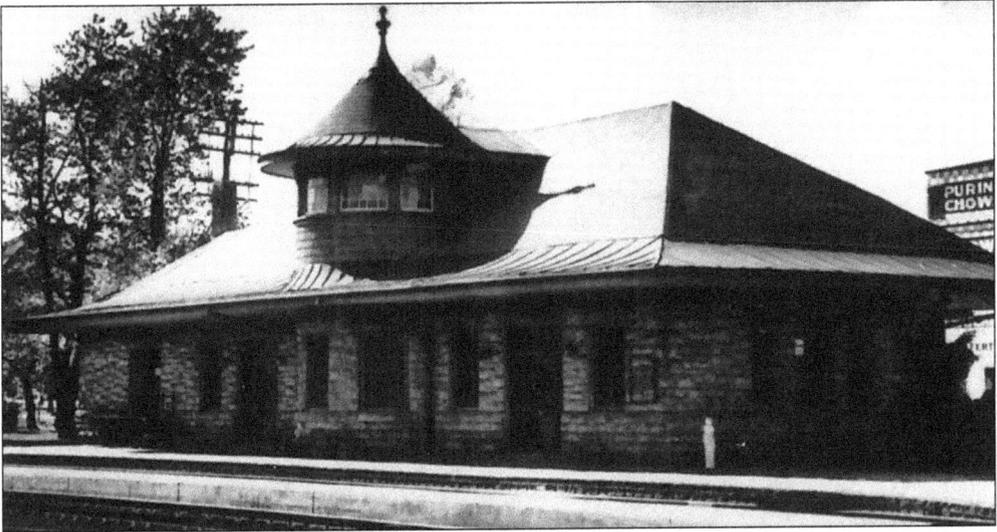

The Kirkwood Train Station appears with the passenger canopy removed. This is a trackside view, date unknown. Amtrak intended to close this landmark in 2002 in a cost-cutting effort, but Kirkwood did not want to lose such an important part of its downtown. The City of Kirkwood purchased the station, and since 2003, it has been staffed by volunteers. The venue is available for rentals for special events.

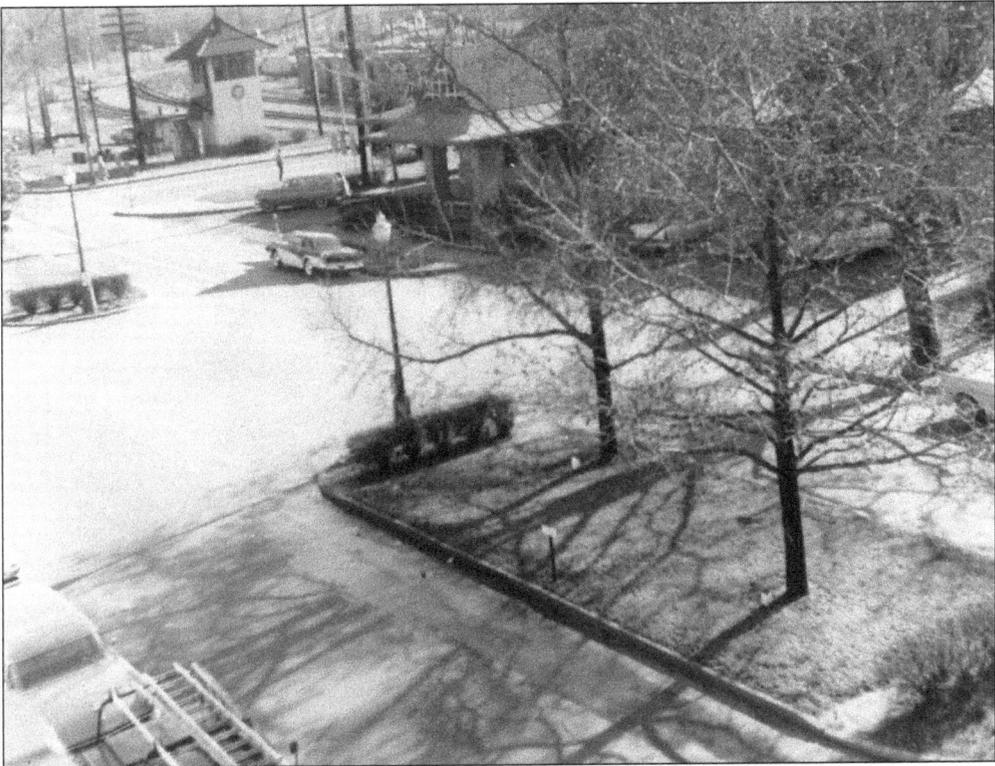

This is an undated view of the train station and control tower at Kirkwood Road and Argonne Drive. The control tower was a beehive of activity run by a four-man team around the clock. The tower was razed in 1964, when it was no longer needed because of updated technology.

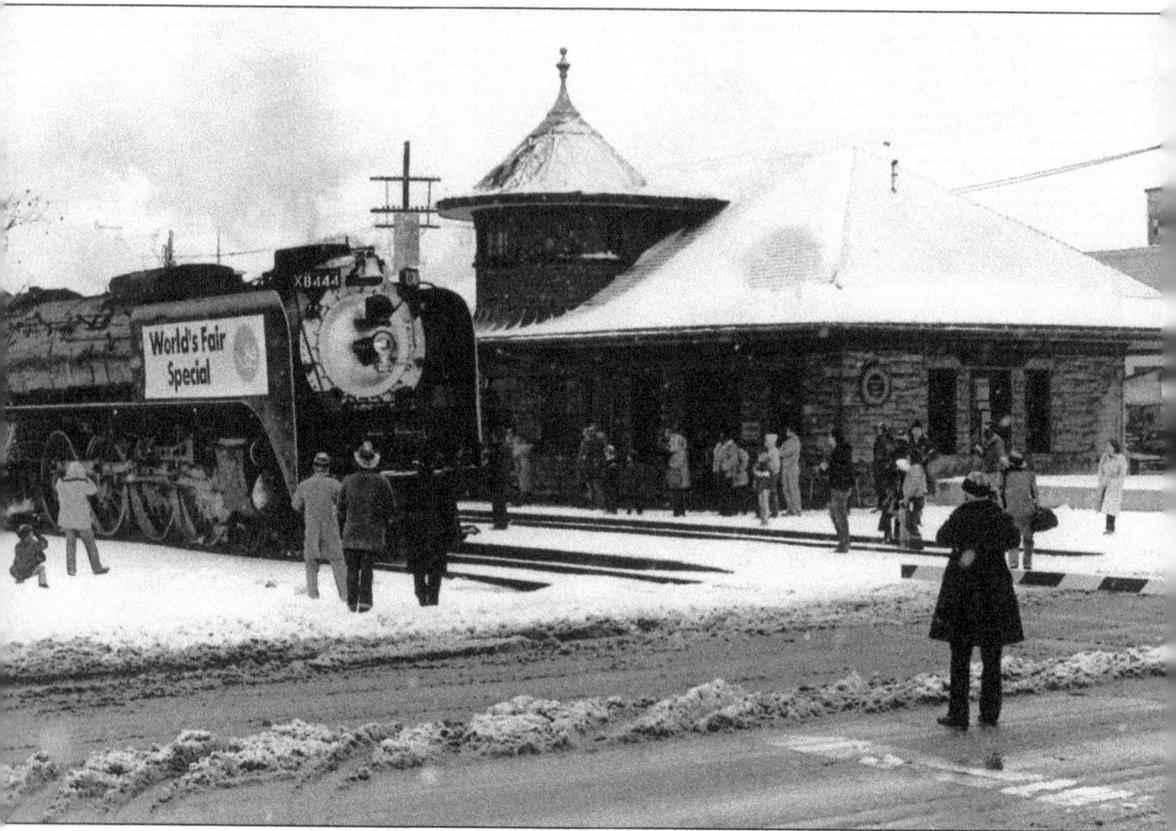

Many train enthusiasts find Kirkwood a prime locale for photography. From time to time, as pictured here, specialty trains pass through. This photograph celebrates a recreation of the steam trains of the 1904 St. Louis World's Fair.

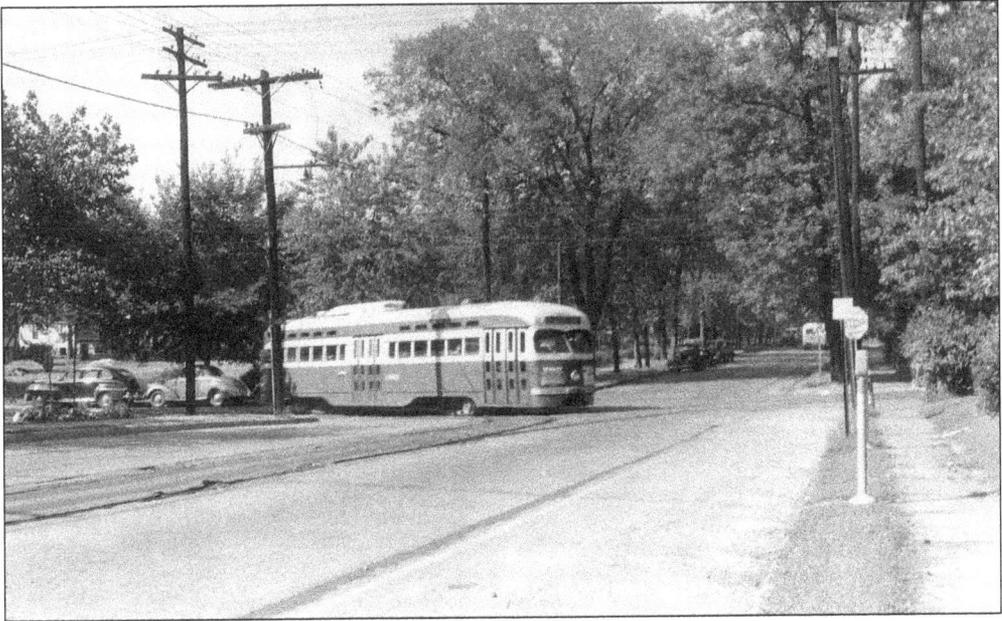

After the railroad came the electric railroad or streetcars in 1896, offering service between St. Louis and Kirkwood and especially the Meramec Highlands Resort. The lines were plagued by financial and labor woes. Shown here is a streamlined car at Clay and Adams Avenue around the late 1940s.

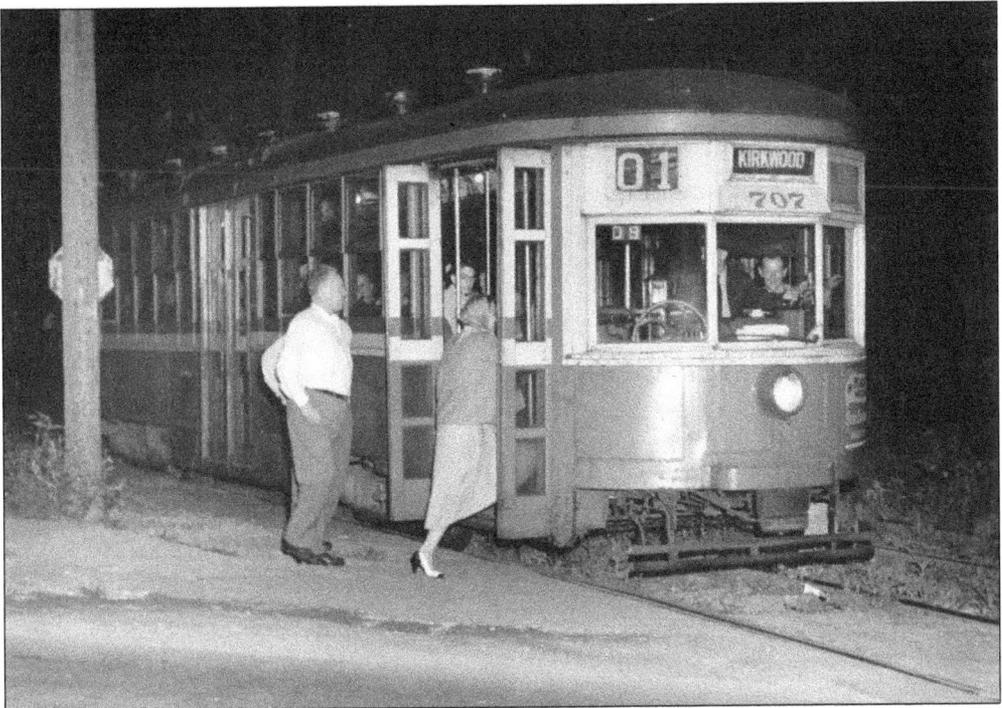

Electric streetcars provided service from Kirkwood to points in and around the city of St. Louis. The streetcar service continued until the 1950s, when bus service took over. The No. 01 ran from Kirkwood to Ferguson.

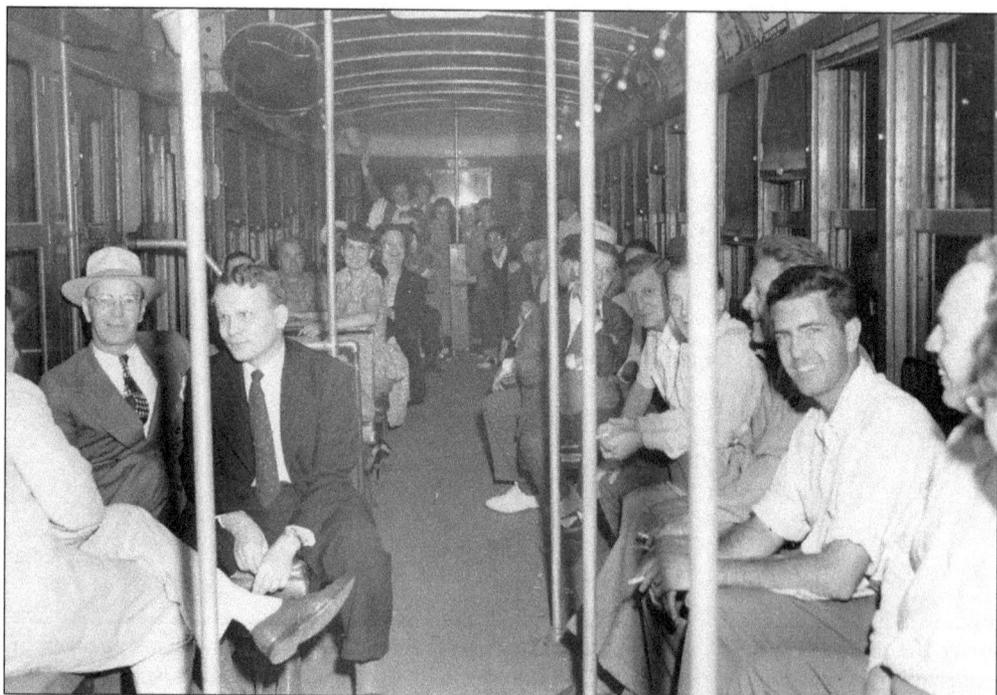

Travelers relax and chat on their trip. Streetcars had an impact on commuter rail travel, reducing and then eliminating it. Buses did the same thing to streetcars, and then automobiles came along and dramatically reduced bus ridership.

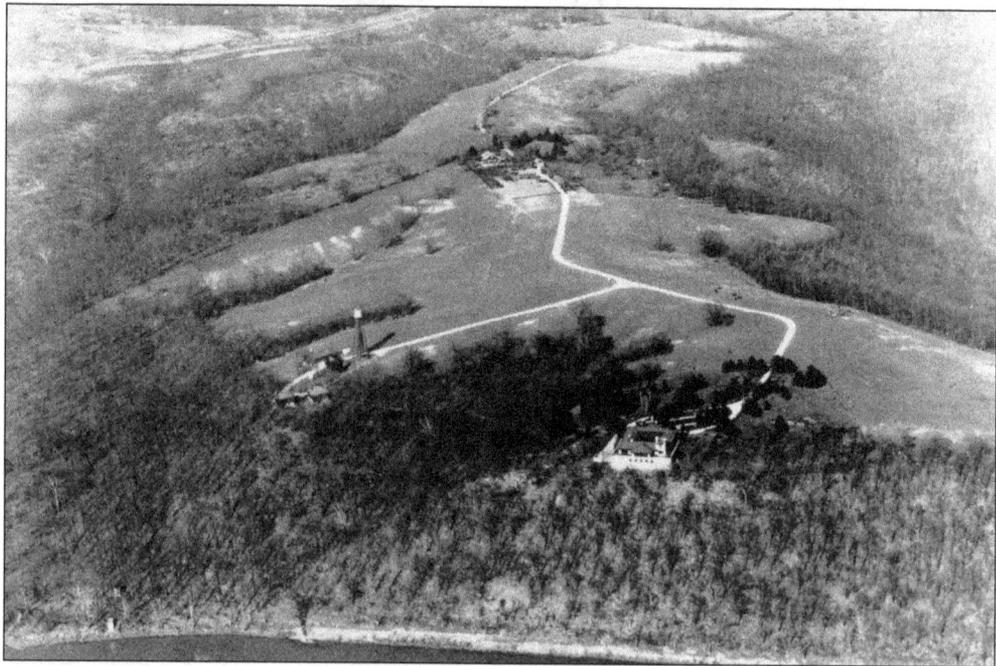

Interstate highways connecting St. Louis north to south and east to west made automobile travel much more convenient and speedy. This is an aerial view of the southwest corner of Kirkwood before Interstate 270 was built.

Three

CITY SERVICES

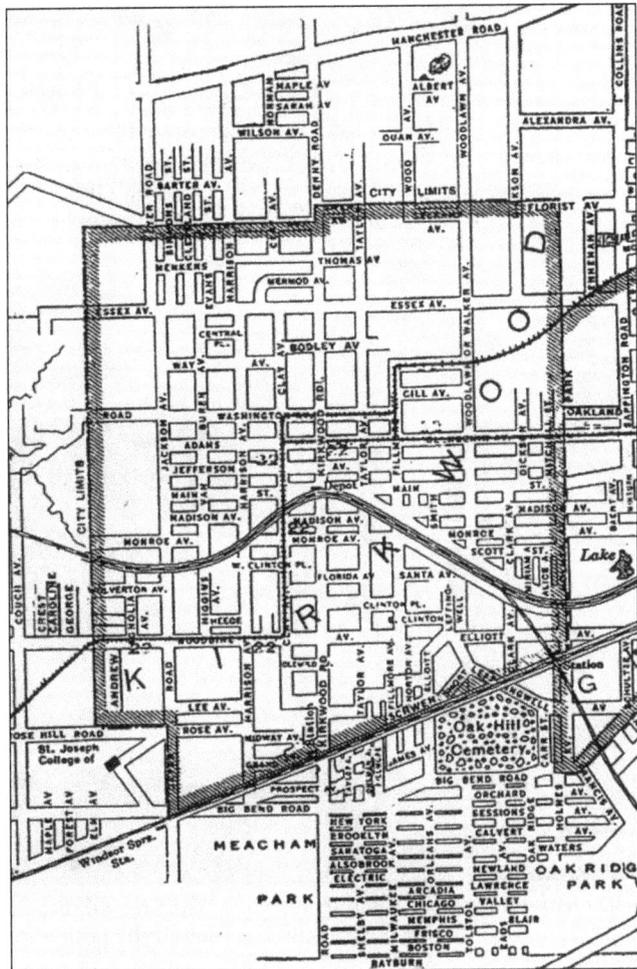

The map shows the limits of the city of Kirkwood in 1915. Note the original street names: Jackson Avenue is now Geyer Road; Main Street is Argonne Drive. Kirkwood Road is no longer Webster Avenue, and the name changed at the city limits to Denny Road rather than today's Lindbergh Boulevard.

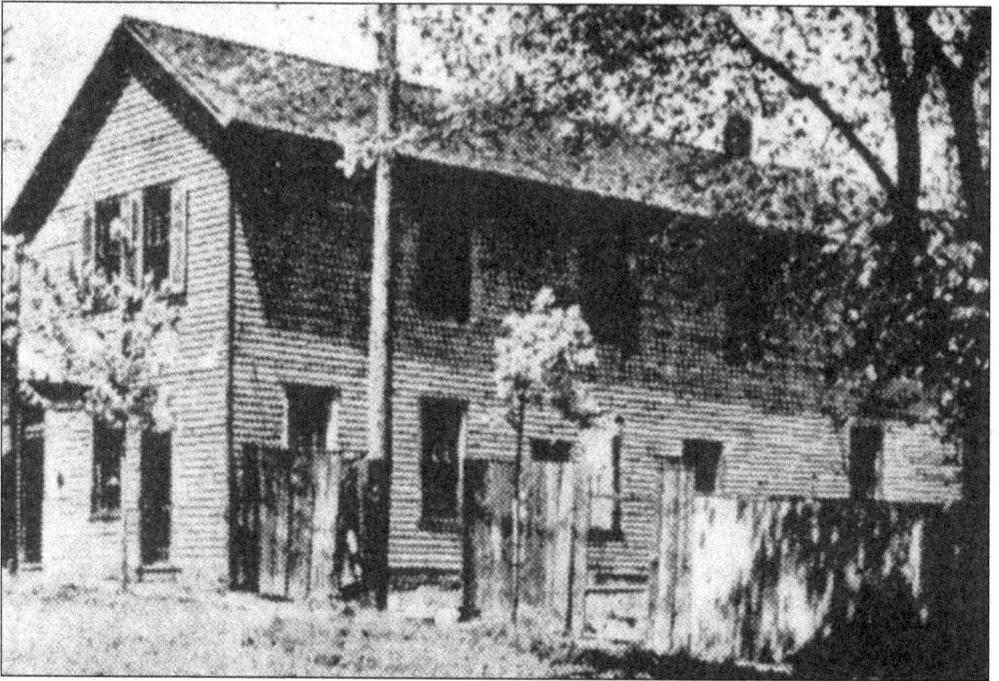

Kirkwood was founded in 1853 and incorporated by the State of Missouri on February 20, 1865. Meetings of the governing body, known as trustees, met in temporary quarters until 1875, when voters approved the purchase for $2,500 of this building at Kirkwood Road and Madison Avenue to use as a city hall and jail. St. Louis County constables were also housed in this location.

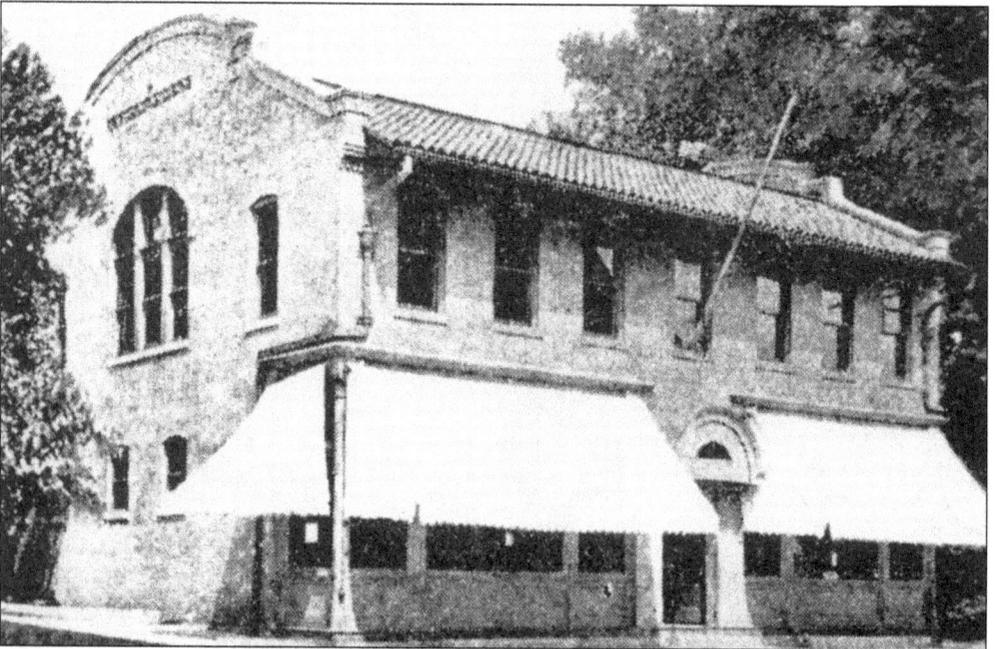

The city built a new city hall in 1915 after the first fell into disrepair. The library was founded on the second floor of this building. It also housed the police and jail. The building was demolished in 1942.

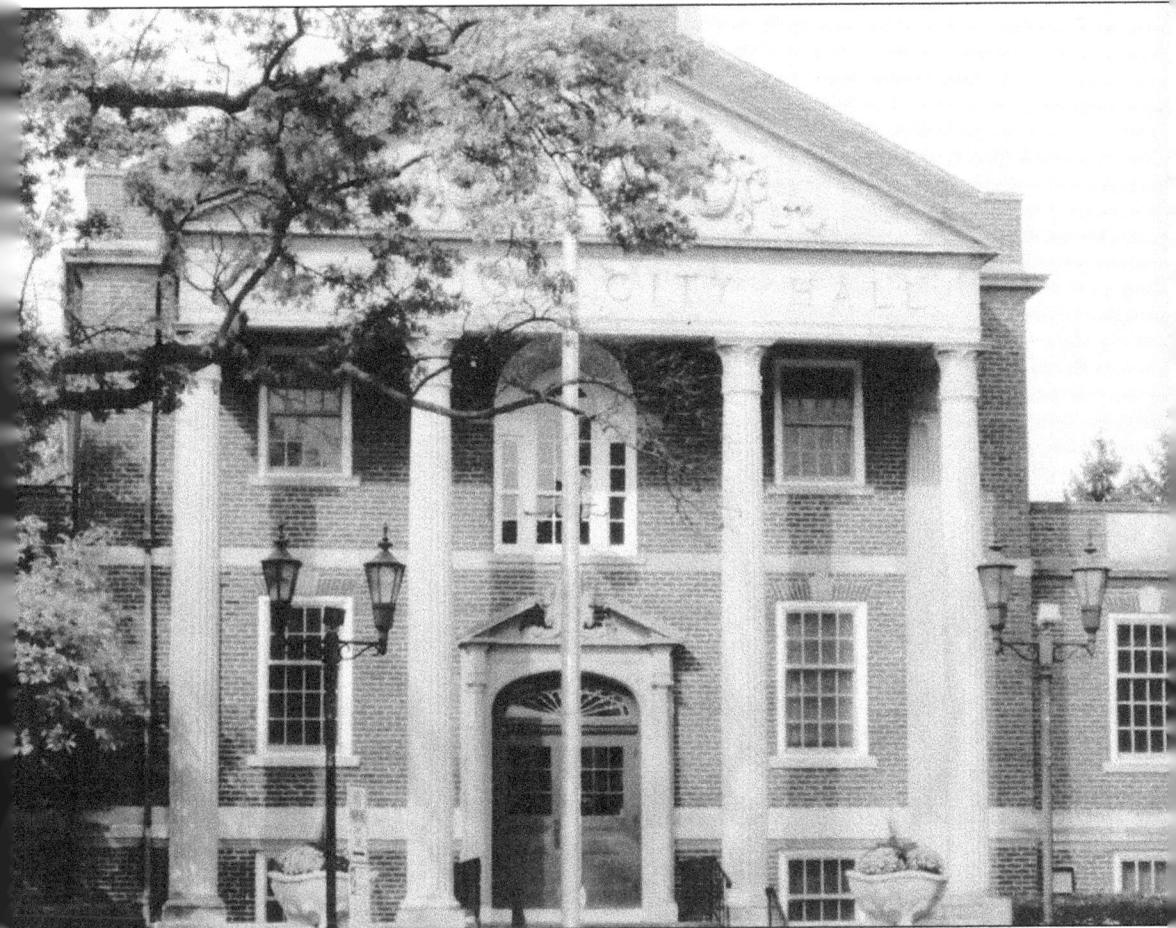

The present city hall was dedicated in 1942 and still serves the city today. Originally, the police department was housed on the first floor, but growth of both city and police necessitated a new police building in 1964. (Author photograph.)

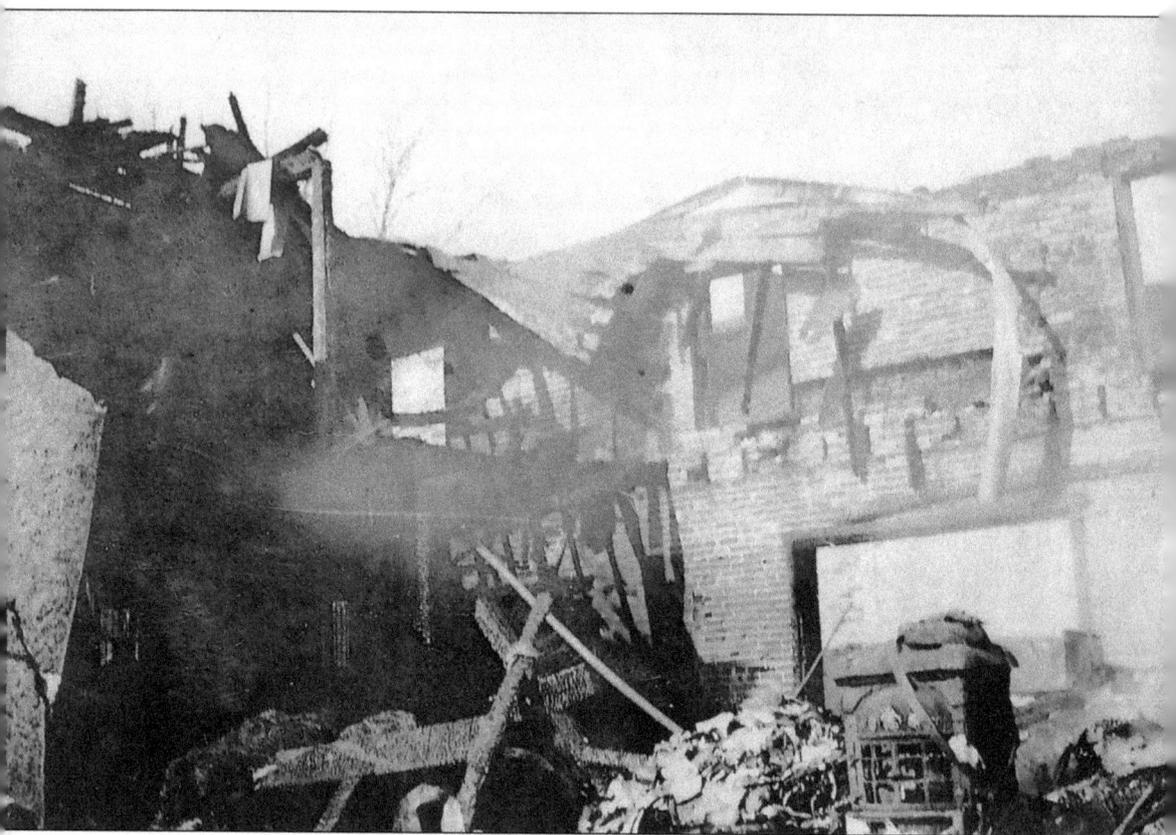

Fires plagued early Kirkwood. This photograph of an alleyway destroyed by flames on November 23, 1913, shows the devastation that fire could cause.

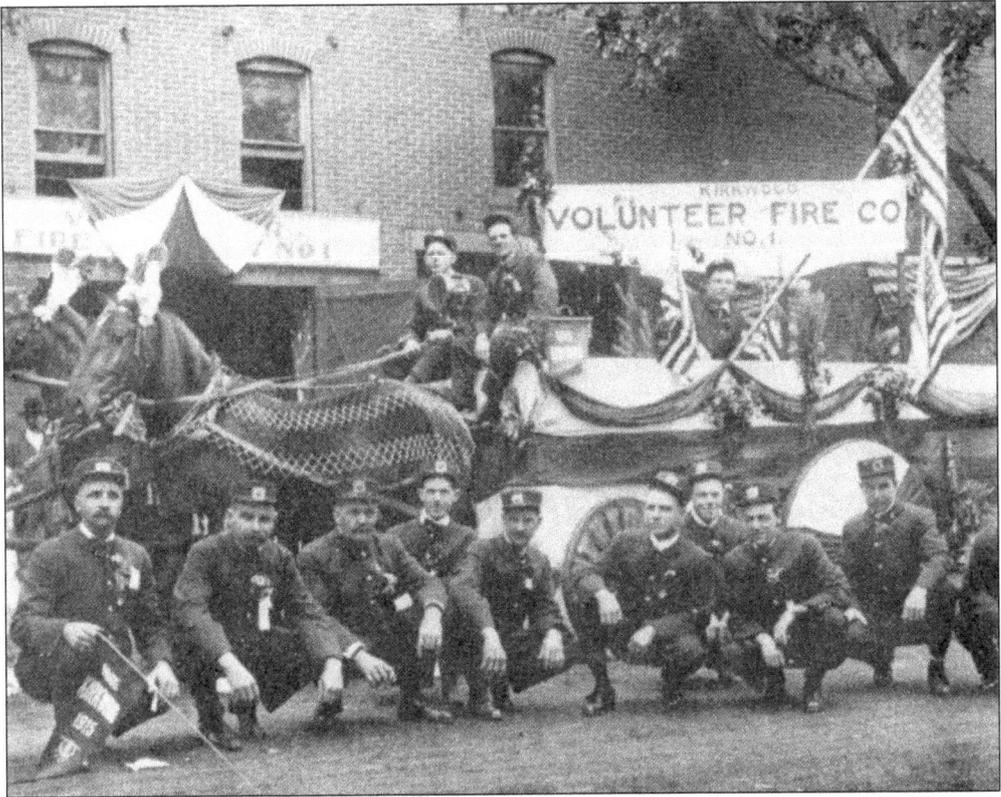

Kirkwood relied on a volunteer fire department like the two pictured (above, around 1905; below, date unknown) until the city government established a paid department in 1918. Volunteers were plagued by poor notification system and poor water delivery. Many buildings in early Kirkwood were lost to fire.

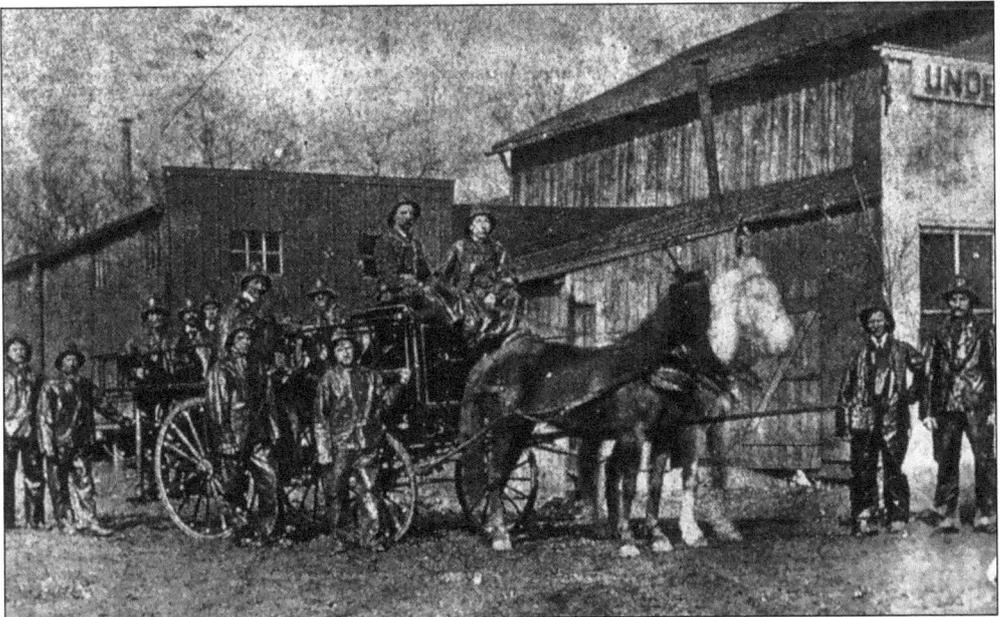

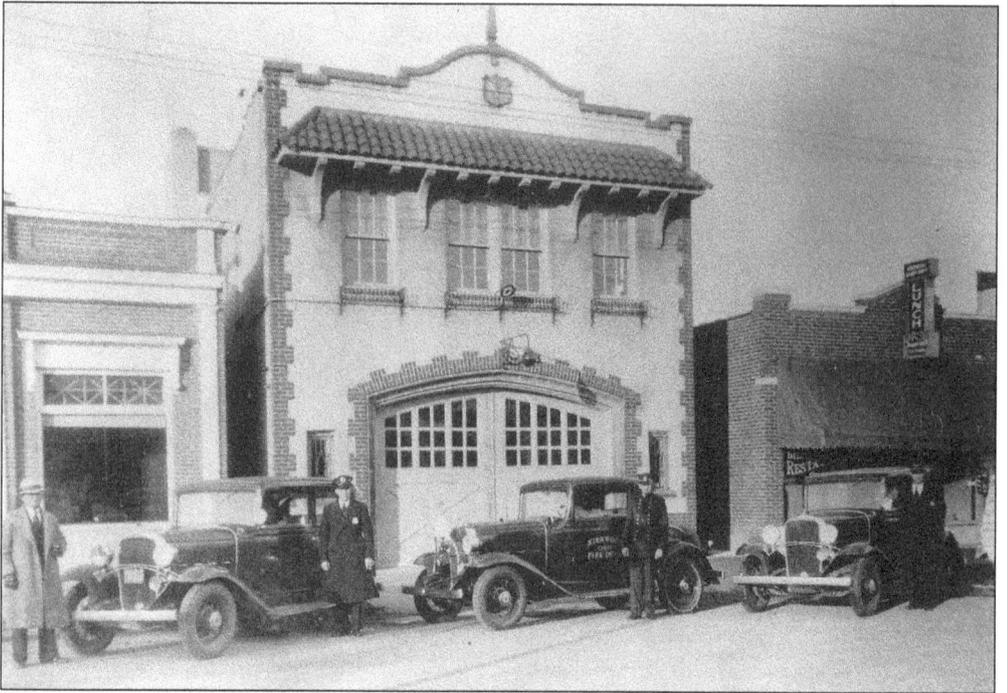

Even though problems with using a volunteer department were gradually resolved, the volunteer corps disbanded, leaving Kirkwood without protection and with the threat of increased insurance costs. The city established a paid fire department in 1918. The station pictured was the second, located on West Argonne Drive (the first one was on West Jefferson Avenue).

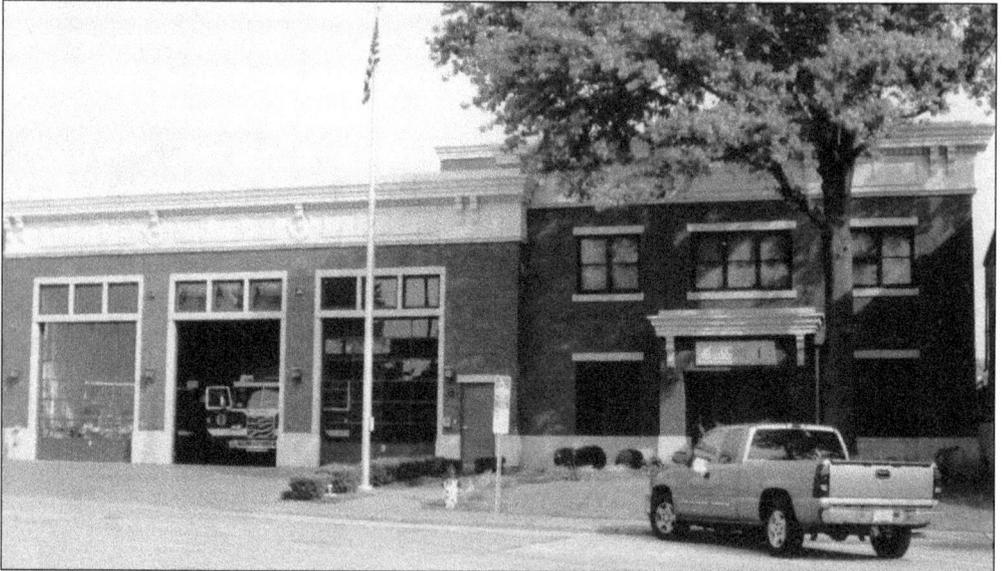

The Kirkwood Fire Department provides fire and paramedic services to Kirkwood and Oakland out of three firehouse locations. The photograph shows Firehouse No. 1, located on Argonne Drive. There are 46 uniformed personnel and one civilian working for the department. The department protects an estimated $27,005,200 worth of property (as of 2011) with an average response time of five minutes (as of 2011). (Author photograph.)

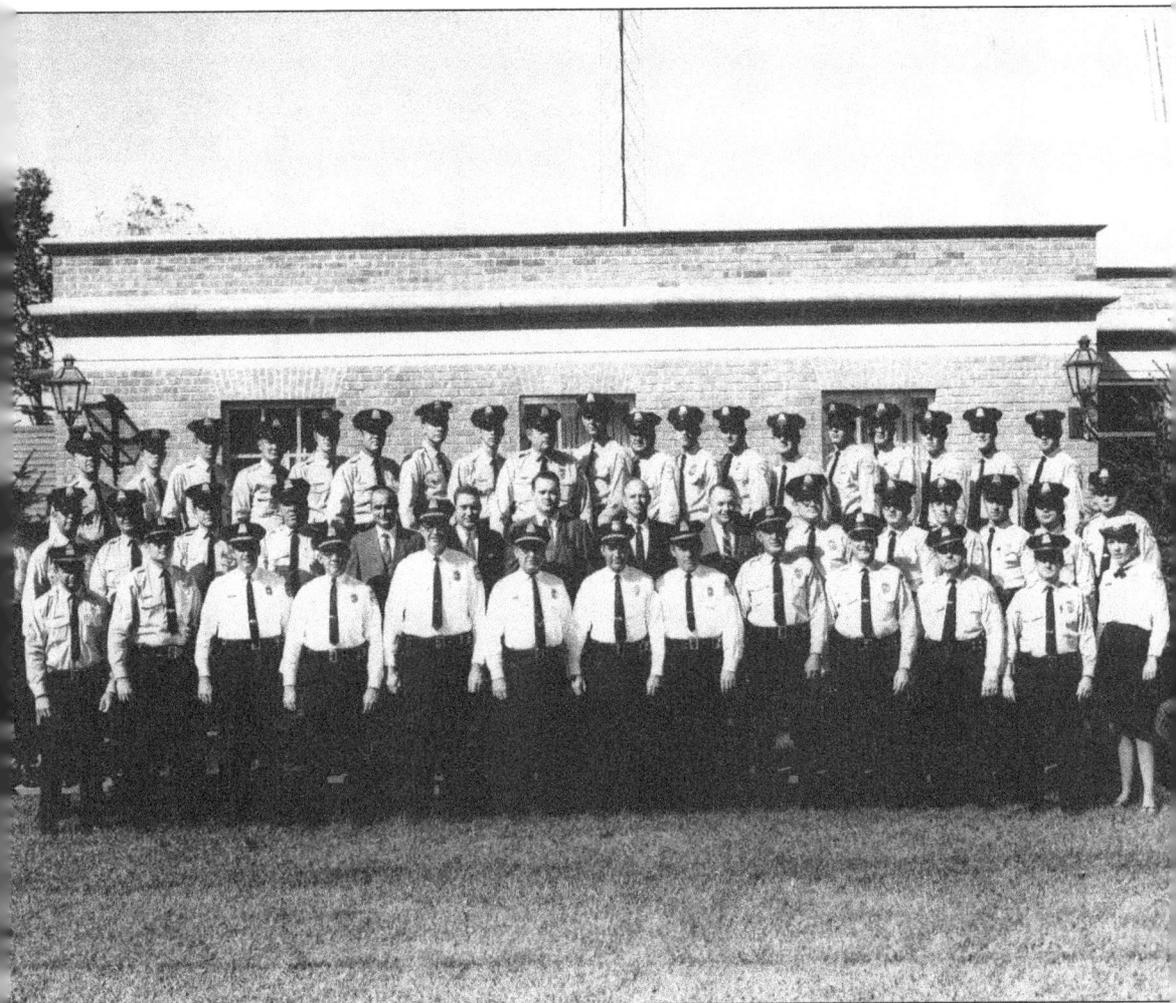

The Kirkwood Police Department gathers for a formal portrait around the 1970s.

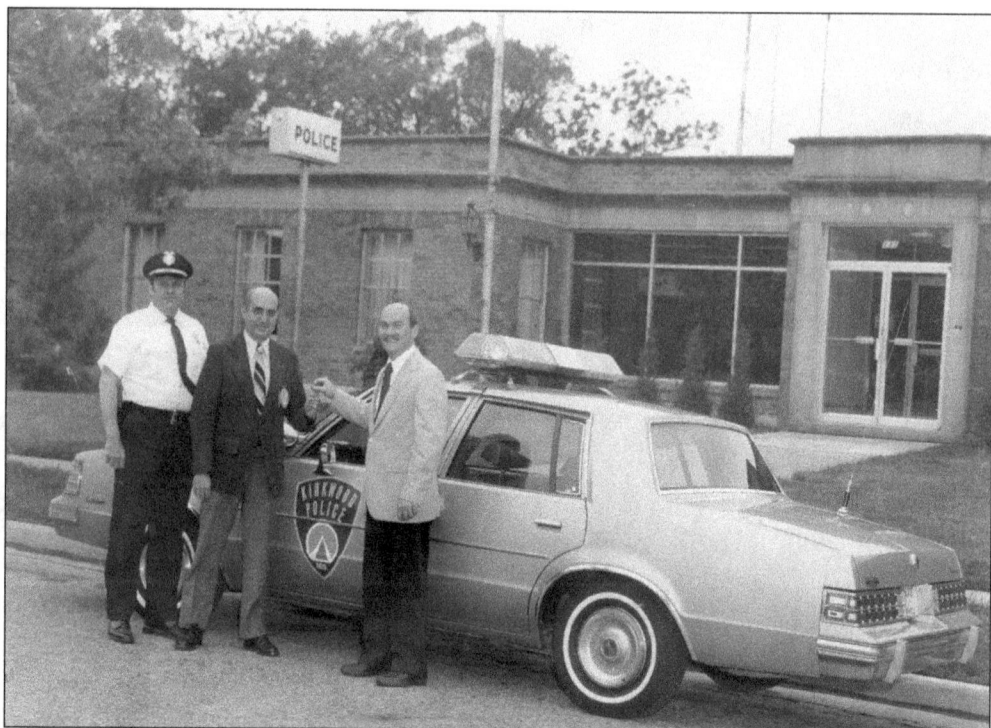

Police chief Dan Linza accepts the keys to a new 1981 Pontiac LeMans police car from Mike McTague of Don Darr Pontiac. Also pictured is Capt. Jim Gerringer. The LeMans was selected for its fuel economy. The exchange takes place outside the police station.

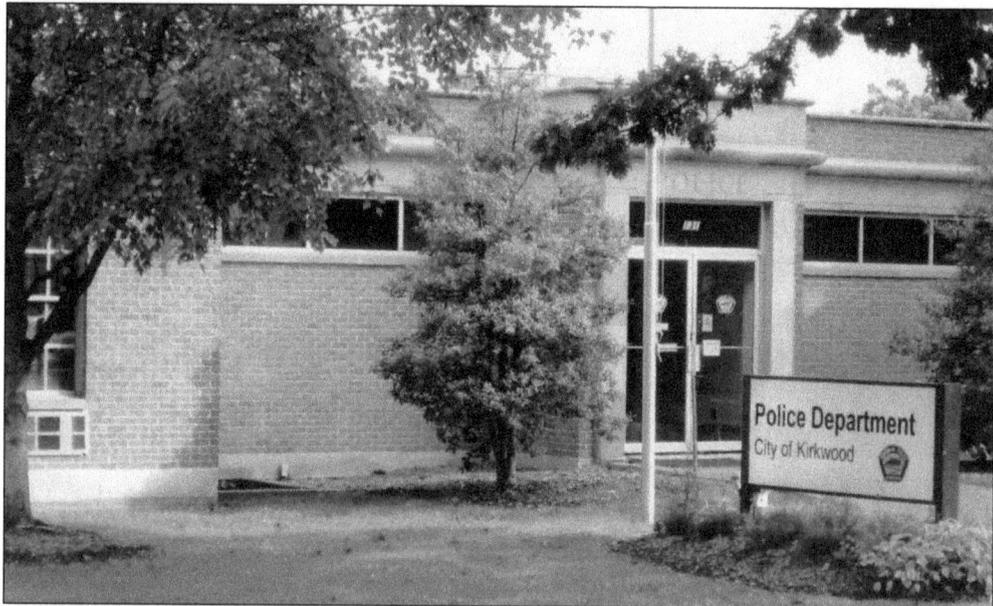

The Kirkwood Police Department has the distinction of being the first police department in St. Louis County, having appointed Henry S. Allen town marshal in 1865. From that one marshal, the department has grown to 59 commissioned officers and 13 full-time and six part-time civilians. (Author photograph.)

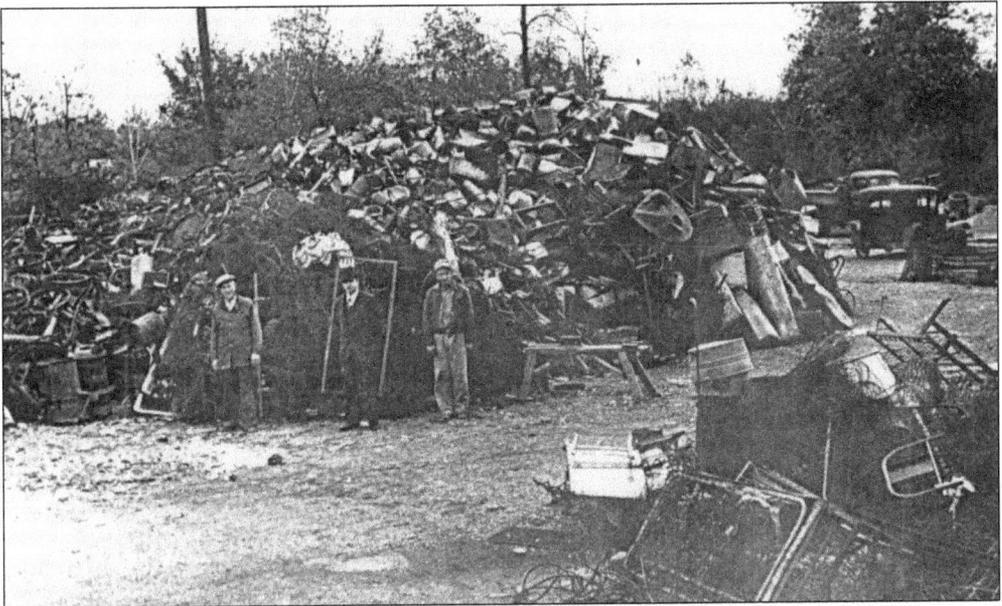

The City of Kirkwood has always been a leader in recycling. This photograph is from a 1942 recycling drive that was part of the war effort. However, the response shows the enthusiasm Kirkwoodians had for recycling even before recycling was a formal part of city services. Pictured from left to right are George Lambert, Joe Roberts, and Earl Davis Sr.

The first municipally supported drop-off recycling depository in the state of Missouri opened in Kirkwood in 1970. The Francis Scheidegger Recycling Depository on South Taylor Avenue was named after Kirkwood council member Francis Scheidegger, a longtime proponent of recycling. The center remains open seven days a week, 24 hours a day, even though Kirkwood added curbside recycling to its city services in January 2011. In 2011, Kirkwood collected 4,171.18 tons of recycling that would have otherwise gone into landfills. (Author photograph.)

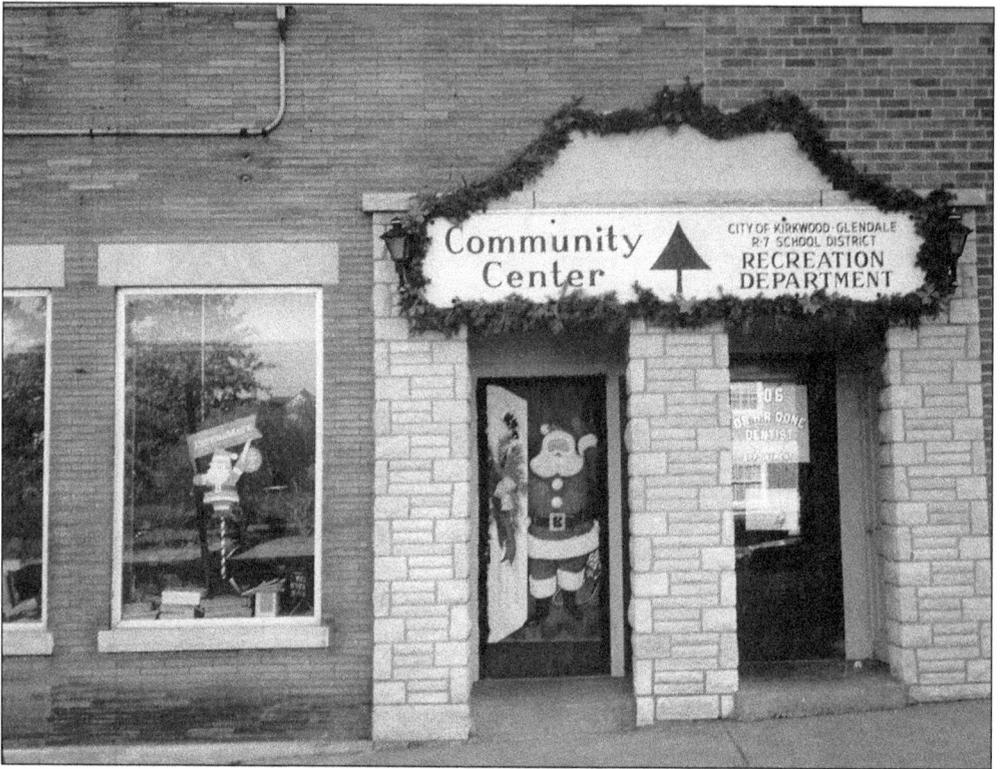

Before the Kirkwood Community Center was built, Kirkwood Parks and Recreation was located on Kirkwood Road across from city hall. This photograph dates from the early 1960s and denotes the community center as encompassing the Kirkwood Glendale R-7 School District.

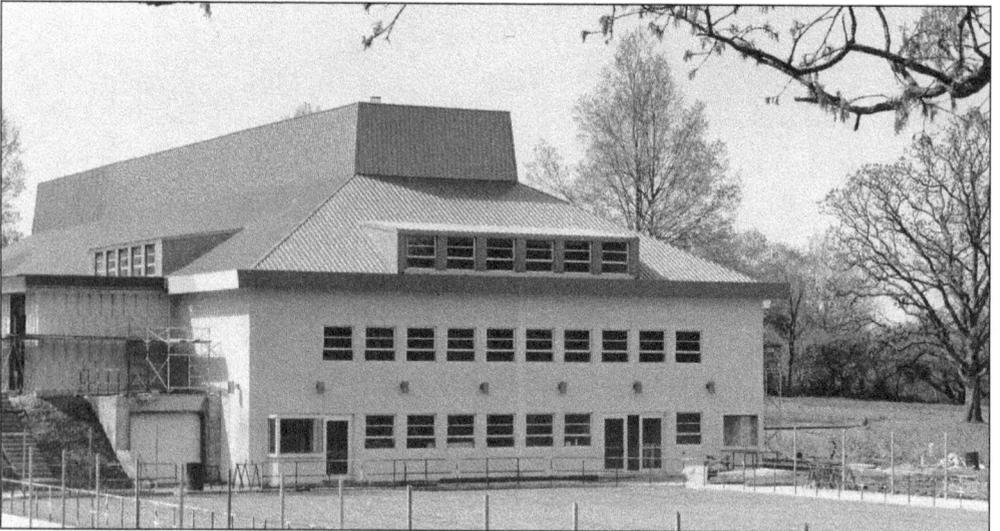

The Kirkwood Community Center was built on Geyer Road at the eastern edge of Kirkwood Park in 1966. The initial parcel, consisting of 20 acres for Kirkwood Park, was purchased in 1941. The park is now 90 acres and includes pavilions, tennis courts, an ice rink, an expanded community center, baseball fields, playgrounds, a lake, a swimming complex, an amphitheater, campsites, picnic areas, and more.

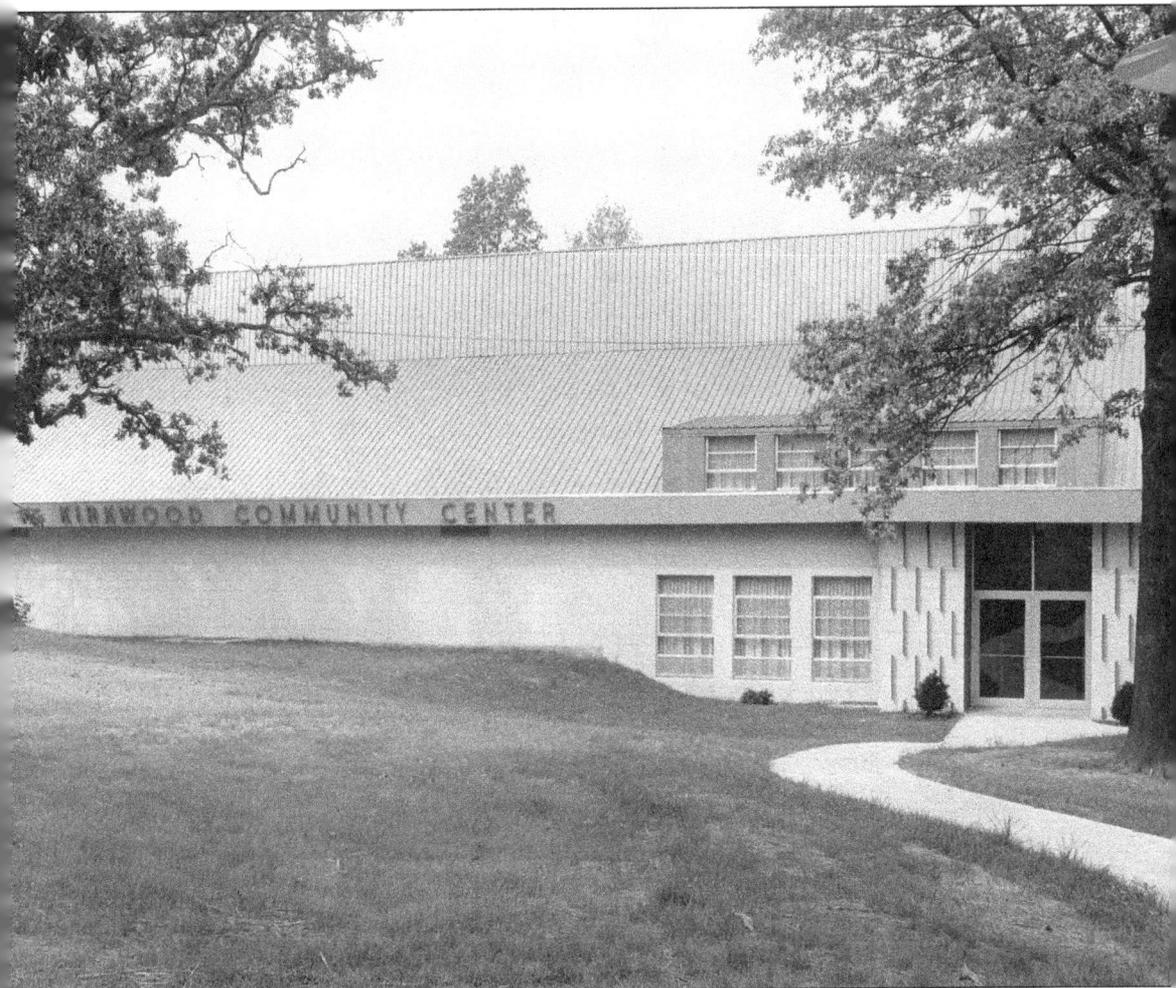

This is a view of the Kirkwood Community Center from the front (Geyer Road side) when it was new, around 1965 or 1966. The first public park, also called Kirkwood Park, was created in 1870 at Argonne Drive and Taylor Avenue. In 1915, a public playground was built at Pitman School, and in 1926, the city established a parks and recreation committee. In early Kirkwood, there was much open land available in and around the city for recreational purposes, but as more people moved to the area and built housing, a demand grew for recreational areas.

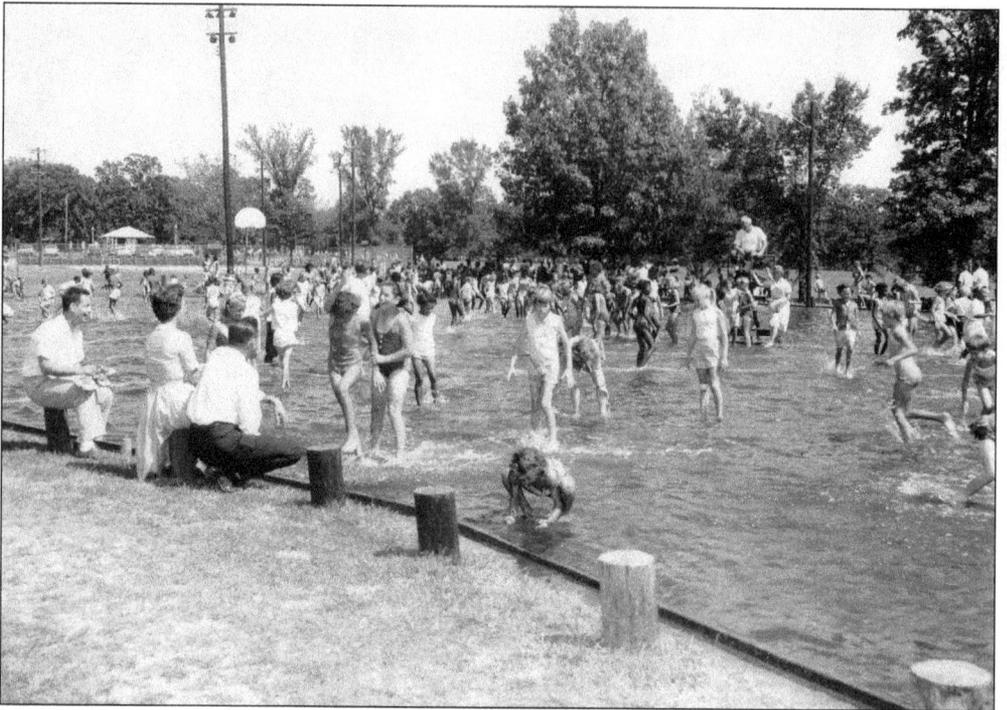

Before Kirkwood had a swimming pool, the police department flooded the parking lot for children to use as a wading pool.

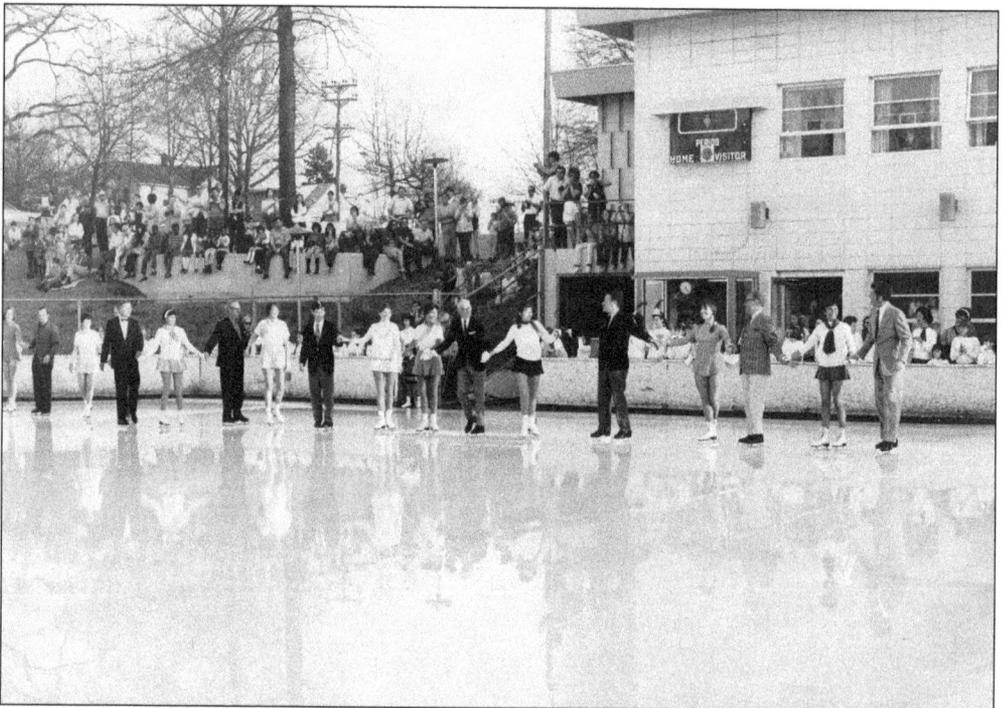

An outdoor ice rink was established adjacent to the Kirkwood Community Center, providing residents a place to ice skate and local hockey teams a rink for practice and games.

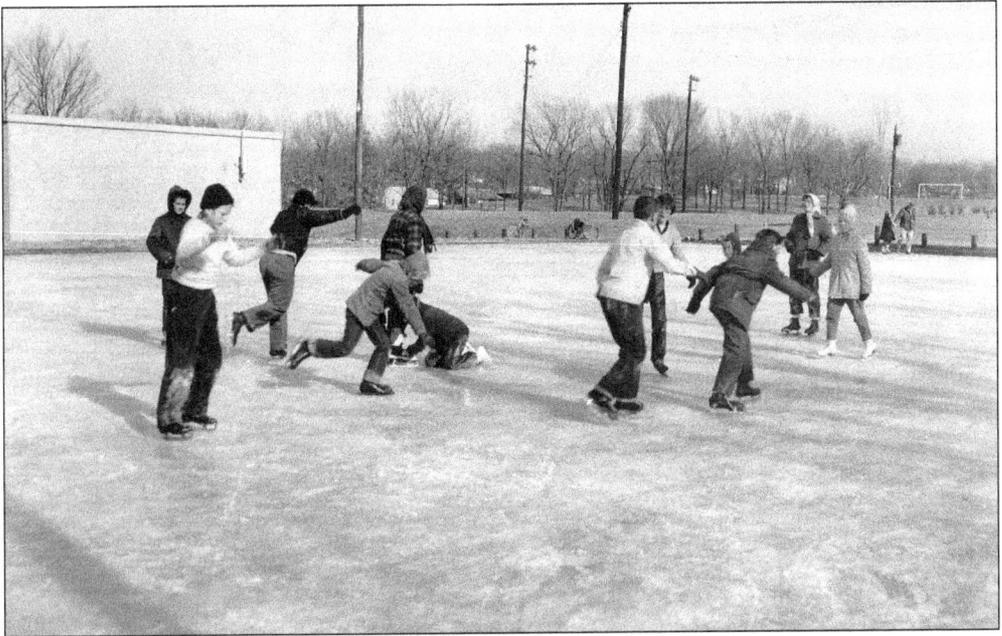

Today, the Kirkwood Community Center sports an enclosed ice rink attached to the building on Geyer Road, but before that enclosure, area children had fun skating outdoors.

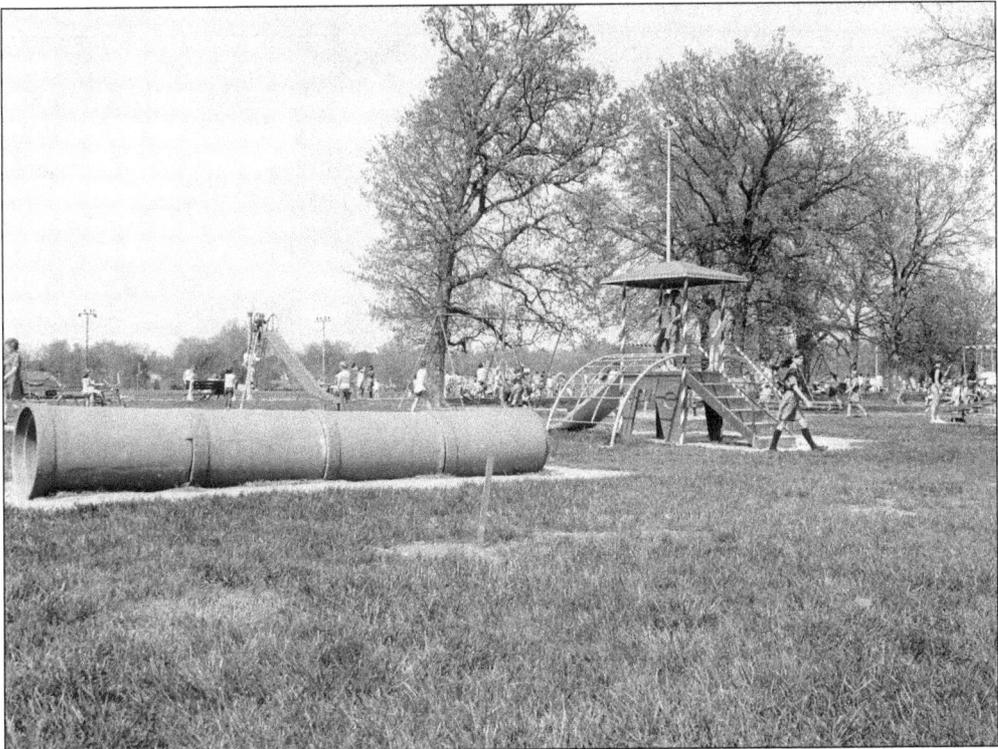

Kirkwood Park, located at Geyer Road and Adams Avenue, also offered a playground for young people. Today, there are two playgrounds available with equipment that is age appropriate for younger and older children.

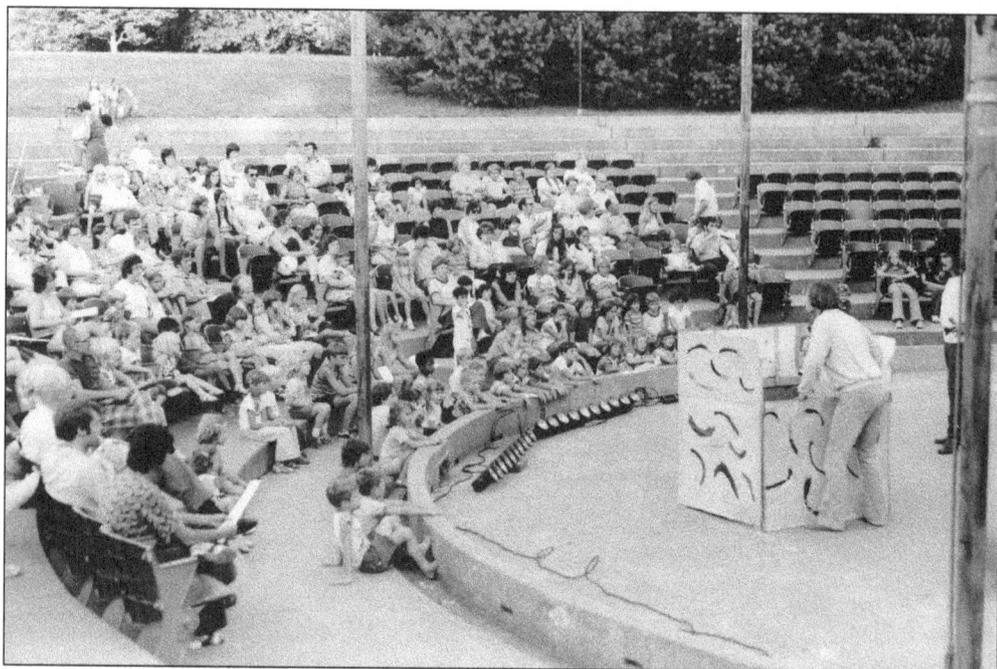

An amphitheater, used for musical and theatrical performances, was dedicated in 1965. The area has been updated in recent years.

Today, the Kirkwood Parks and Recreation Department operates 14 parks around the city ranging in size from 125 acres to neighborhood parks of less than half an acre. This includes Walker Park, pictured here. Other sites include McEntee Memorial Park, Fireman's Park, Greentree Park, Emmenegger Nature Park, Little Mitchell Park, Fillmore Park, Dee Koestering Park, Connor Park, Grant's Trail, Meacham Park Memorial, Avery Park, Monfort Park, and Historic Quinette Cemetery. (Author photograph.)

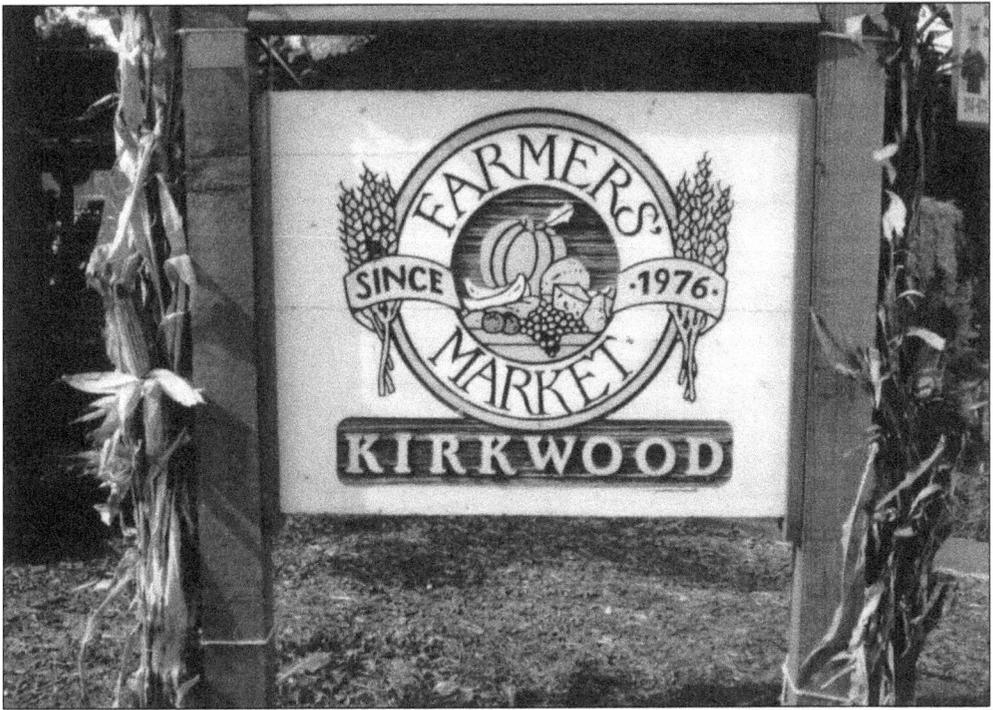

The Kirkwood Farmers Market has been located at Argonne Drive and Taylor Avenue since 1976. It offers fresh fruits and vegetables seasonally to area residents. (Author photograph.)

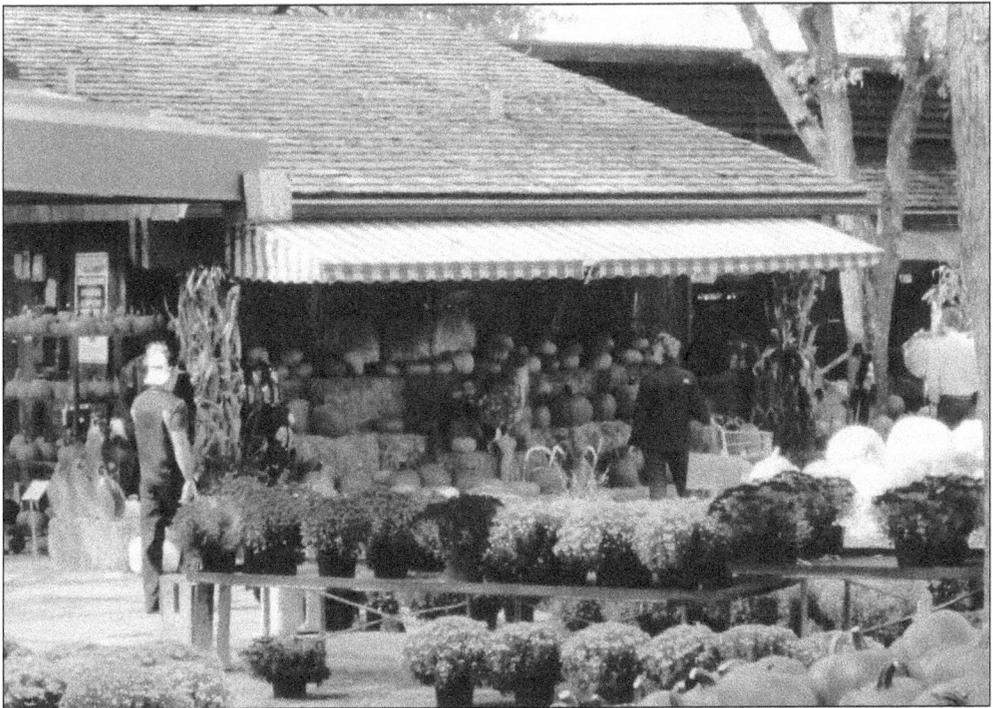

The farmers market is also a holiday shopping location, offering pumpkins at Halloween and Christmas trees and decorations seasonally. (Author photograph.)

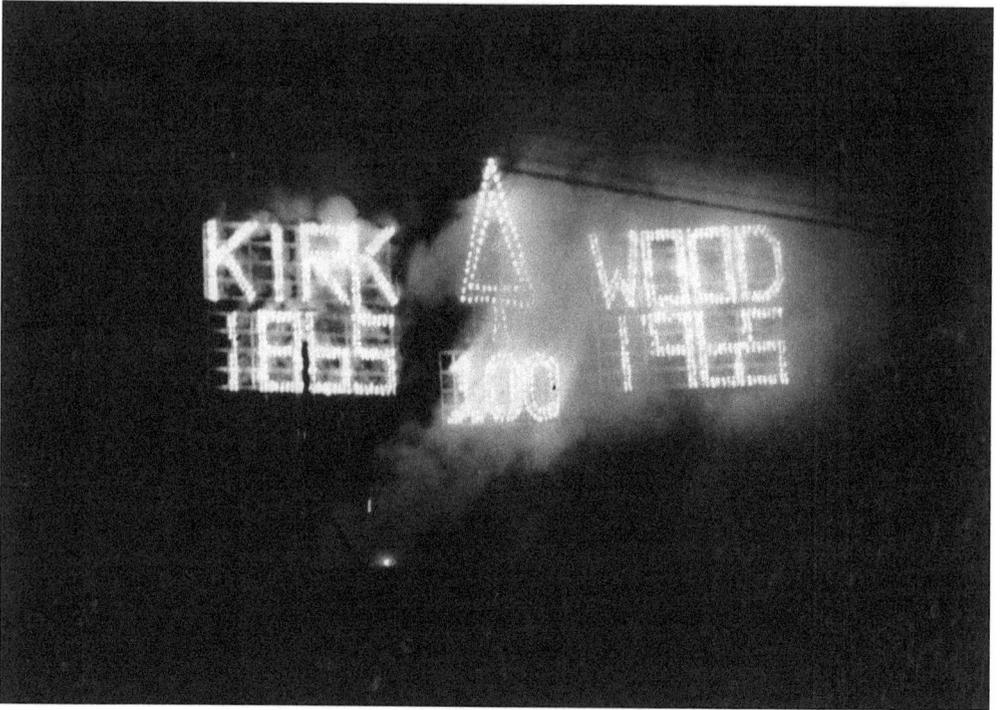

In 1965, Kirkwood celebrated its 100th anniversary as an incorporated city with a Freedom Fiesta. This is a sample of the fireworks display.

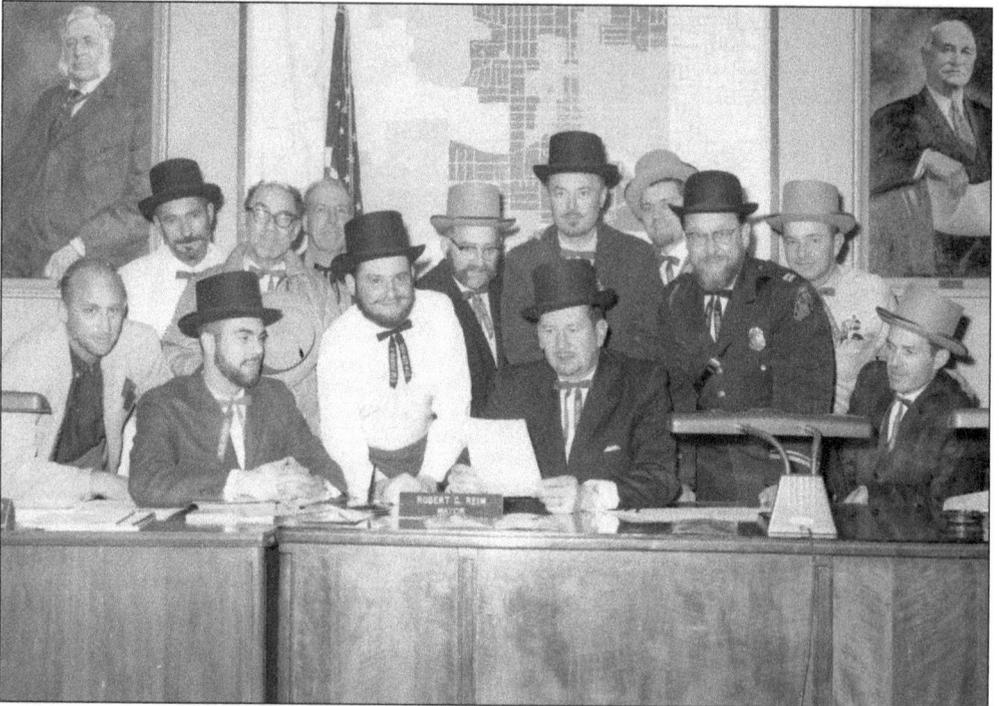

When the City of Kirkwood celebrated its centennial in 1965, the Kirkwood Chamber of Commerce entered wholly into the spirit of the festivities (subjects unidentified).

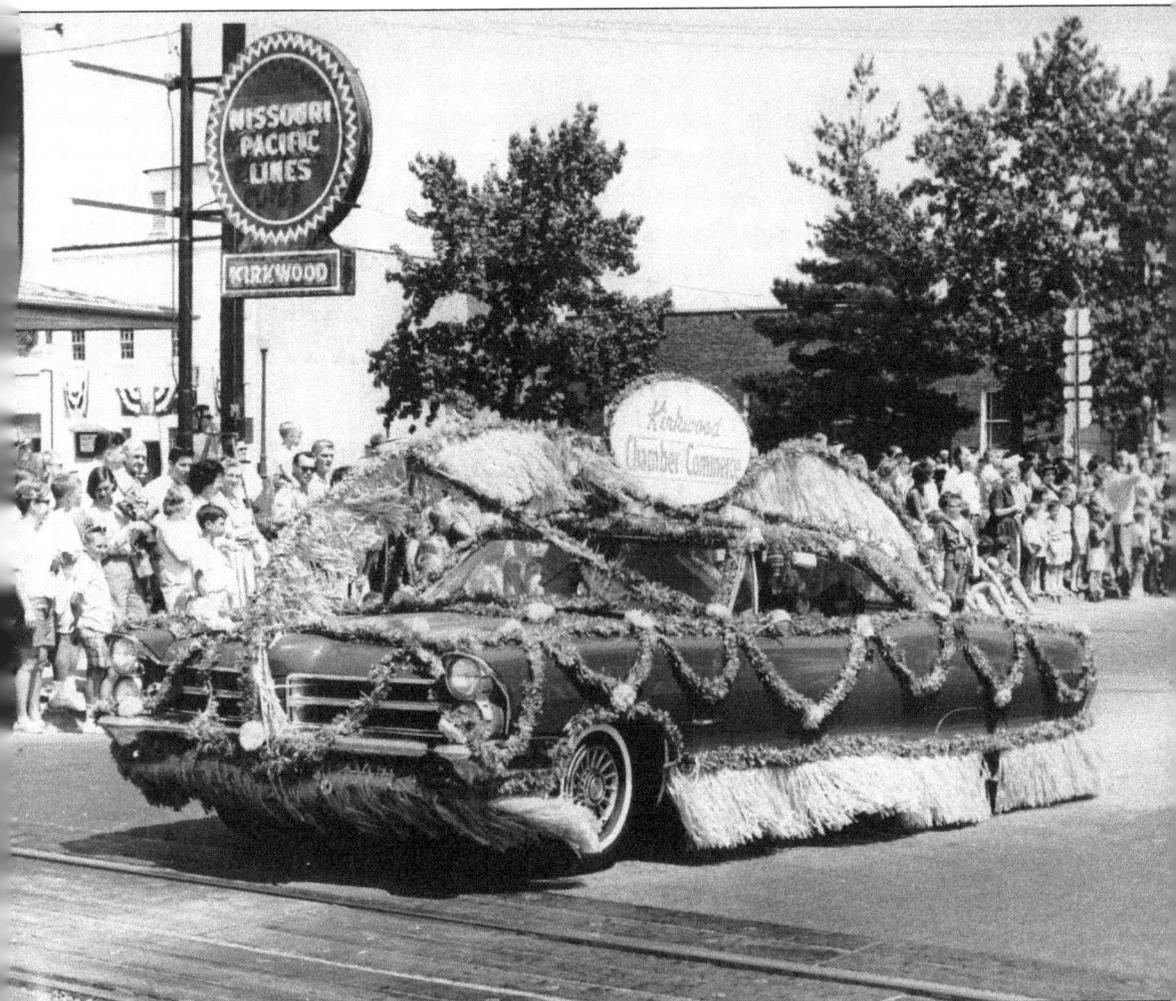

A parade was part of the Kirkwood Centennial festivities. Note the Missouri Pacific buzz saw that welcomed trains to the city in the background.

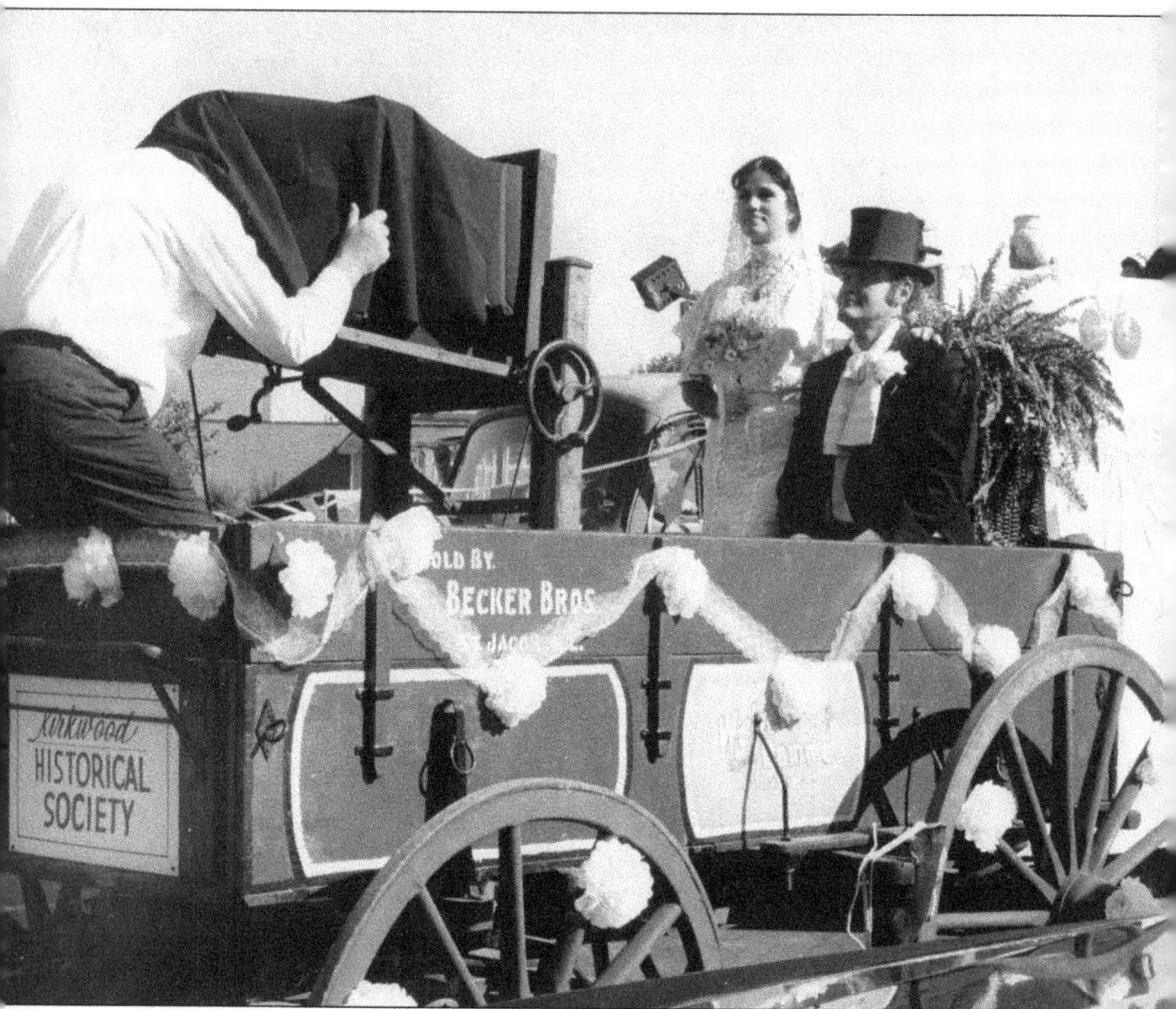

The Greentree Parade and Festival are annual events in Kirkwood in September. Fred and Carol Miller pose on the Kirkwood Historical Society's winning parade float in 1976.

Four

KIRKWOOD LIBRARY

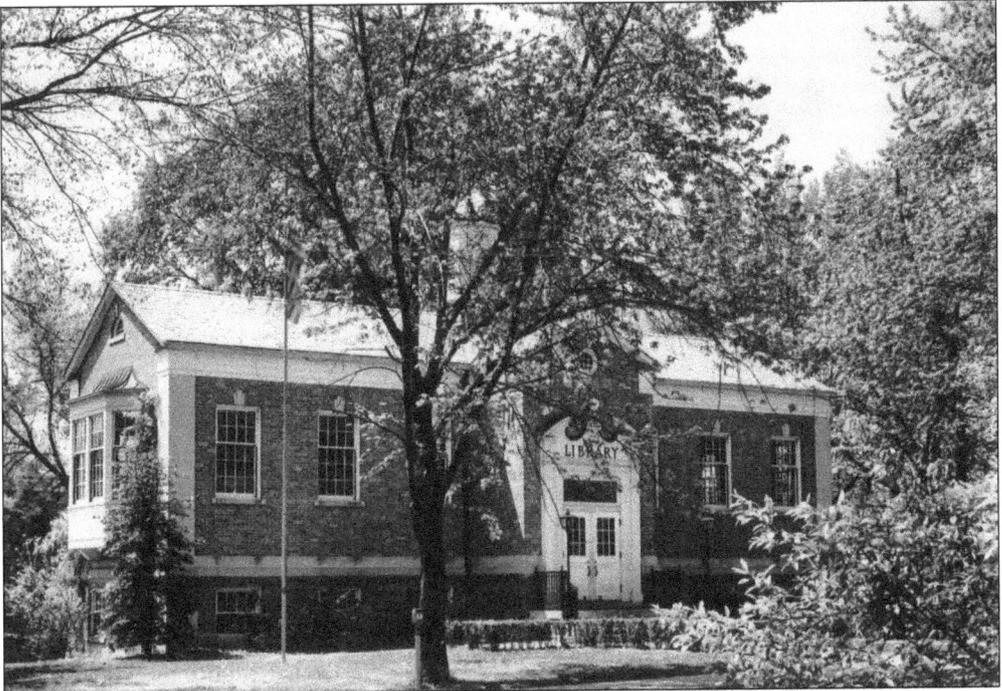

The Kirkwood Public Library opened on May 10, 1924, in the Kirkwood City Hall, sharing space with the engineering department. It had the distinction of being the first tax-supported public library in St. Louis County. The book collection was donated, and the first librarian worked part-time. This library building, pictured around 1949, was constructed on the corner of Taylor and Jefferson Avenues in 1940. A 1938 bond-issue election failed because voters found an alternate site unsatisfactory.

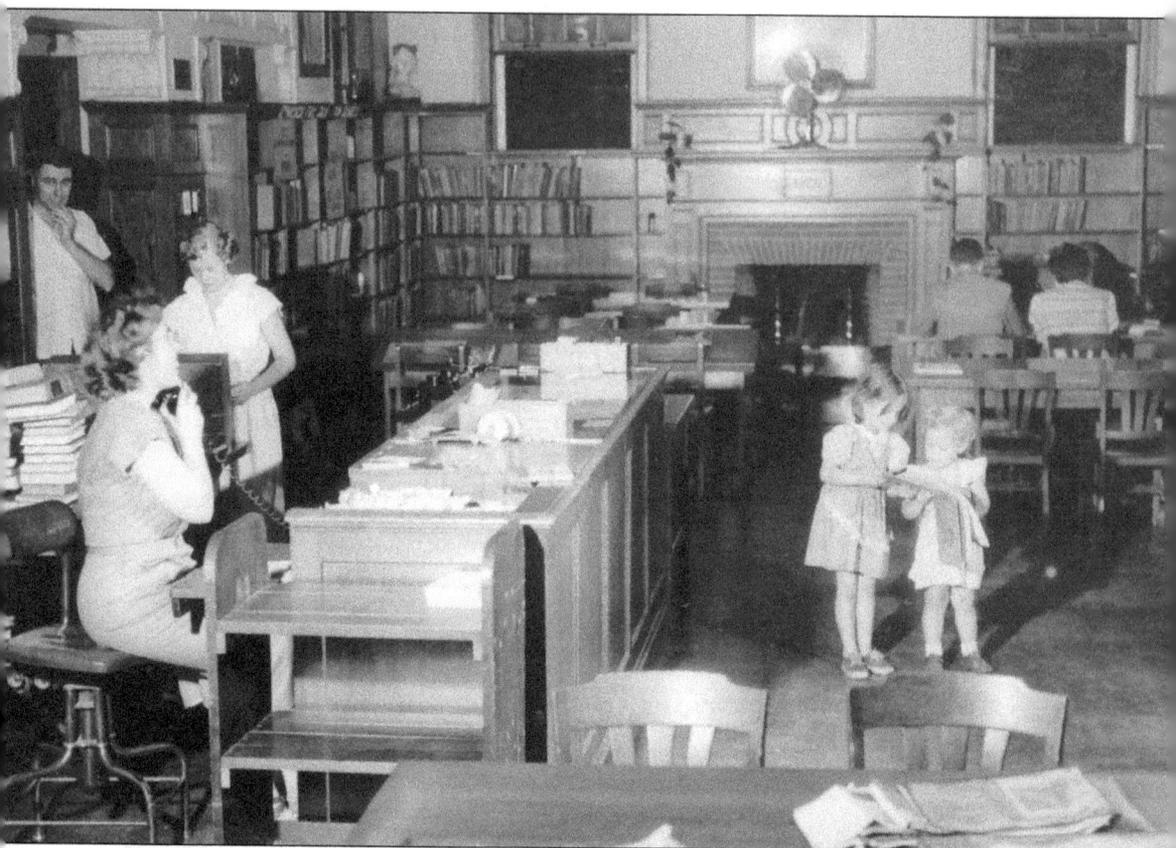

This is a view of the library interior in 1949. Note the fireplace surrounded by bookshelves. The opposite end of the building featured a window seat.

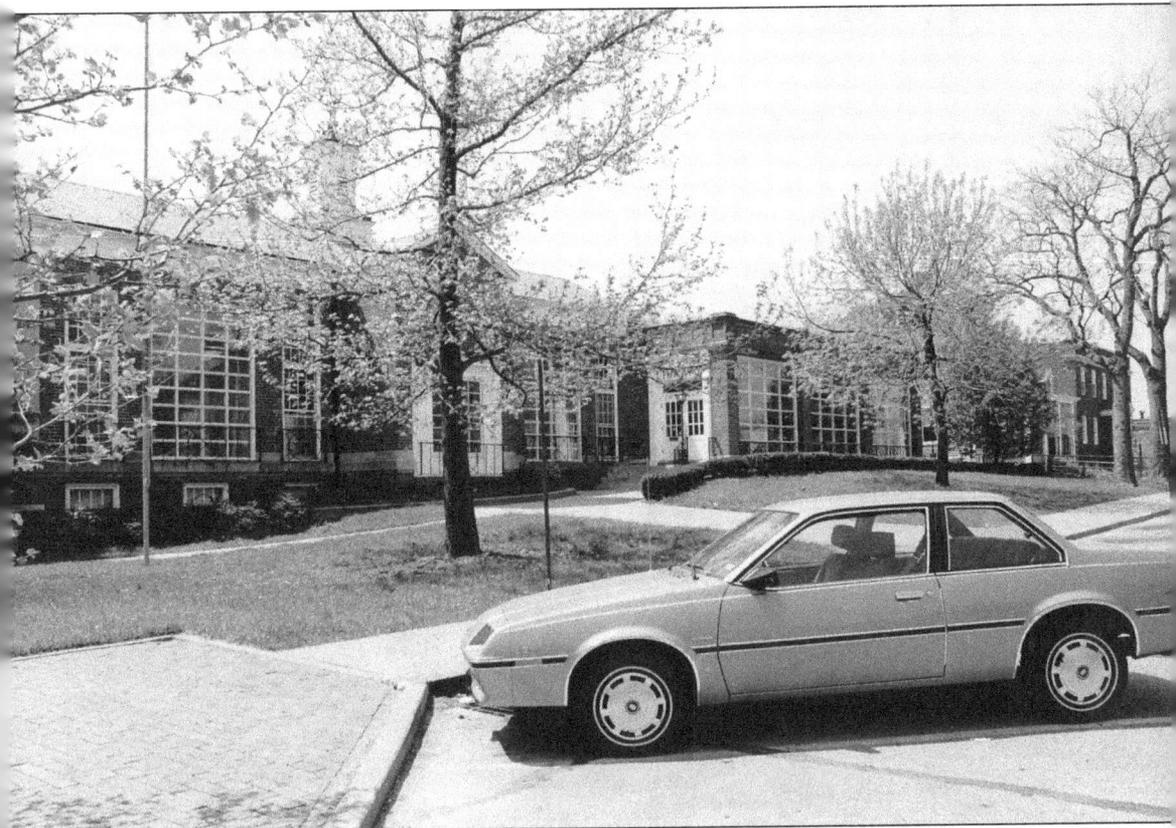

Kirkwood Public Library was further improved in 1955, doubling the floor space and adding an auditorium. In 1964, an addition was built on the south side, and an elevator brought the building into compliance with the Americans with Disabilities Act in 1994. A bond issue passed in 1994 also made it possible for the library to open for the first time on Sunday. Tax increases to improve library services and facilities require approval of two-thirds of voters. The photograph shows the building around 1987.

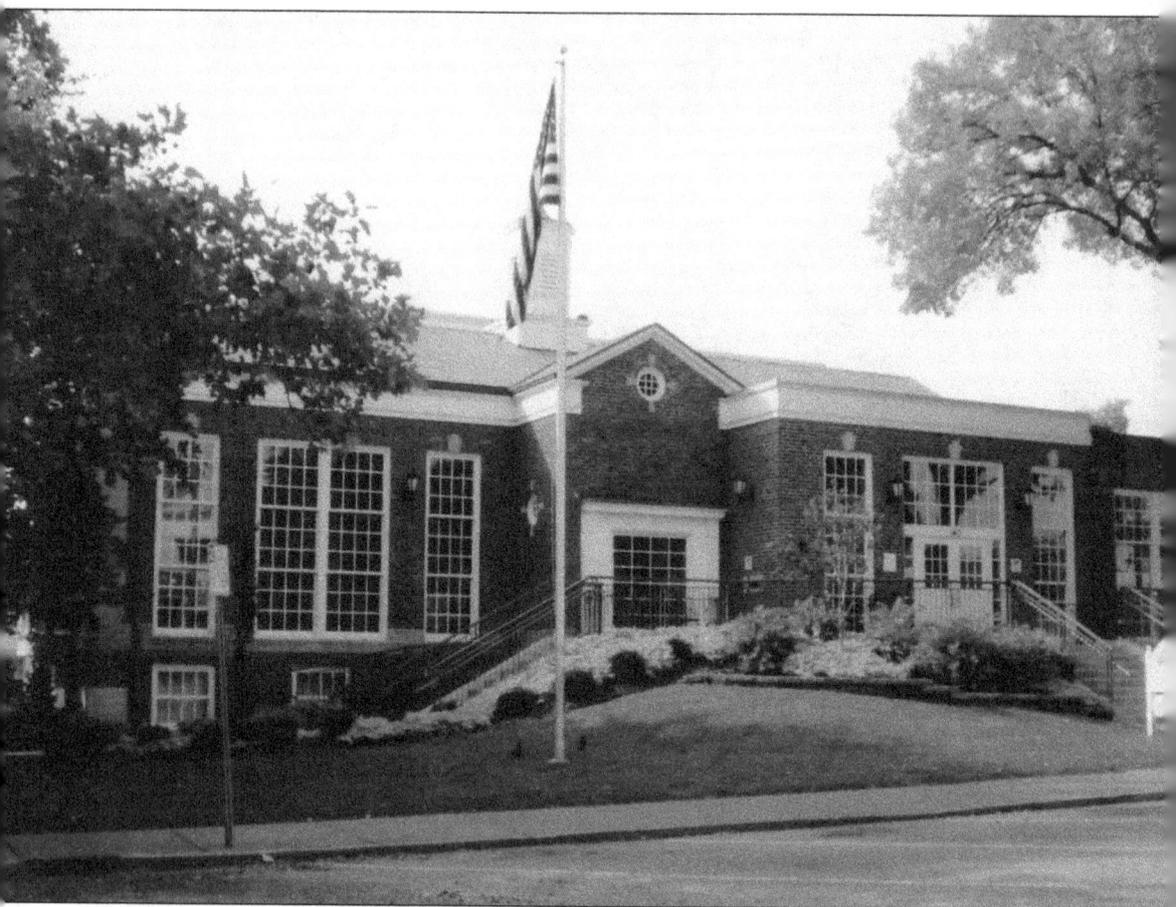

In November 2007, Kirkwood Public Library was named Missouri Library of the Year, and the community also passed a bond issue to renovate the building. The renovation increased the square footage from 23,000 to 25,000 and reconstructed the lower level to be more accessible and efficient. The "new" library, pictured here, reopened August 14, 2010. (Author photograph.)

Five

KIRKWOOD BUSINESS

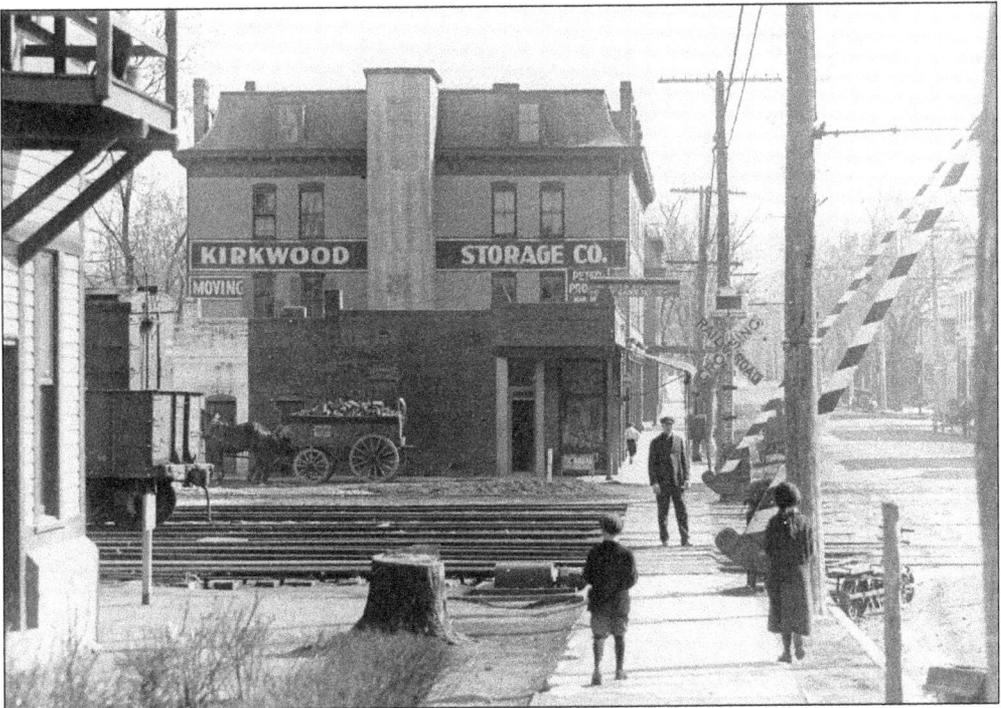

This photograph offers a view south from the railroad tracks down Kirkwood Road in the early 1900s. The structure on the left is the railroad communication tower.

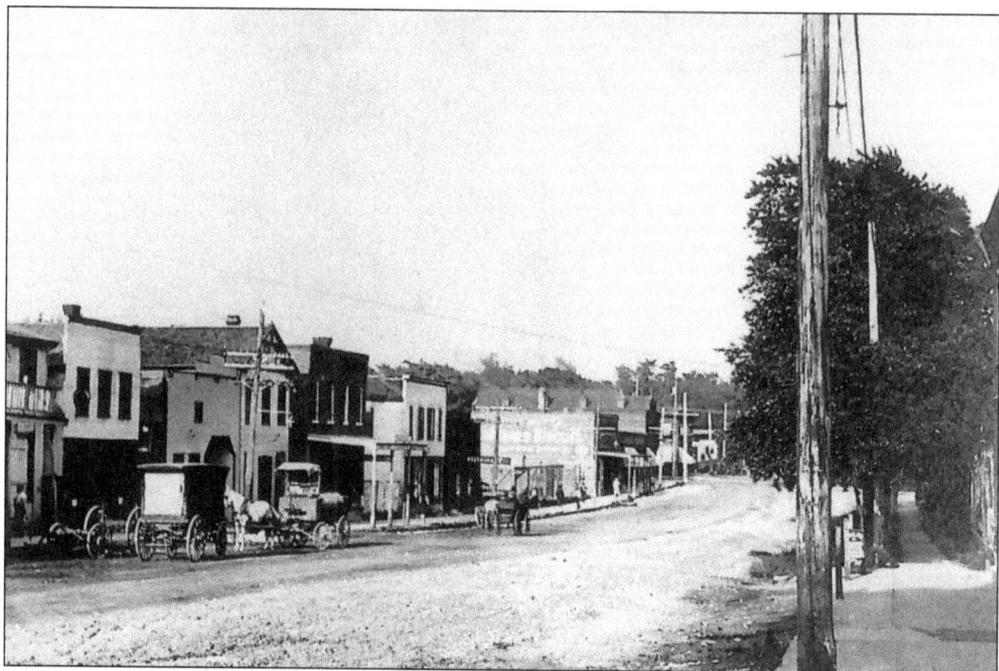

This historical view depicts the north side of Main Street (now Argonne Drive) around 1911. This was the heart of downtown then and today.

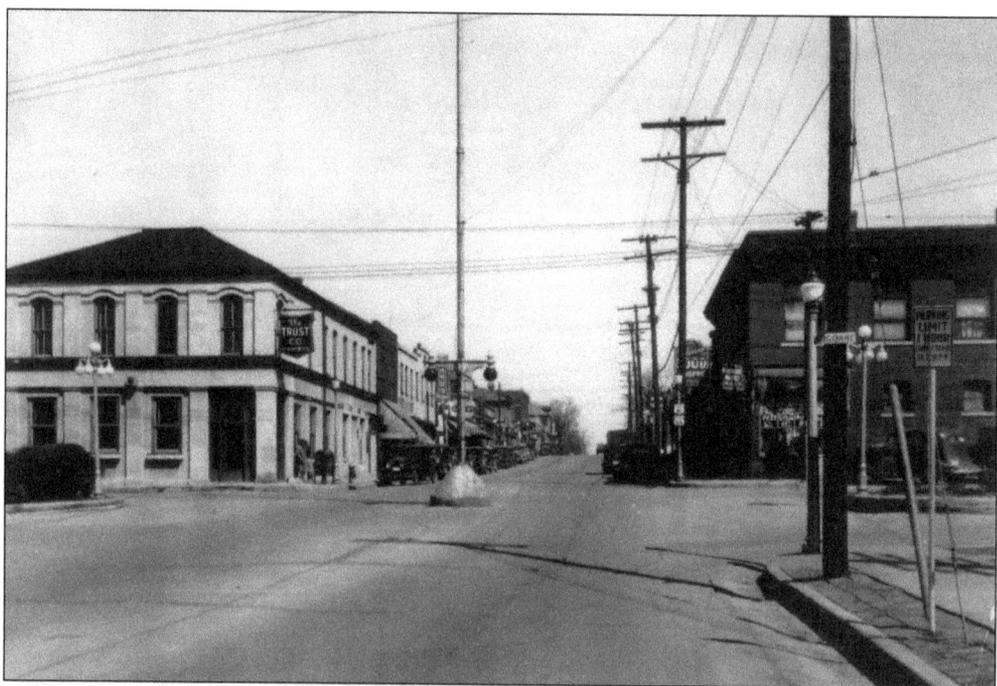

Kirkwood Road (once called Webster Avenue) and Argonne Drive (formerly Main Street) have long been the heart of the Kirkwood business district. This c. 1930s photograph looks north on Kirkwood Road from Argonne Drive. Note the flagpole in the middle of the intersection.

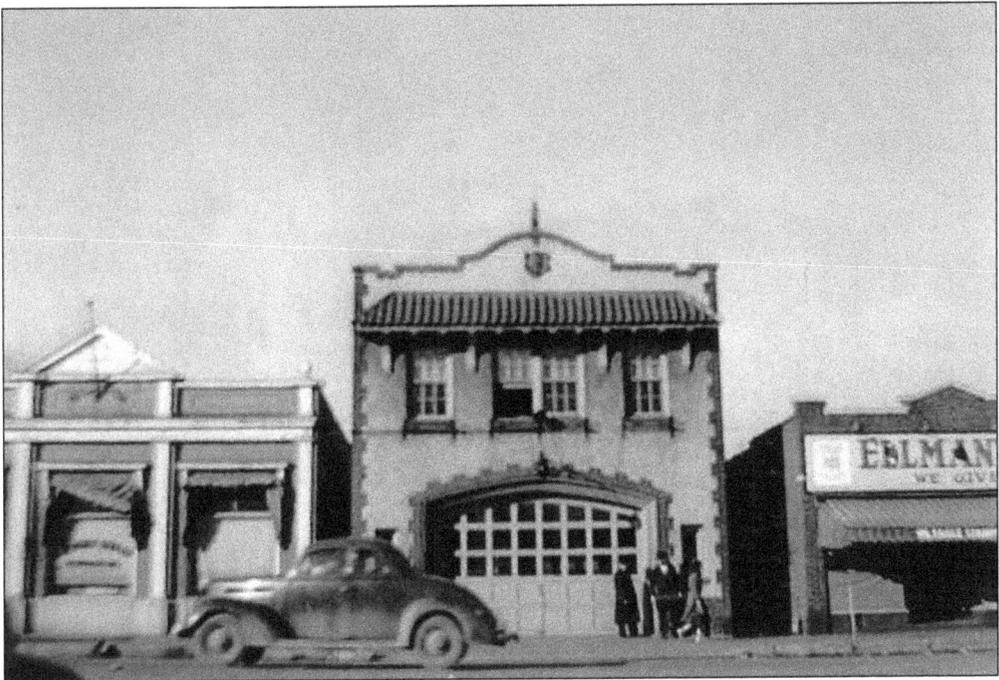

This undated view of West Argonne Drive's north side offers a glimpse of Ellman's Department Store as well as the building that was originally the fire station.

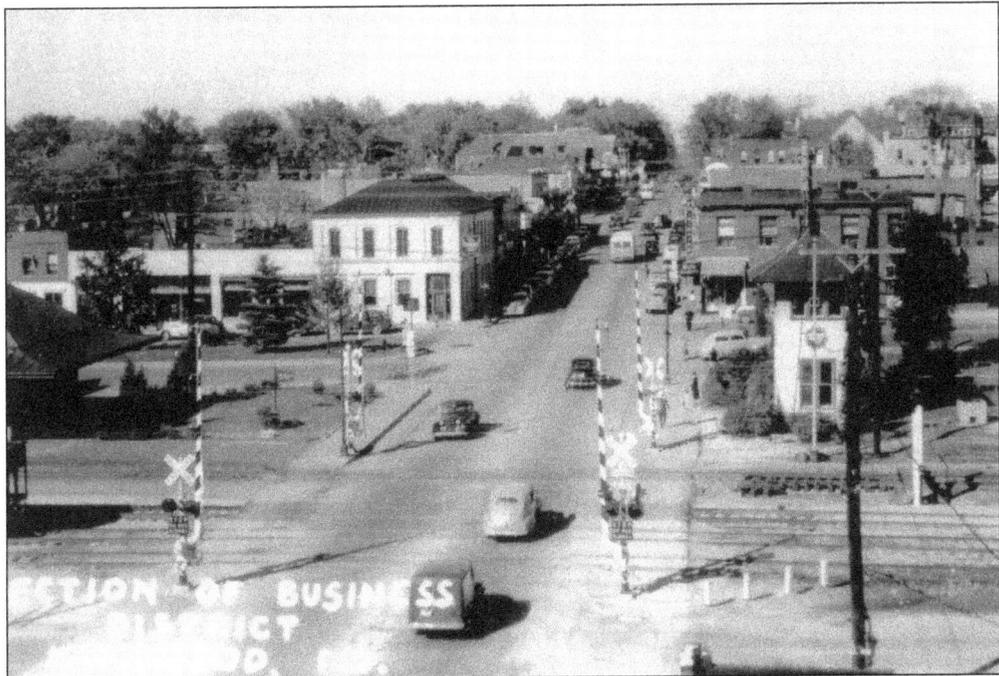

Here is another view in a different, unknown year of the business district looking north on Kirkwood Road.

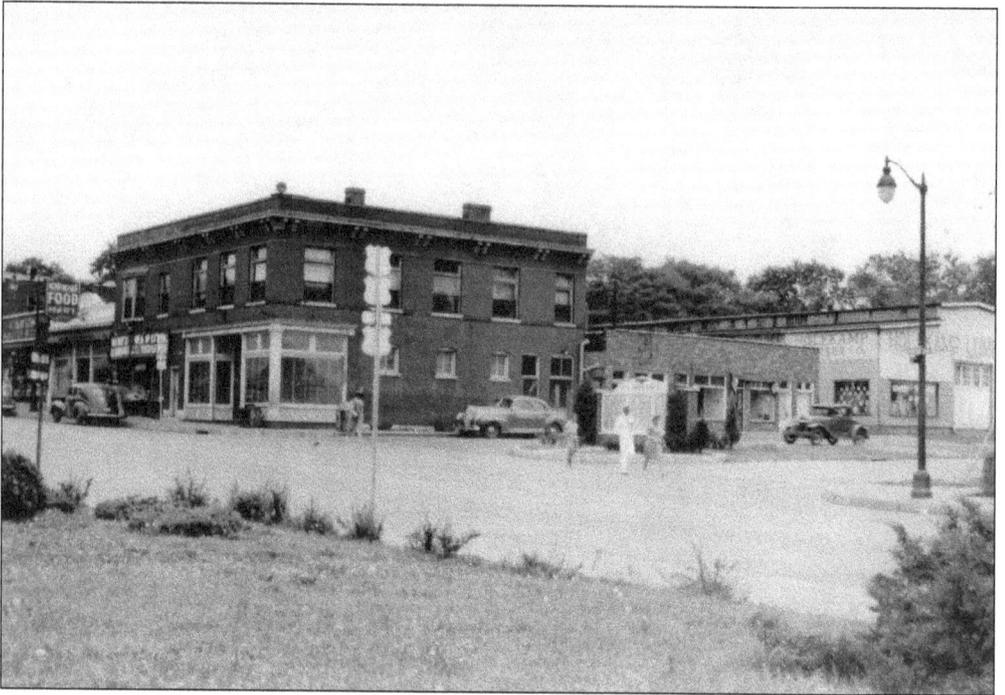

Seen here is a c. 1946 view of the east side of Kirkwood Road and the north side of Argonne Drive from the front of the train station.

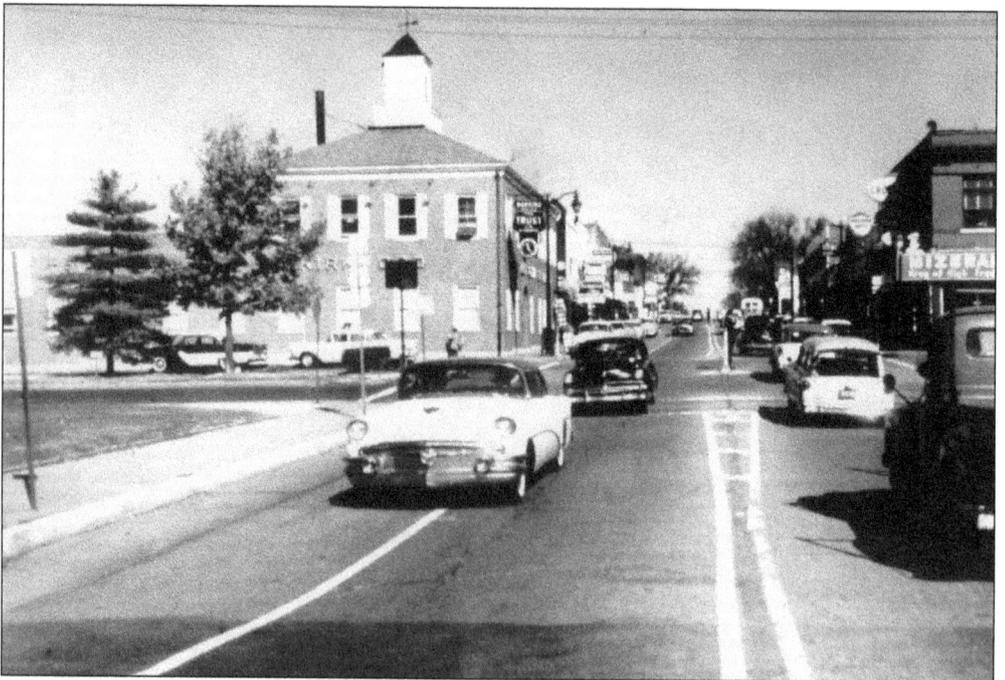

This view, facing north on Kirkwood Road, shows a modified Kirkwood Trust Company around the 1950s.

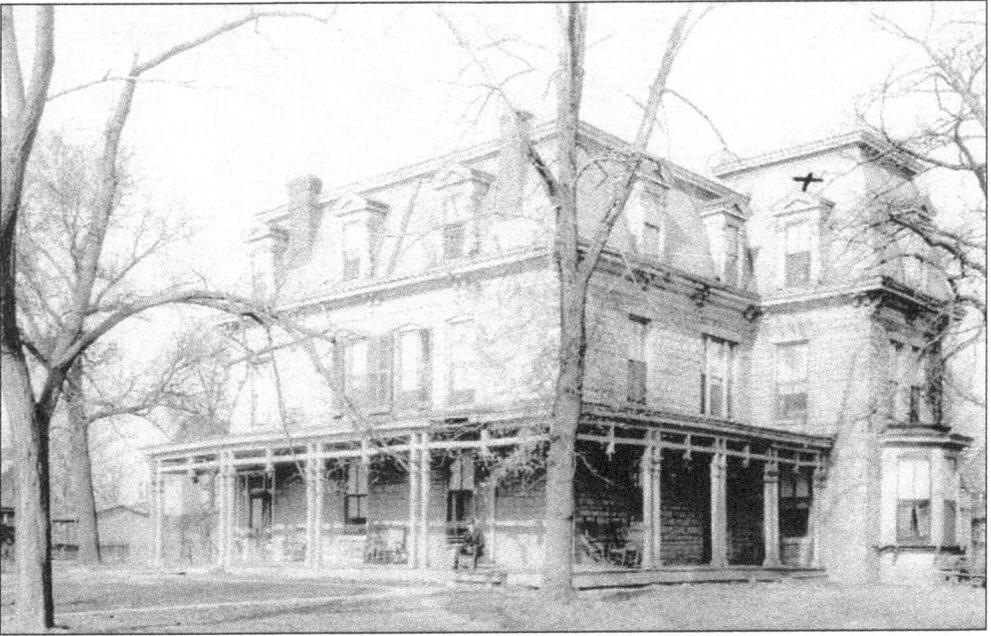

After the closing of Kirkwood Seminary, the property traveled through several hands and ended up as the Oakwood Hotel under the ownership of Lettie L. Gardner. The hotel was a gathering and meeting place for the citizens of Kirkwood.

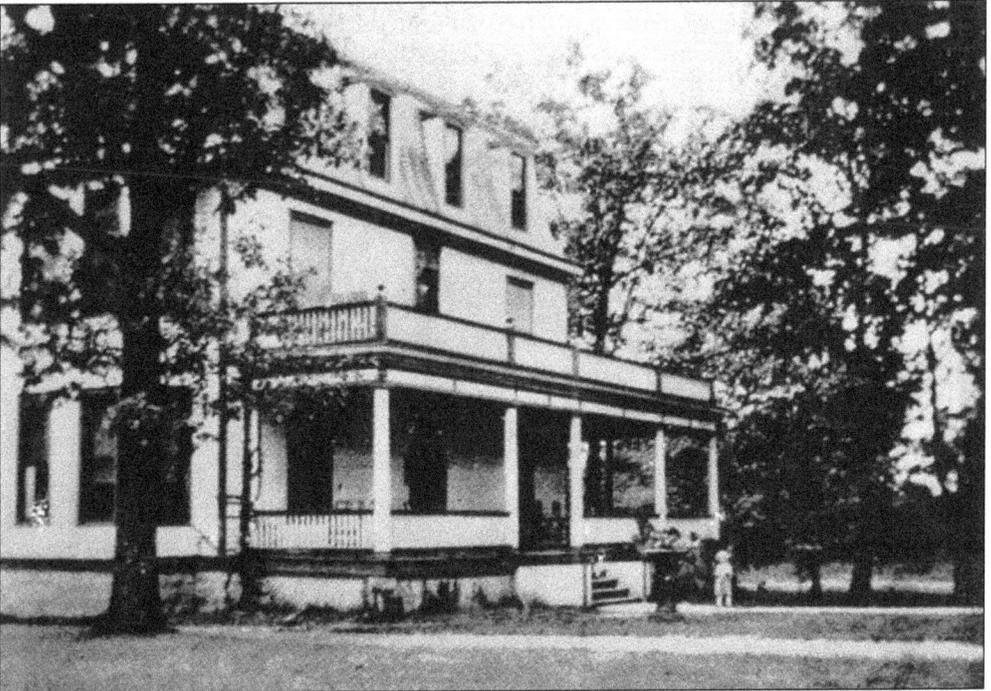

The Lexington Hotel, pictured before 1908, was located at the corner of Adams and Woodlawn Avenues and was established to provide accommodations for 1904 St. Louis World's Fair visitors. It continued as a resort and hotel (with name changes to Woodlawn Inn and Woodlawn Hotel) until 1947, when the Kirkwood Baptist Church purchased the property.

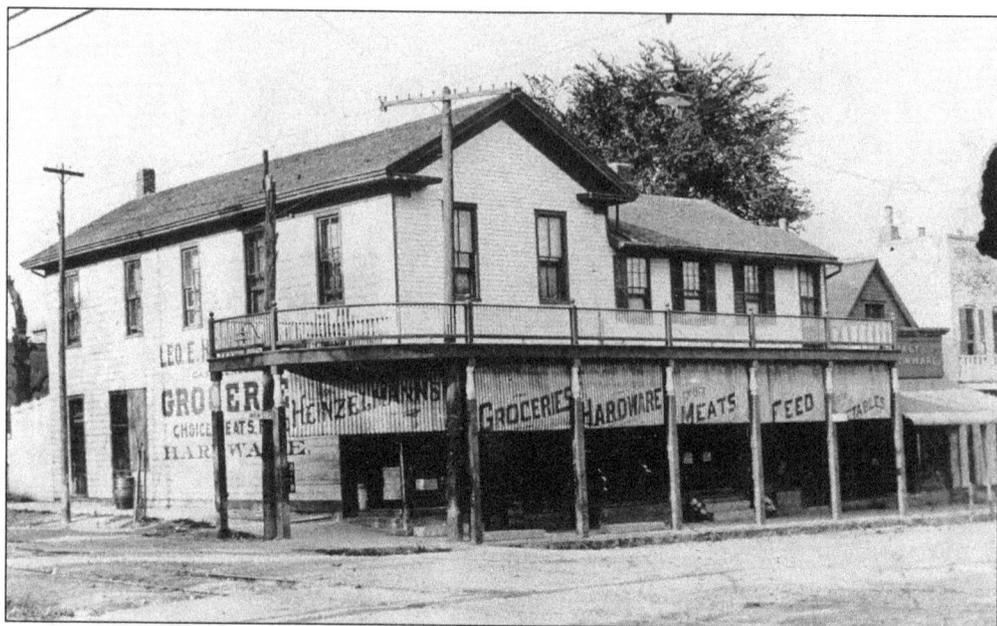

The Heinzelmann general store was established in 1875. At the time of the early-1900s photograph, it was operated by Leo E. Heinzelmann, whose father founded the business. The Kirkwood business community was relatively small until after the Civil War, when locally owned businesses took root in the area between Madison Avenue on the south, Adams Avenue on the north, Taylor Avenue on the east, and Clay Avenue on the west. The building in the picture still stands at the corner of Clay Avenue and Argonne Drive (then Main Street), although the structure has been altered.

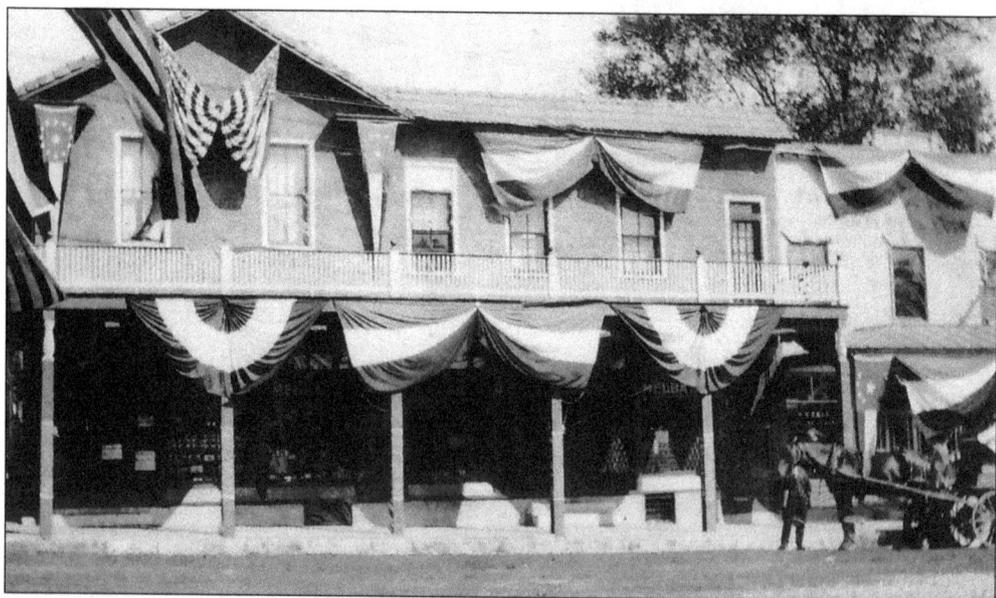

This is another view of the Heinzelmann's general store in 1915. The building is still host to a retail business.

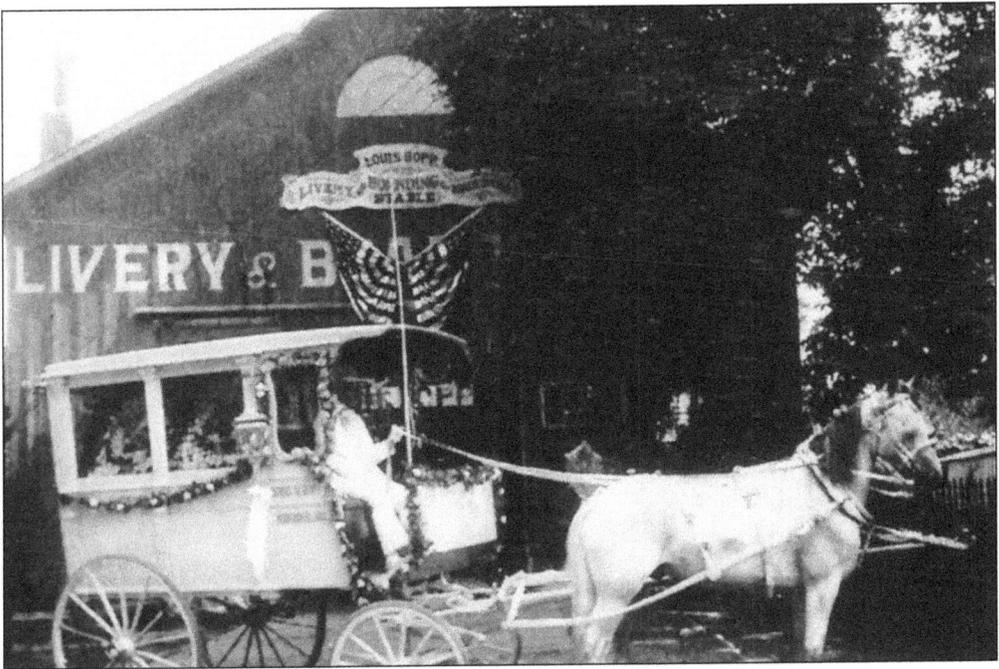

The Bopp family shares a long history with the city of Kirkwood. Louis Bopp owned a livery and boarding stable. The carriage shown in this undated photograph is decorated, most likely for a parade or community event.

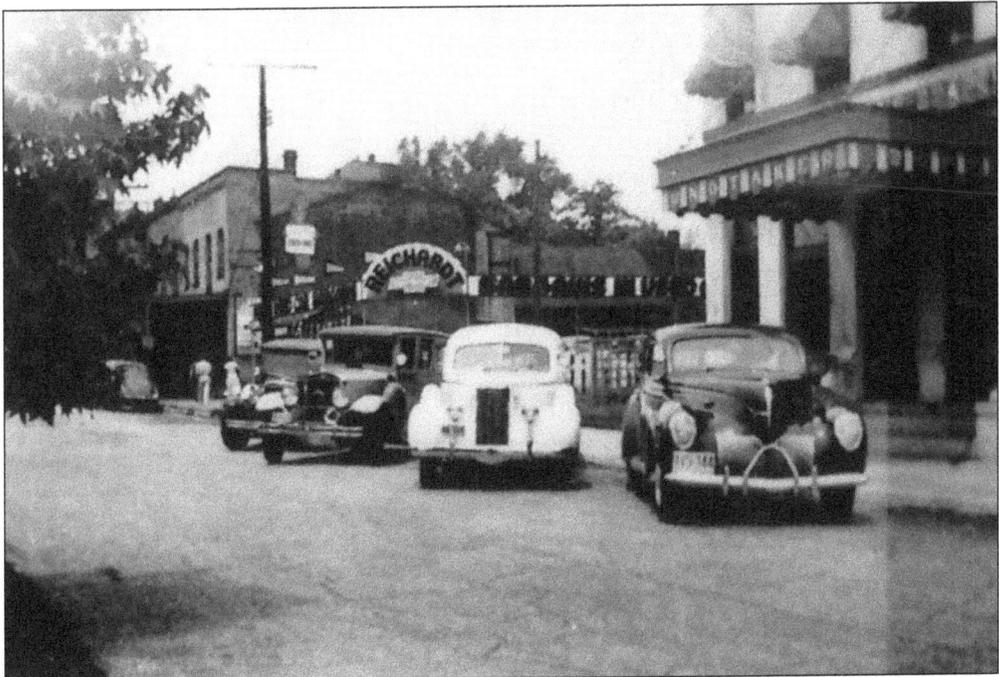

Bopp Chapel, pictured here on Argonne Drive around the 1930s, was established in 1902 and still operates in a different location today. It is the oldest continuously operating business in the city of Kirkwood.

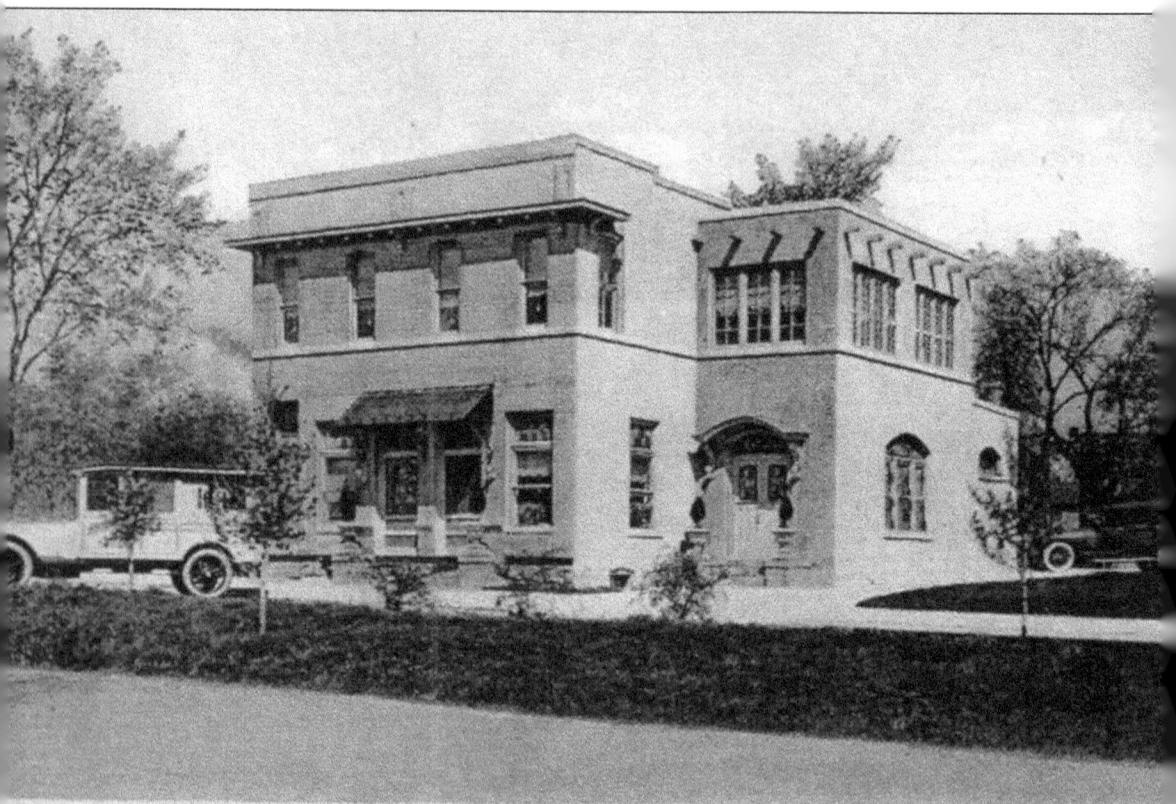

This is a postcard view of Louis H. Bopp Undertakers when it was located on Argonne Drive in the early decades of the 20th century.

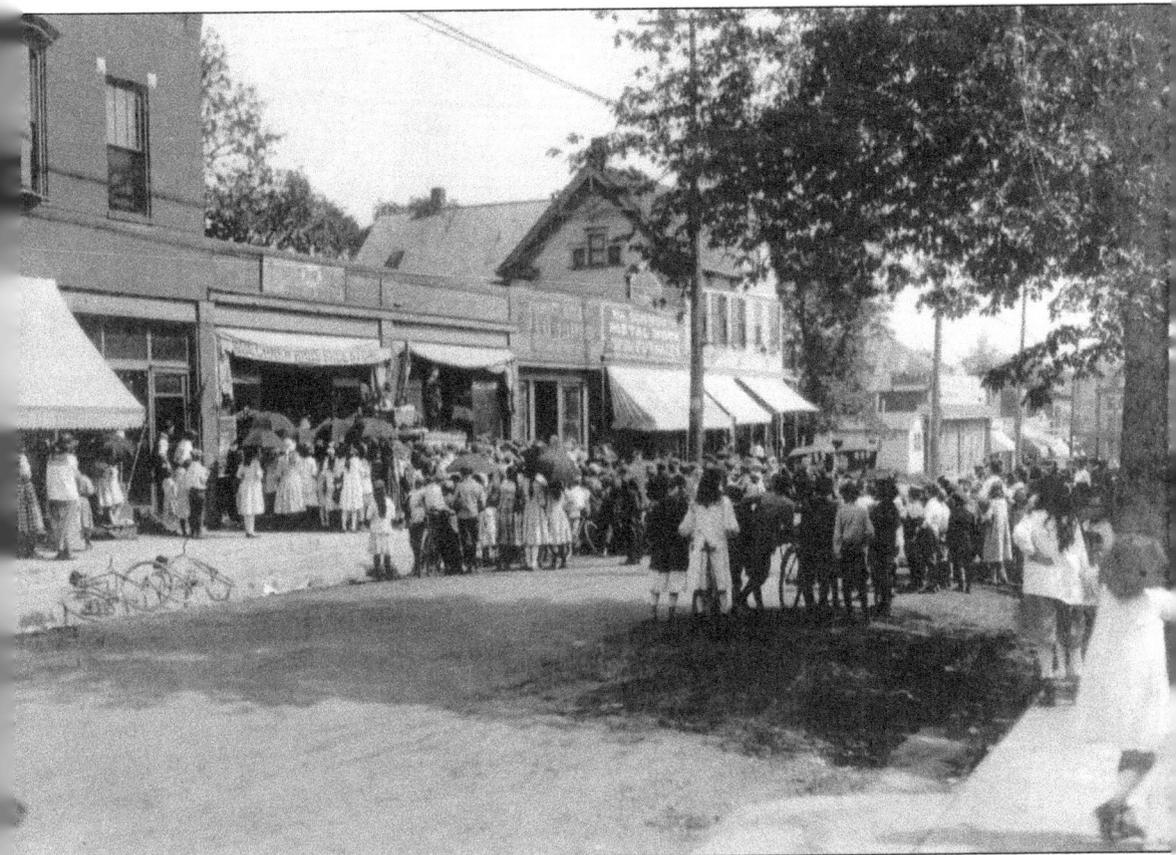

This photograph shows not only a slice of Kirkwood life in 1915, but also a bit of the pop culture of the time. Children gathered to catch a glimpse of Buster Brown and his dog, Tige, upon their visit to Buechner Bros. Shoe Store. Buster Brown was the name of a line of children's shoes produced in St. Louis.

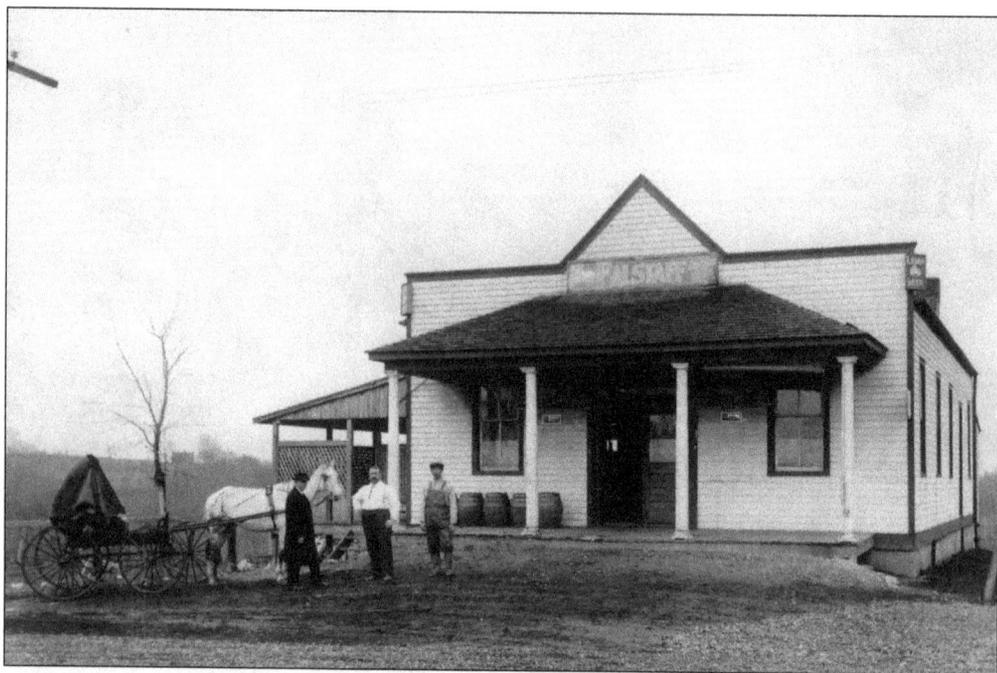

Neighborhood bars and restaurants have always been an important and popular part of life in Kirkwood. Pictured at an unknown date is the Repetto Saloon on Big Bend Boulevard.

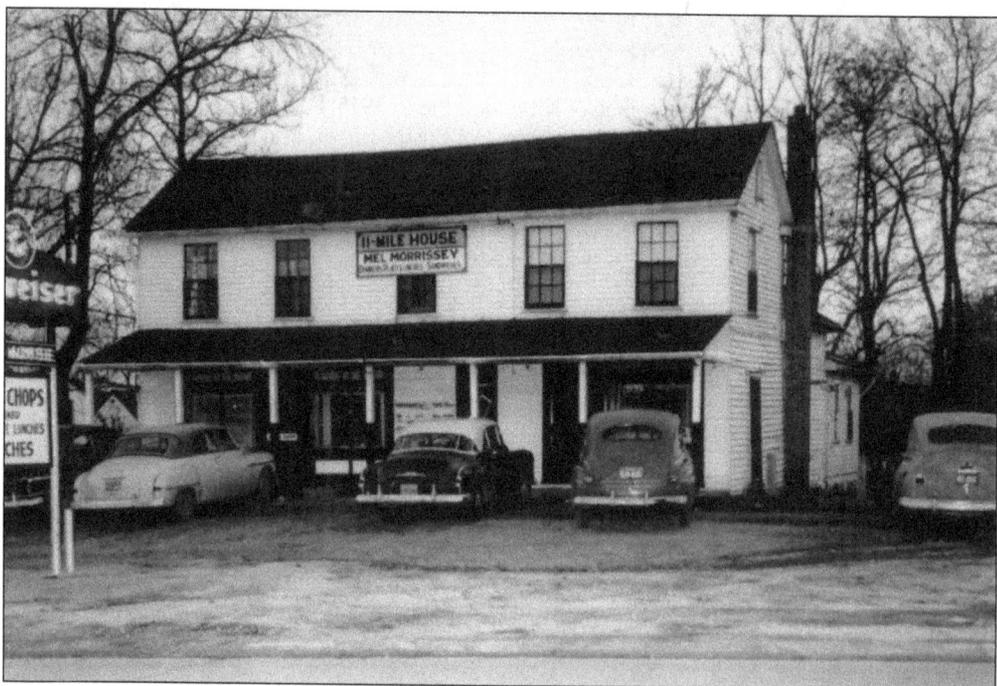

Originally one of the "mile" houses west from the city of St. Louis, Eleven Mile House, as pictured here in the 1940s, was a freestanding restaurant at Manchester Road and Woodlawn Avenue. The bar and restaurant is now in a shopping strip near that original location.

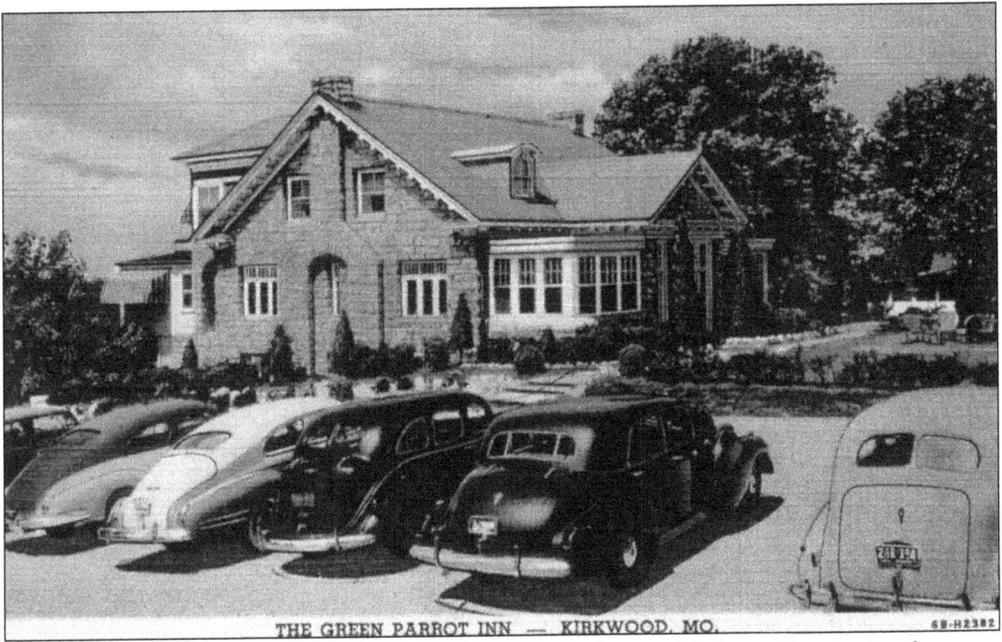

The Green Parrot Inn, pictured in this undated postcard, was a Kirkwood institution for many years, famous for its family-style fried chicken dinners.

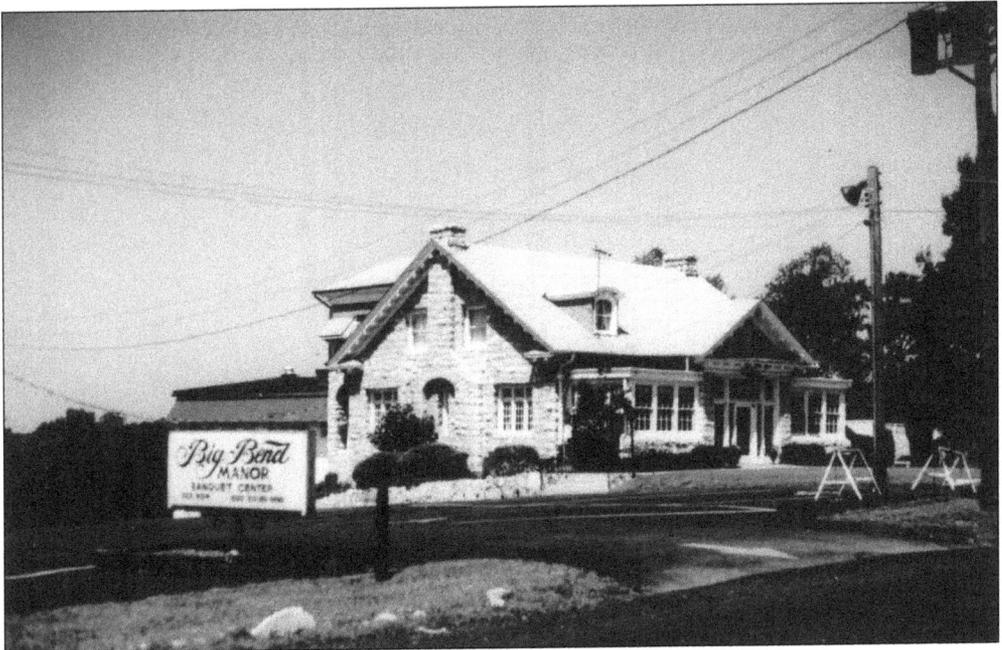

Show here as Big Bend Manor, a banquet center, this building earlier housed the Green Parrot Inn. Today, it is a private residence, and the property is a residential development.

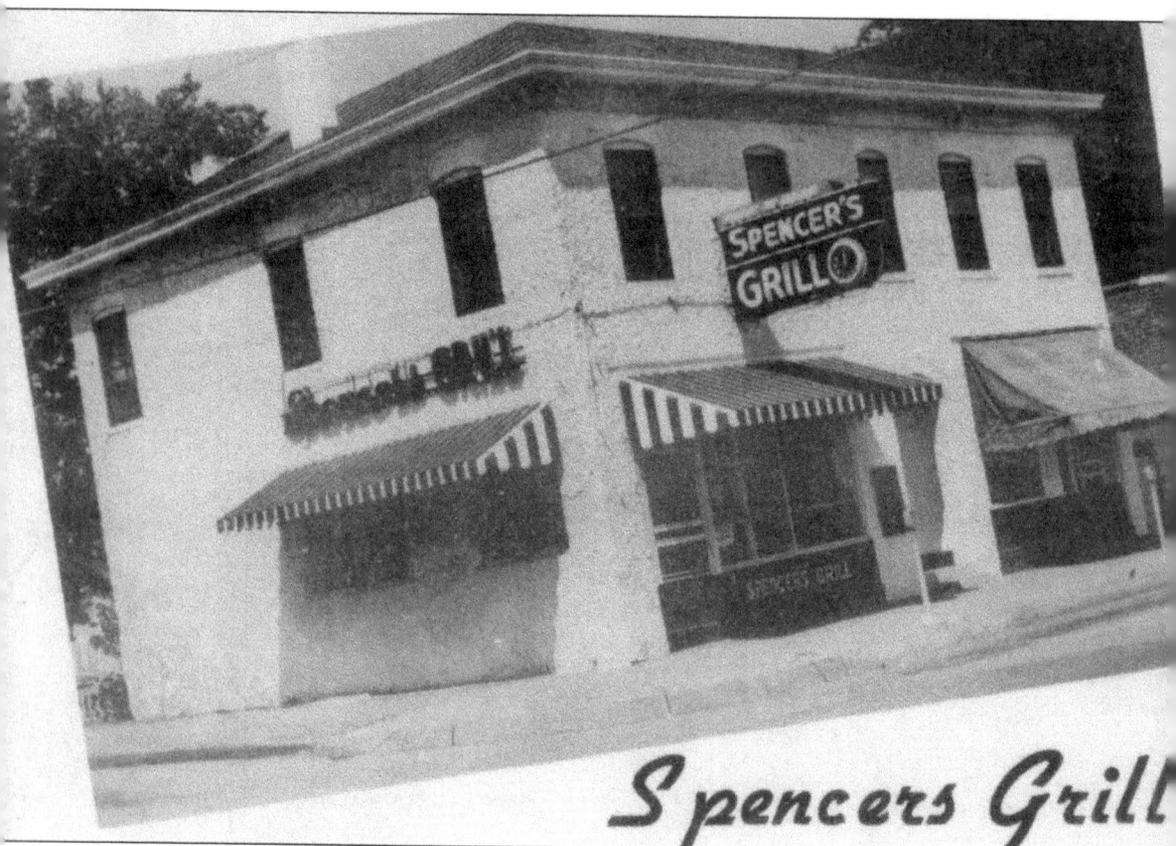

Proof of the popularity of local eateries is Spencer's Grill, located on Kirkwood Road. The clock-studded neon sign has been a Kirkwood landmark since 1946.

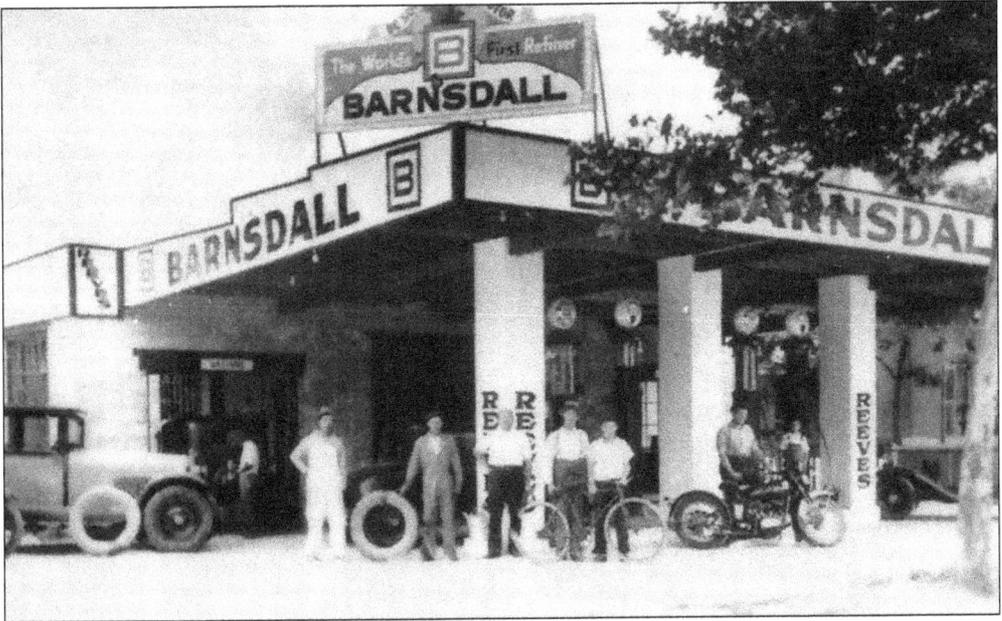

This undated photograph of the Reeves filling station captures the varied modes of transportation serviced—motorcycle, bicycle, and automobile. When cars began making an appearance on Kirkwood roads, there was also a need for service stations such as Reeves. However, there was a resistance to allowing such businesses within the city. In 1910, any tanks, receptacles, or warehouses that stored oil or oil products were banned. The demand for filling stations necessitated a rethinking, and the first approval was awarded to a station in May 1912. One of the concerns was fire, as the storage tanks were aboveground in those early days.

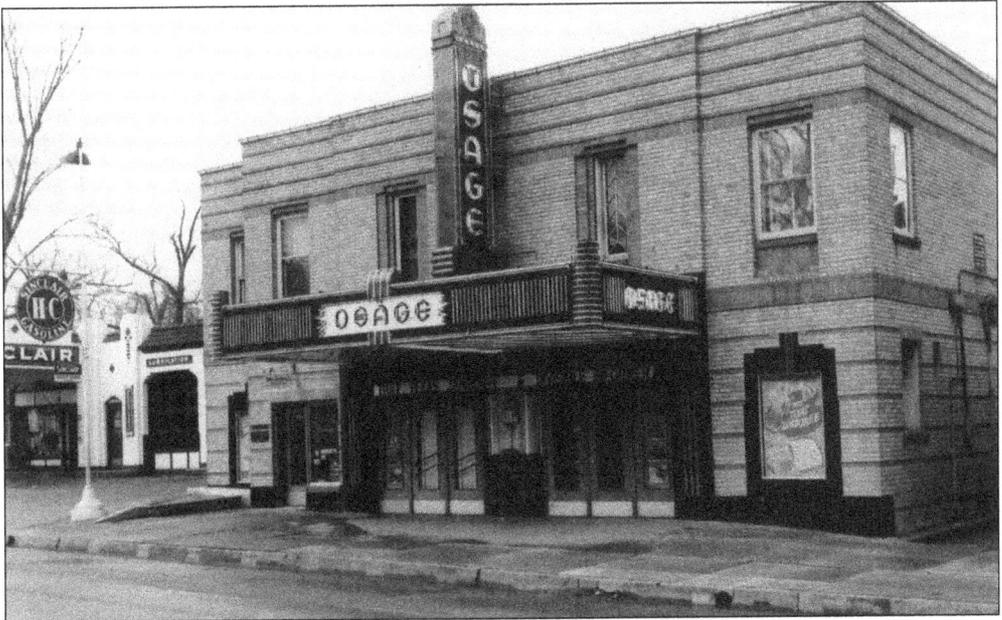

The Osage Theatre, shown here around 1947, opened on Kirkwood Road in January 1937. Adult moviegoers could see a film for 25¢ and bring their children for 10¢. The theater had a life as a movie house until 1999. Today, it has been repurposed into offices and condos.

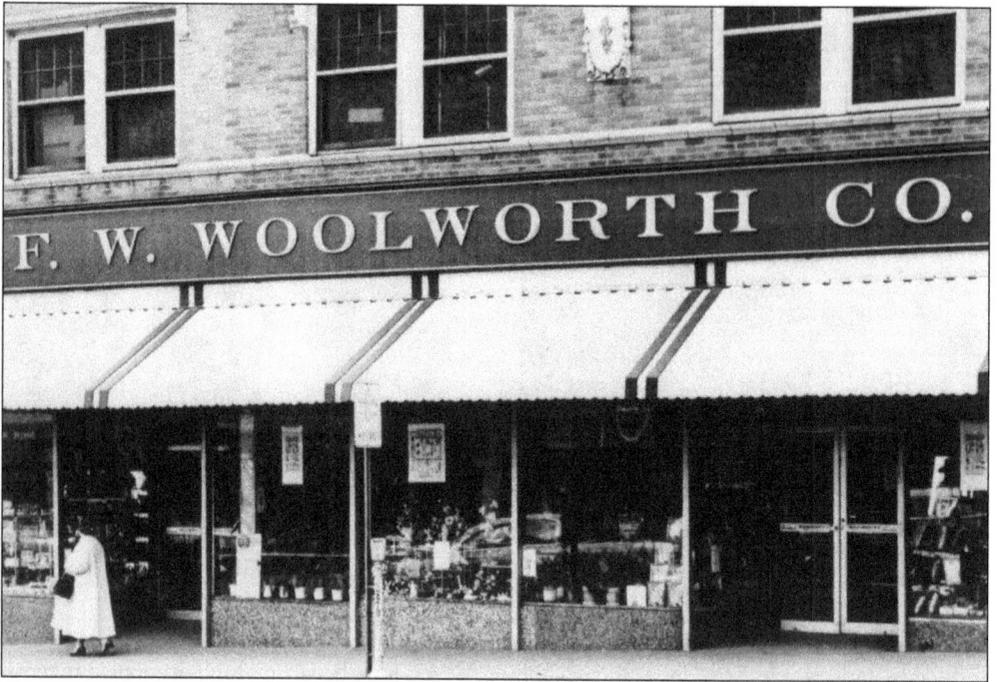

F.W. Woolworth Company, a five-and-dime store, was a staple of many 1950s childhoods. The Kirkwood store is shown here around 1965. With the rise of big-box discount shopping, the Woolworth's chain disappeared in the 1970s. Below is an undated photograph of Woolworth's and surrounding businesses in the heart of Kirkwood.

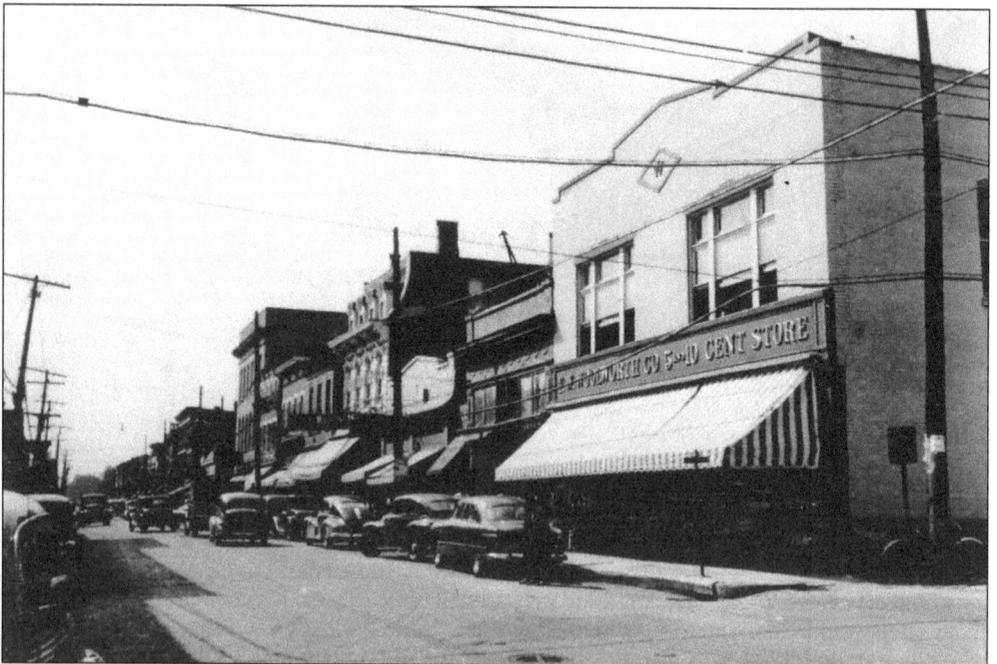

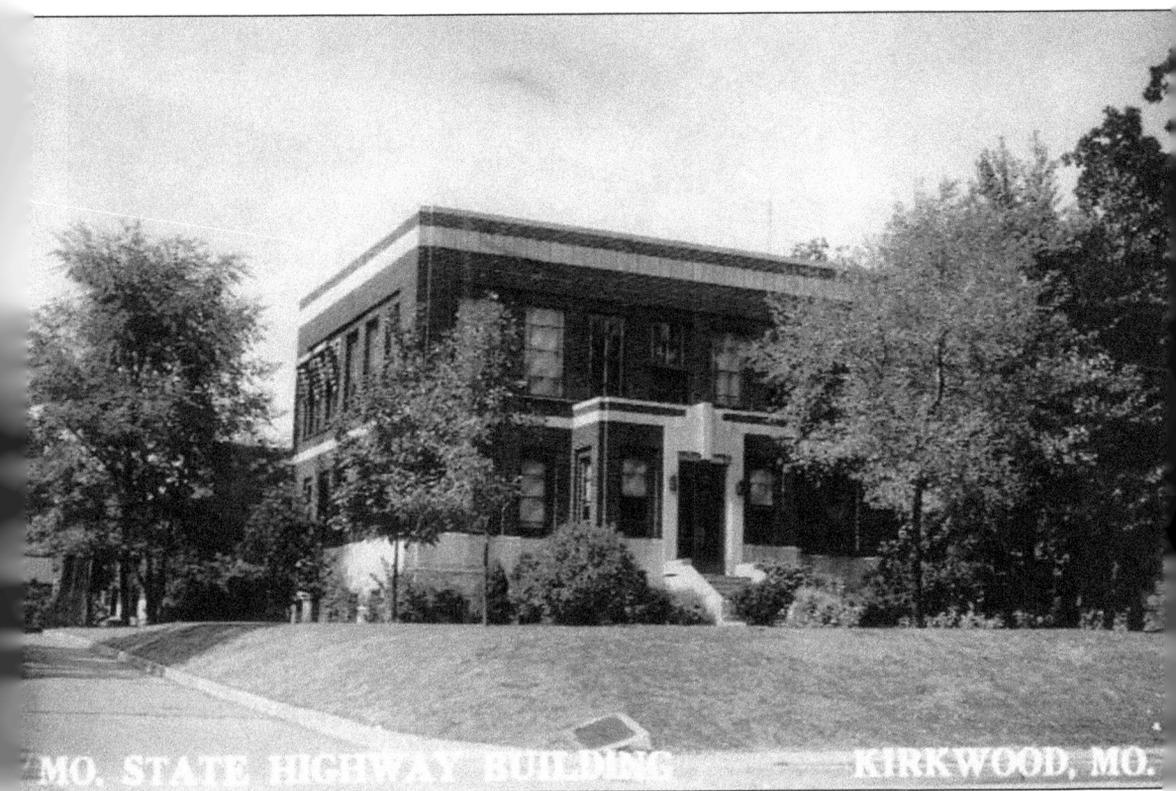

MO. STATE HIGHWAY BUILDING KIRKWOOD, MO.

The Missouri State Highway Department regional office was at one time located on South Kirkwood Road. The department outgrew its offices, and the space was redeveloped. It presently houses a bank, the US Post Office, and a number of eateries, offices, and businesses.

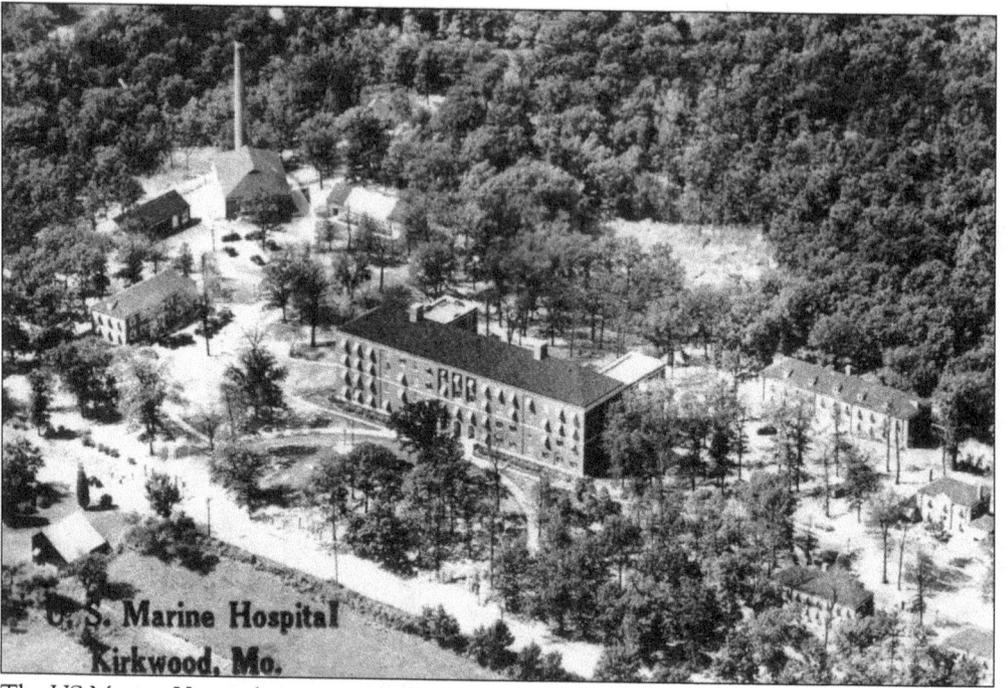

The US Marine Hospital, seen in this aerial view, came to Kirkwood in 1939. The hospital was operated by the US Public Health Service for the benefit of seamen, public health employees, and anyone with the federal river service.

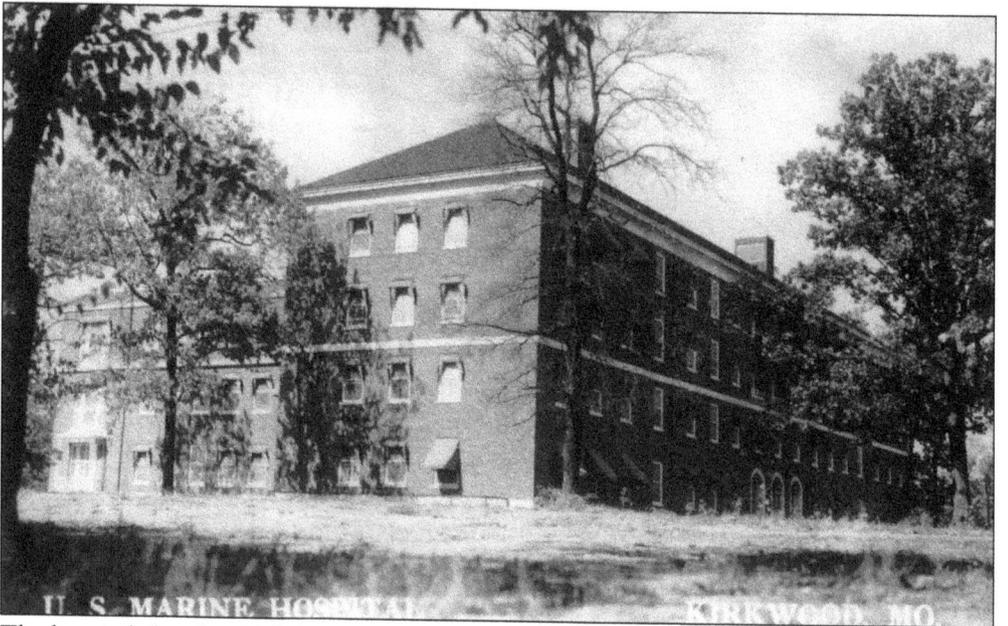

The hospital closed in 1953 but reopened as St. Joseph's Hospital in 1954 after remodeling and updating by the Sisters of St. Joseph of Carondelet. St. Joseph's closed in 2009, when the sisters built a new facility further west in St. Louis County. The site is now a retirement community.

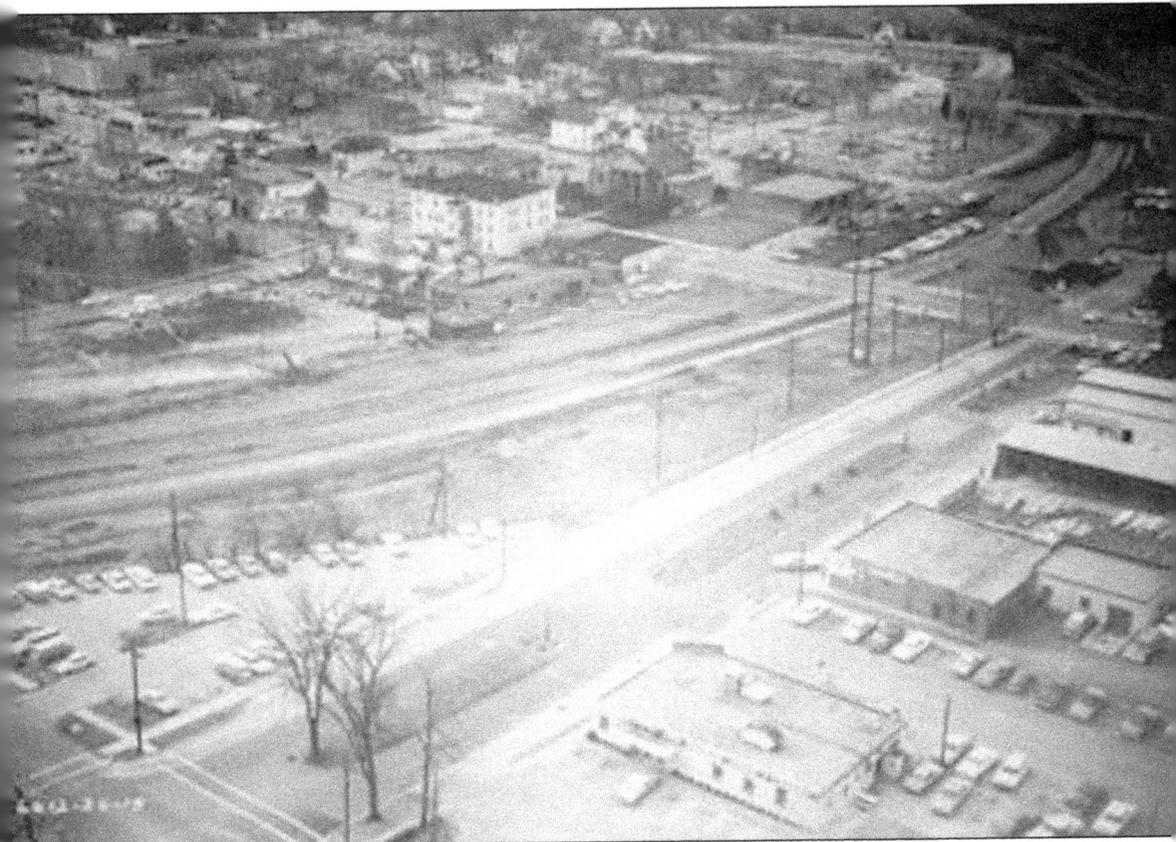

This aerial photograph of Kirkwood was taken in 1960 and focuses on the area near the train station and city hall (Kirkwood Road and Argonne Drive).

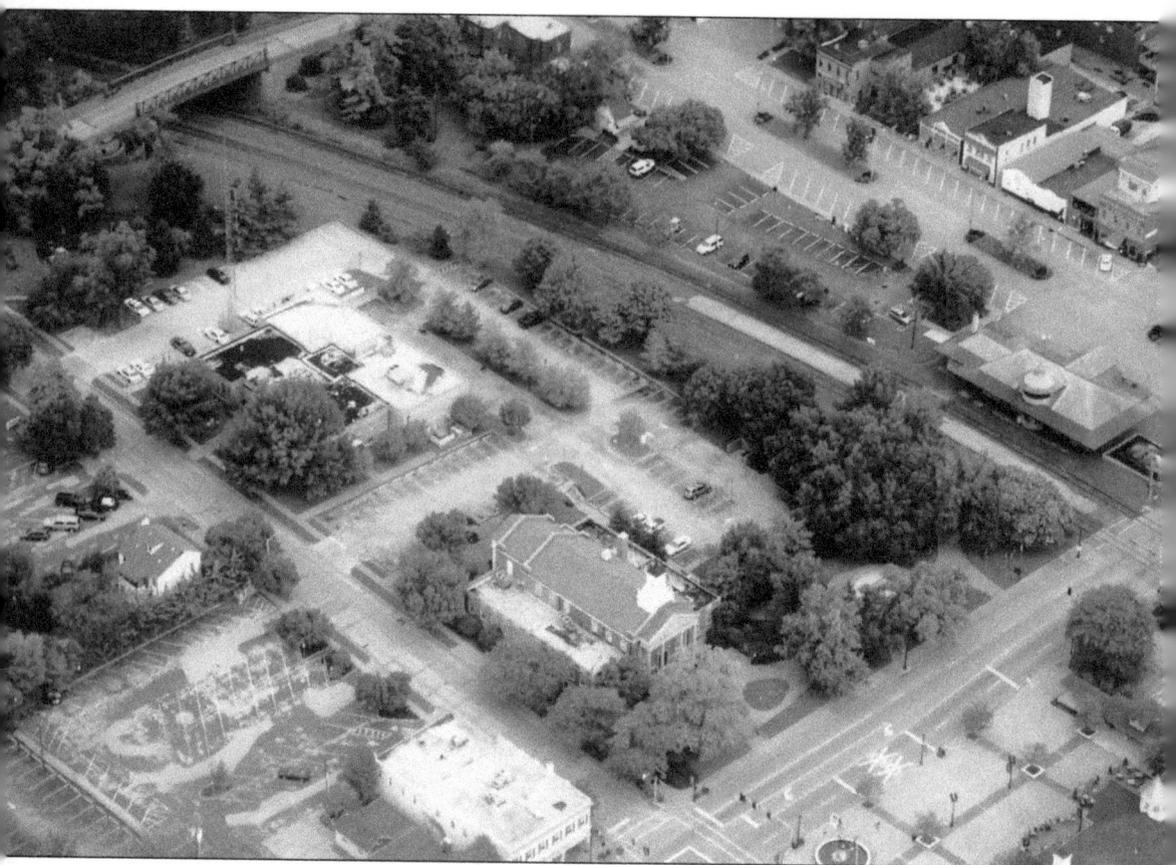

The southern edge of the Kirkwood business district is seen here in an aerial photograph taken on July 12, 2009. The city hall, police station, train station, and businesses on the north side of Argonne Drive are visible.

Six

KIRKWOOD CHURCHES

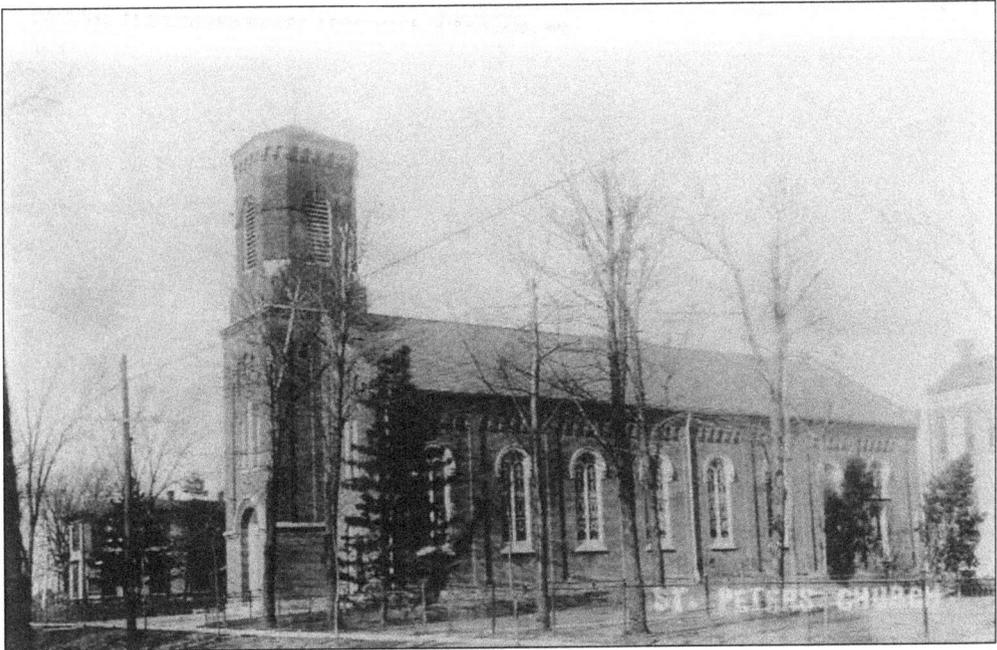

St. Peter Catholic Church is the oldest church in the area, predating even the city of Kirkwood. The cornerstone for the original church building, located near the current-day St. Peter Cemetery on Geyer Road (then Jackson Avenue), was laid in August 1833. That church burned in 1875. This undated photograph shows the second St. Peter Church, located on Argonne Drive (then Main Street) and erected in 1867–1868.

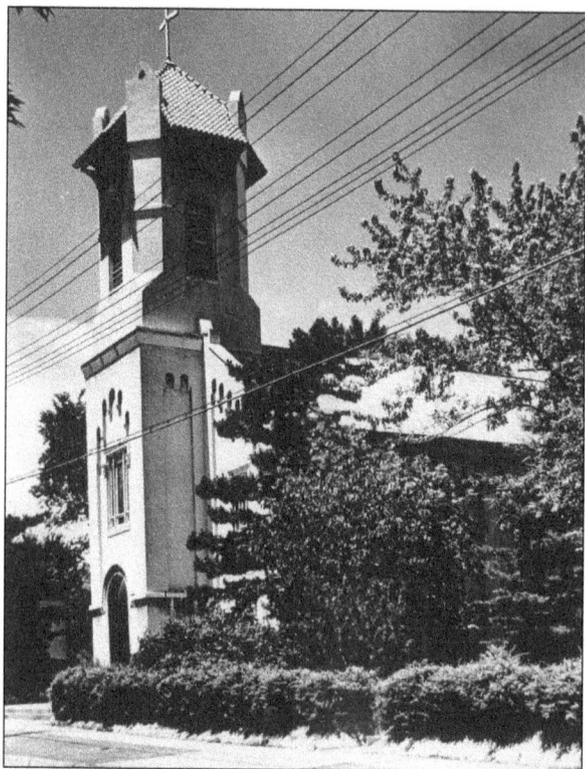

St. Peter Church was remodeled in the 1920s, and its exterior was stuccoed.

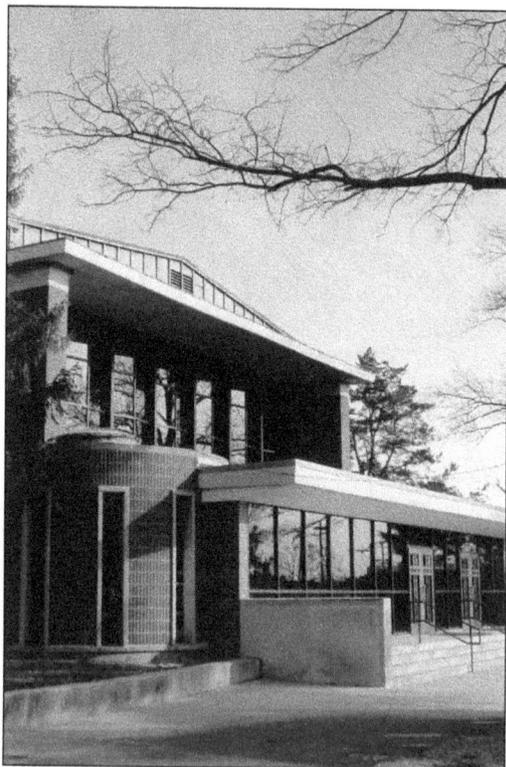

This, the third home of St. Peter Church, was dedicated in 1951, and the first mass was celebrated on August 30, 1952, by Fr. Alphonse Westhoff. The church was recently renovated and enlarged around 2010. (Author photograph.)

Pictured here is an early, undated view of Grace Church. The Episcopal church was founded in Kirkwood early on, with the Bodleys, Elliotts, Leffingwells, and Houghs all practicing the faith. First meetings were held in the Bodley home. The cornerstone of the first Grace Church was laid August 7, 1859, and the first services were held on May 27, 1860. The building now houses Eliot Chapel.

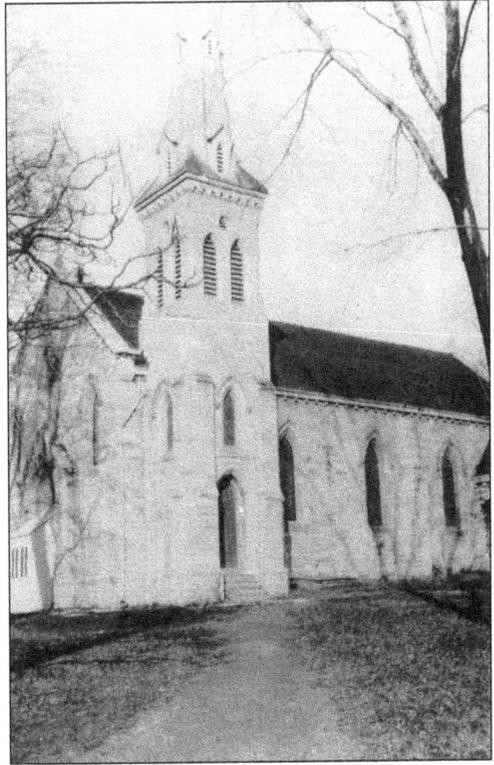

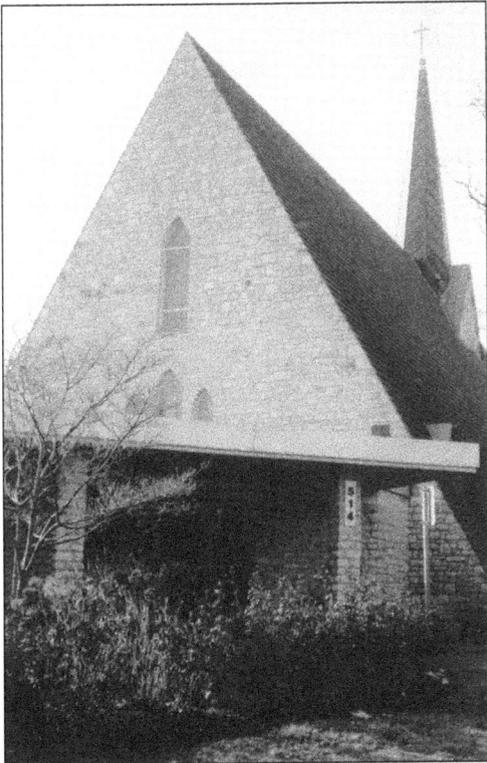

In 1961, Grace Episcopal Church constructed a new building at the corner of Argonne Drive and Woodlawn Avenue to accommodate a growing congregation. (Author photograph.)

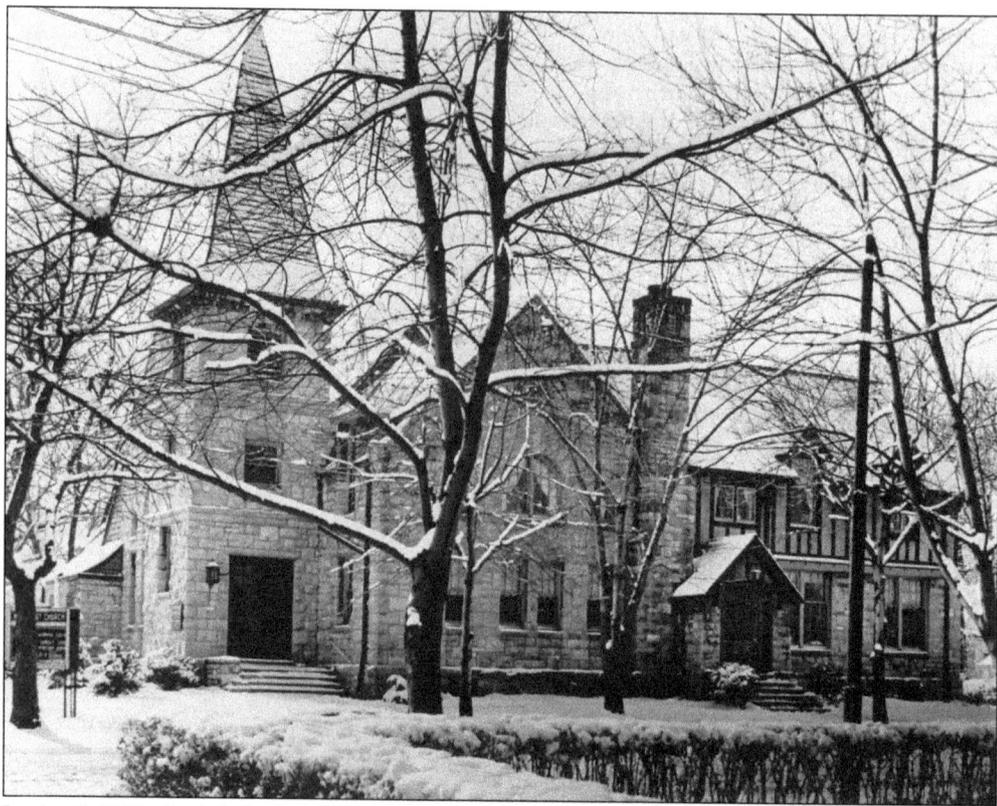

In April 1869, the Methodist Episcopal Church, South, came to Kirkwood. The congregation purchased a lot in 1870 at the corner of Clay and Washington Avenues, erecting a frame sanctuary there by 1873. However, in 1877, the church lost everything when the congregation could not meet its financial obligations. A smaller structure known as Boyle Chapel was built on a donated lot at the corner of Clay and Adams Avenues and used for worship until 1885, when the original church was repurchased and remodeled. That building suffered the fate of many early Kirkwood structures: complete destruction by fire on March 25, 1894. A new building, seen here around 1949, was completed in 1895. A new church, still in service, dates from 1964.

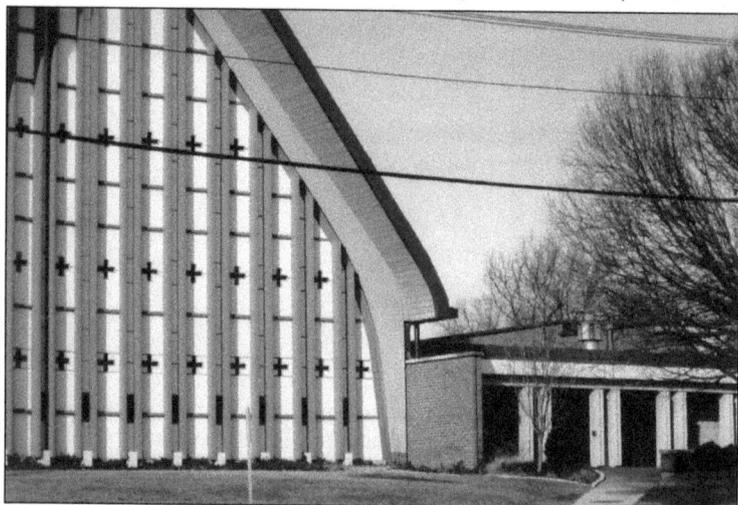

The current sanctuary of Kirkwood United Methodist Church was consecrated on February 2, 1964. (Author photograph.)

This is the second building housing the Baptist church in Kirkwood. Built in 1896, it was located on the southwest corner of Kirkwood Road and Washington Avenue. The church's activity in the city dated from 1870. The congregation has been known as the First Baptist Church of Kirkwood, Wetzel Memorial Baptist Church, and today, Kirkwood Baptist Church. The final name change came in 1947, when the congregation bought the Woodlawn Hotel and relocated to its new building at Adams and Woodlawn Avenues.

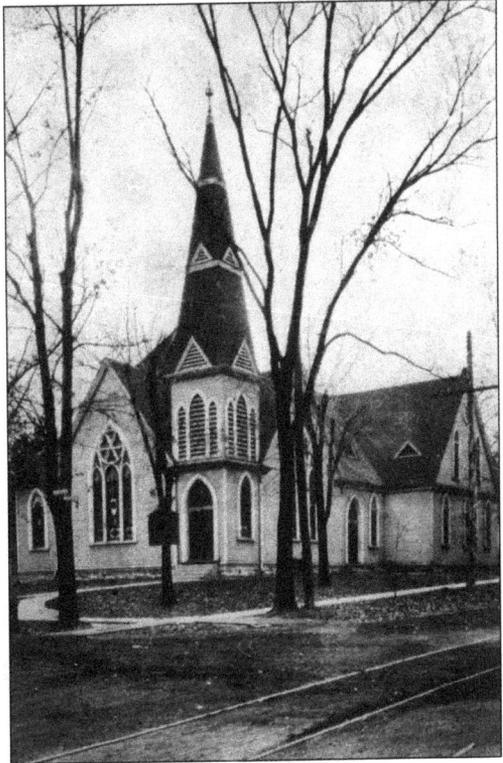

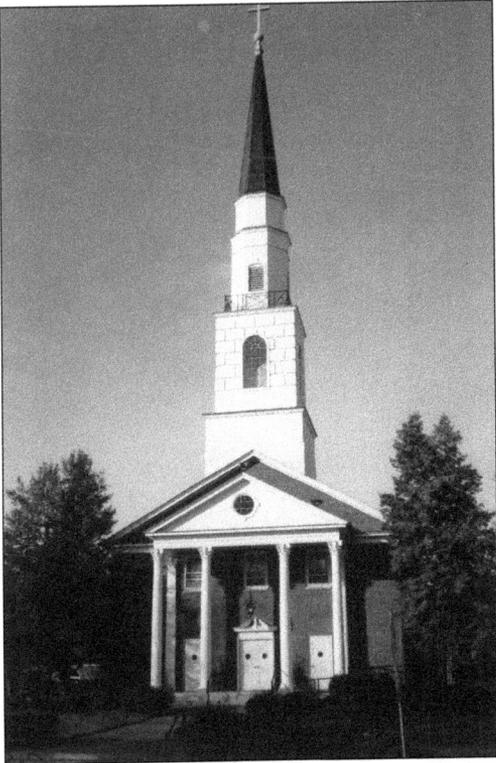

The Kirkwood Baptist Church, built in 1947, is pictured here as it appears today. (Author photograph.)

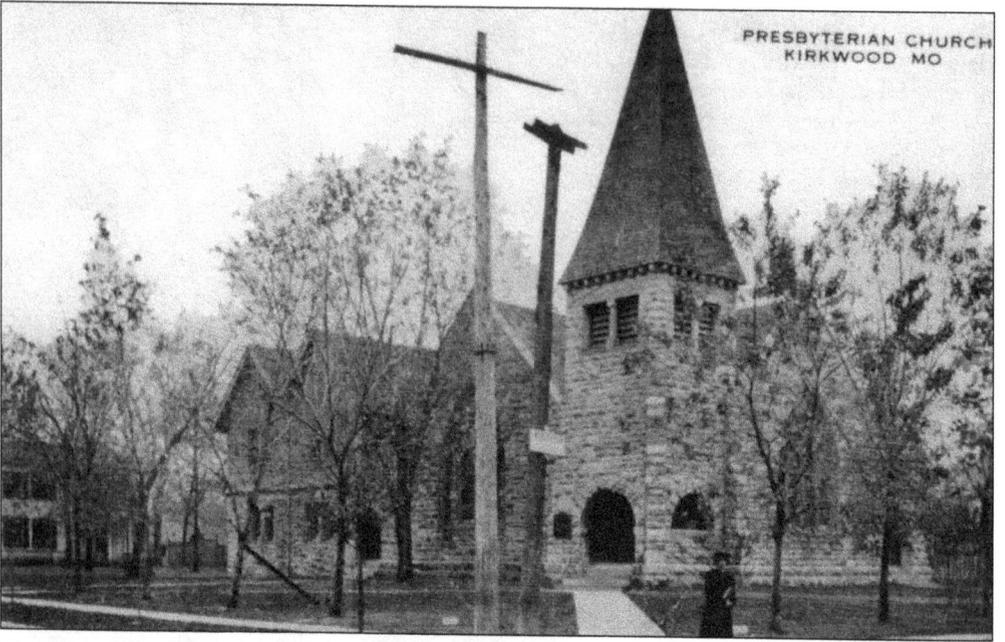

PRESBYTERIAN CHURCH
KIRKWOOD MO

The Presbyterian Church was established early in Kirkwood, in 1854. This, the second building, was constructed around 1888 at the corner of Kirkwood Road and Adams Avenue. According to *A Glimpse of Early Kirkwood, Volume II*, the house behind the church was the childhood home of Pulitzer Prize–winning poet Marianne Moore.

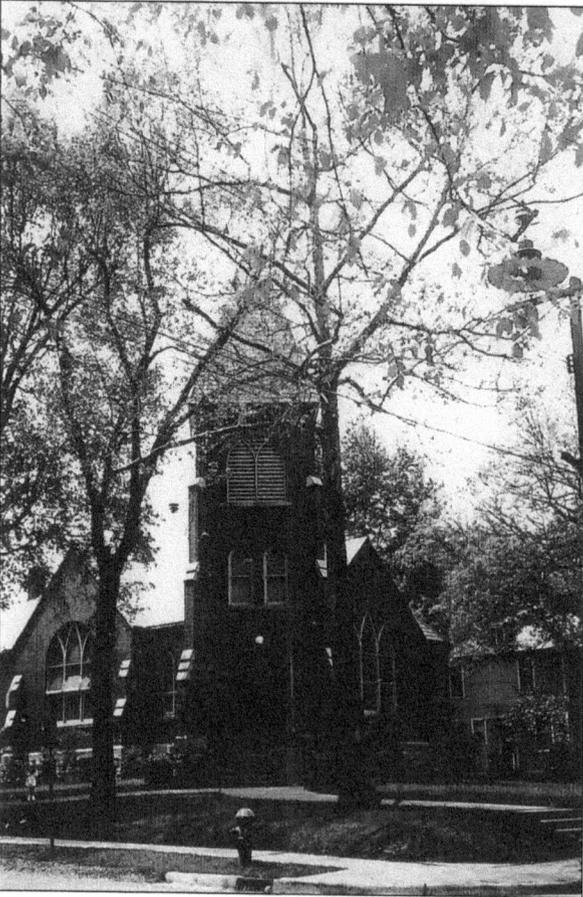

This is a view of the second house of worship for Concordia Lutheran Church, built at Clinton Place and South Taylor Avenue in 1907.

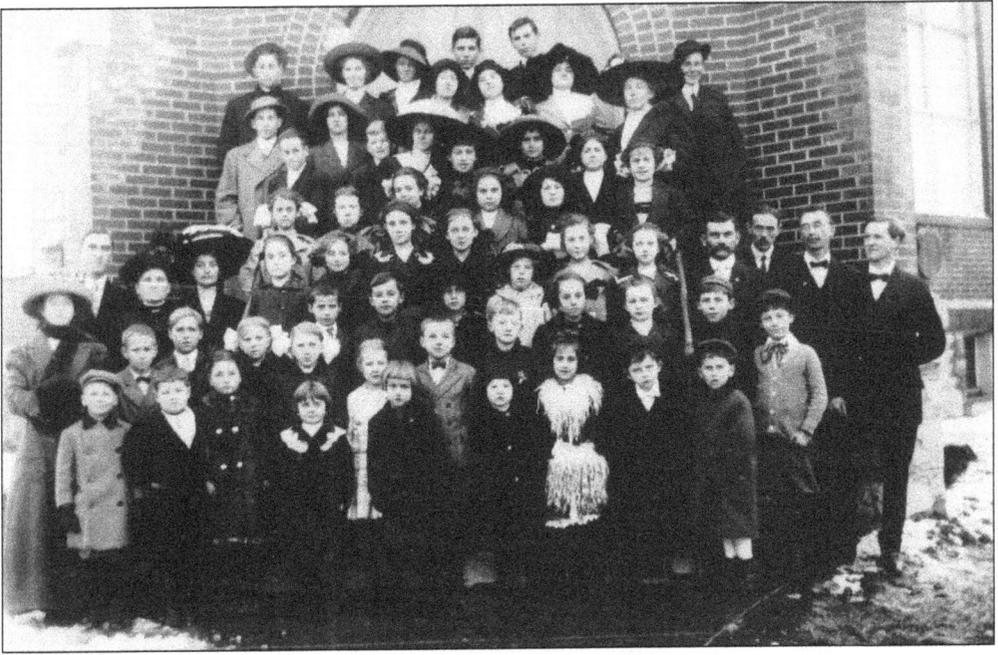

Concordia Lutheran Church was founded in April 1874, and the congregation originally worshipped in a frame building on West Madison Avenue erected by the Bopp family. In 1907, a larger brick structure replaced the original church at a new location of East Clinton Place and Taylor Avenue (where Kirkwood House is presently located). This is a photograph of the congregation on the steps of that church.

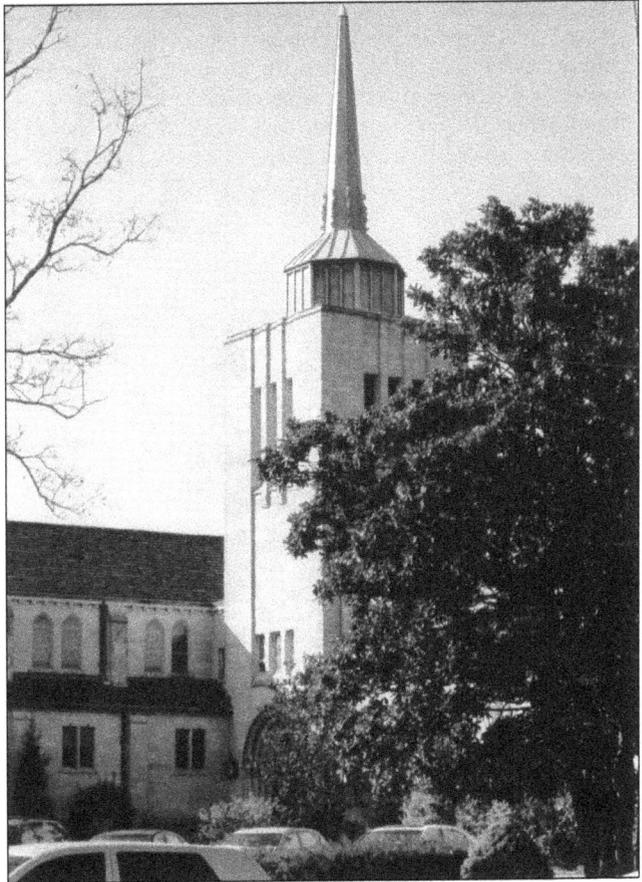

Concordia Lutheran Church moved to a new location at Kirkwood Road and Woodbine Avenue in 1948 due to growth in the congregation. Christ Community Lutheran School is located adjacent to the church. (Author photograph.)

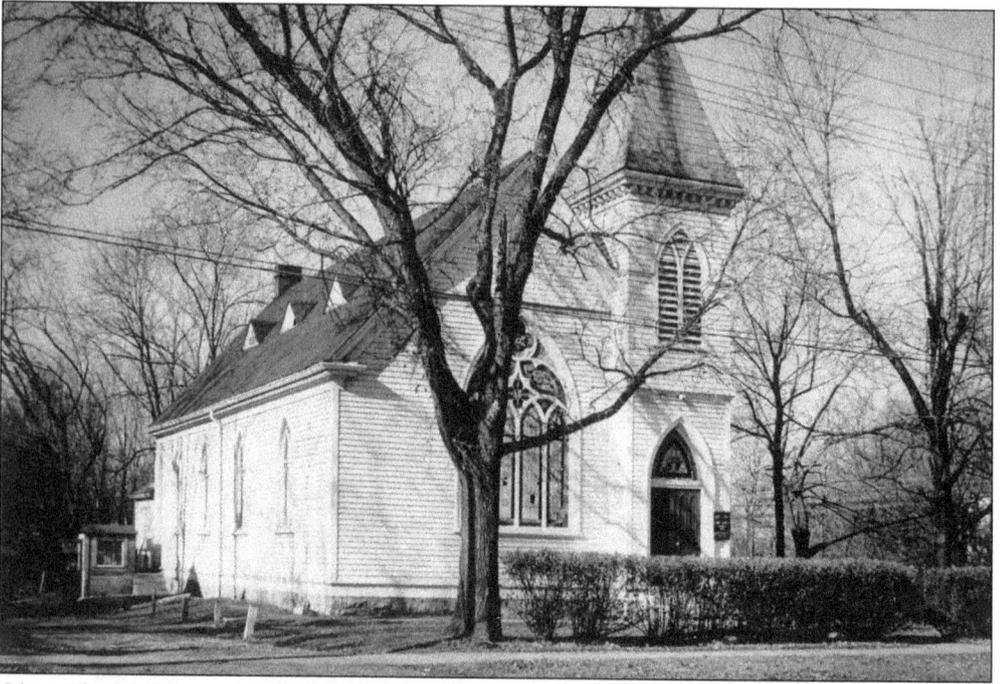

Olive Chapel African Methodist Episcopal Church sits at the corner of Monroe and Harrison Avenues today since 1923, when the congregation purchased the white frame chapel (pictured around 1950) from Evangelische Freunden Gemeinde, an offshoot of Concordia Lutheran Church. The congregation met in earlier days at 330 West Washington Avenue and dates back to 1853, when it was served by a circuit rider.

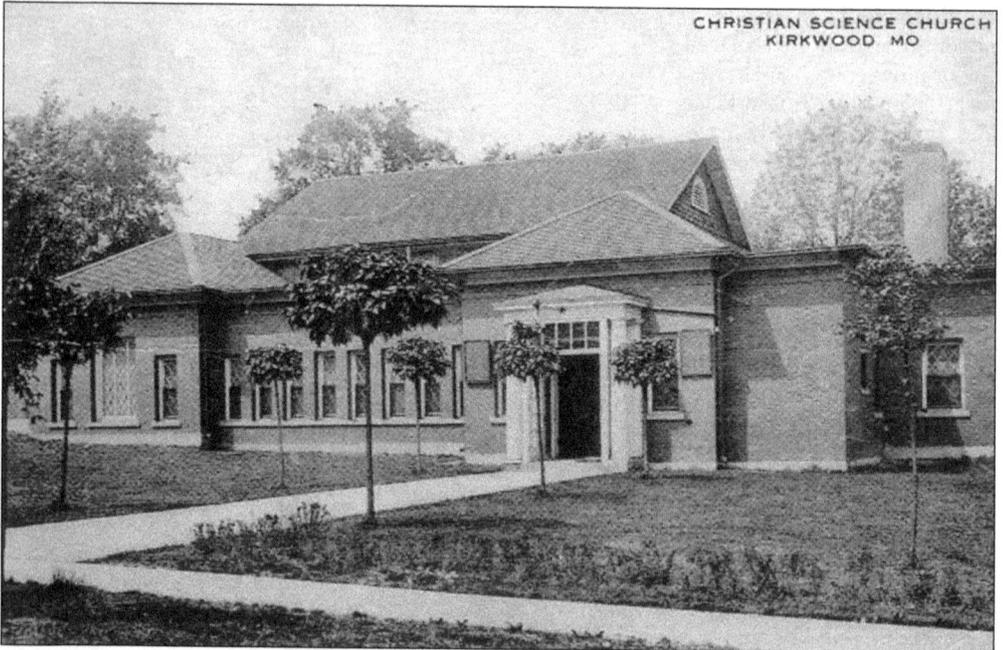

CHRISTIAN SCIENCE CHURCH
KIRKWOOD MO

Before building their own facility, Christian Scientists in Kirkwood worshipped at Choral Hall beginning in 1906. Their building, pictured here in an undated postcard, was opened in 1909.

Seven

KIRKWOOD EDUCATION

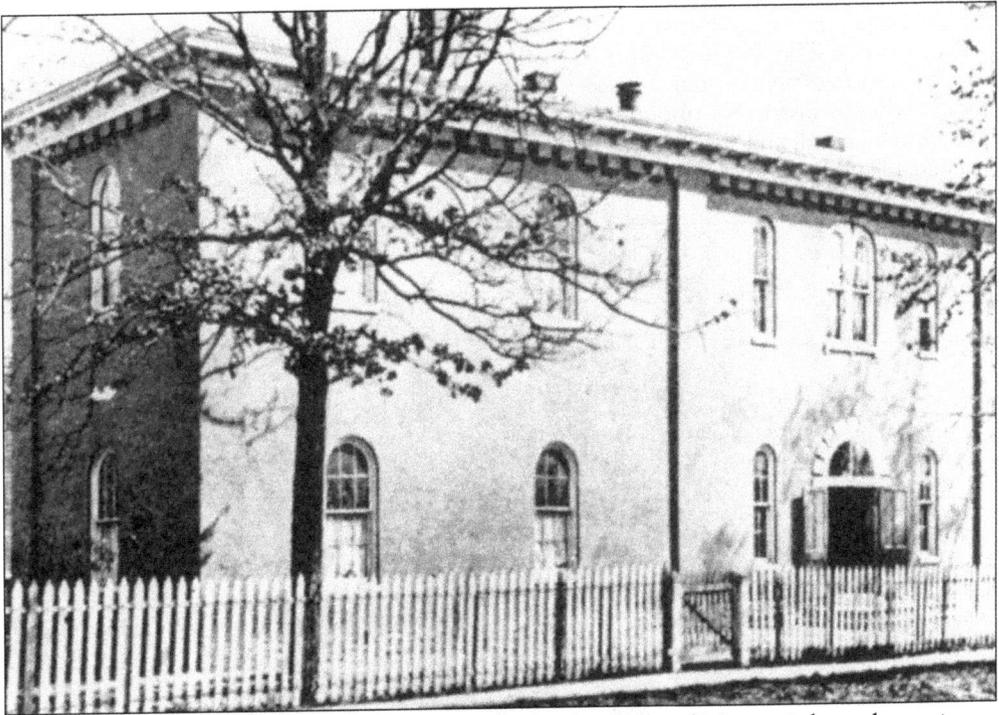

Kirkwood School District was granted a charter by the State of Missouri three days prior to the city on February 17, 1865. The first directors were Albert G. Edwards, John W. Sutherland, Leonard B. Holland, William T. Essex, Augustus S. Mermod, and Henry T. Mudd. The tax rate was one per cent of assessed valuation, and the boundaries of the school district extended beyond those of the town (as they do today). The first building was temporary, but a permanent building was erected and eventually named Jefferson School (pictured around 1912). It was located at the northwest corner of Clay and Jefferson Avenues. Grades one through eight attended the school. It was demolished in 1922.

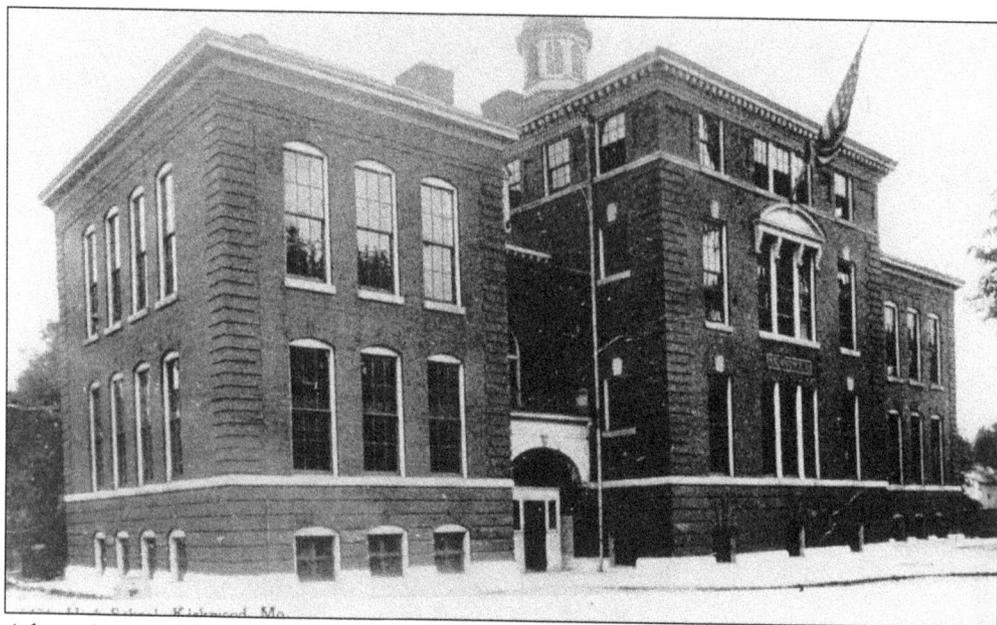

Adams Avenue School, pictured around 1905, housed the second high school in the Kirkwood School District. The first was destroyed by fire in 1900. Kirkwood was the first district in St. Louis County to establish a four-year secondary public school curriculum. Students were admitted from outside the district for tuition if space was available. A new high school was built in 1922 on Kirkwood Road, and the Adams Avenue building was then used for elementary classrooms. The school building was eventually sold to the Archdiocese of St. Louis, and Coyle High School was built in its place.

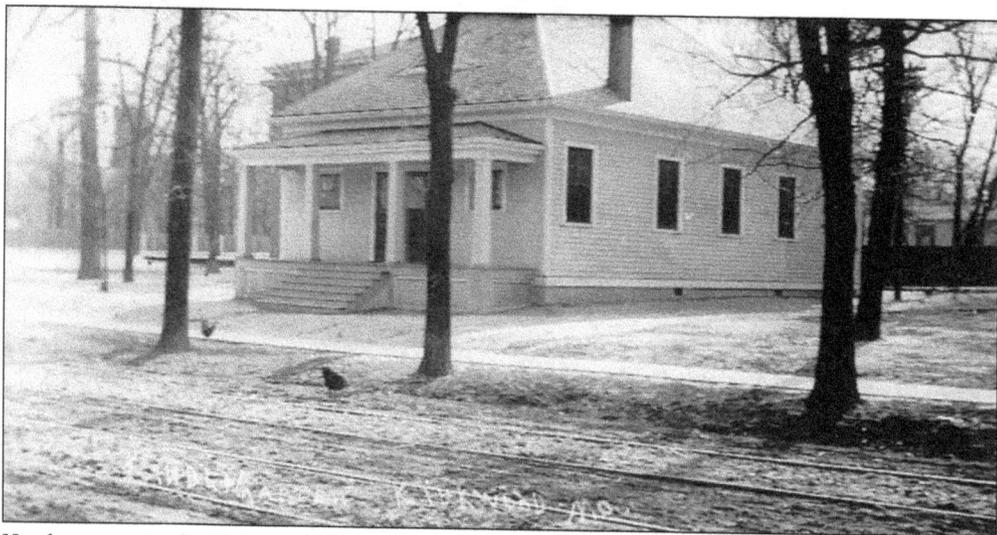

Kindergarten in the Kirkwood School District opened in September 1908 in the building pictured here, which was located on Clay Avenue between Adams and Jefferson Avenues. Early education was a progressive idea, and Kirkwood was ahead of the times when it established the program. The kindergarten was known as the Katherine Tracy Kindergarten, named after a St. Louis public school teacher who lived in Kirkwood and was a proponent of early childhood education. Friends of Katherine Tracy raised the initial $1,000 to construct the kindergarten building. It continued in service until 1939, when the children attending classes there transferred to Pitman School.

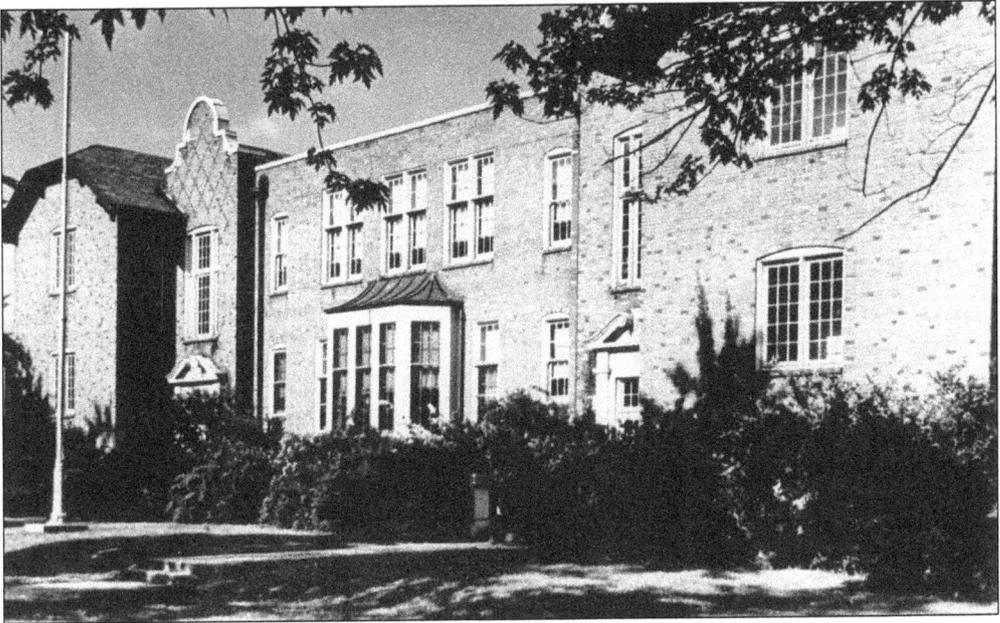

Pitman School opened on November 9, 1914, at the corner of Kirkwood Road and Adams Avenue. The school was named after Dr. John Pitman, a prominent medical doctor who settled in Kirkwood in the late 1860s. He served on the school board from 1879 to 1911. In 1971, Pitman School featured "open classrooms," and students throughout the district could enroll in classes with team teaching and no grade levels. Pitman closed in the mid-1970s due to declining enrollment in the district.

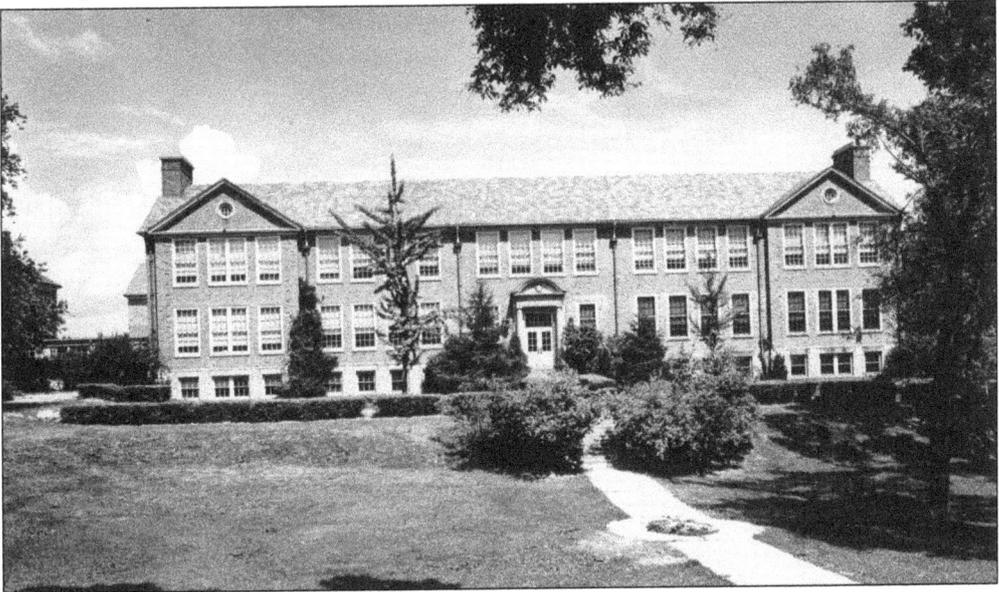

Kirkwood citizens voted to build a new high school in 1920, and it opened in September 1922 on Kirkwood Road. In September 1930, a second building (pictured here at an unknown date) opened next to the high school to house a junior high school. Today, the entire campus is known as Nipher Middle School. The name honors Francis E. Nipher, a professor of astronomy and physics at Washington University. Professor Nipher lived in Kirkwood, and after he retired, he conducted much of his scientific research from his home.

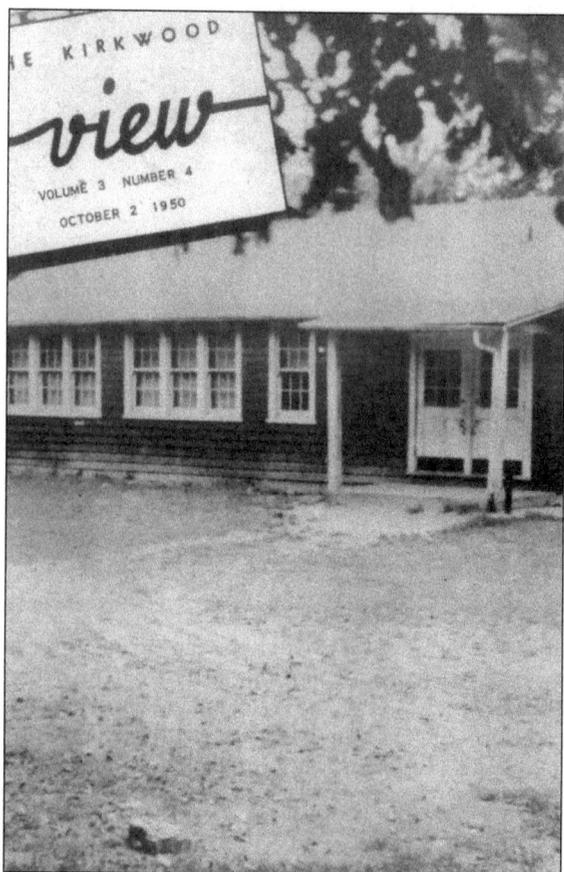

The Booker T. Washington School (on Adams Avenue near Geyer Road) is a symbol for the struggle for educational equality in Kirkwood. African American students were housed in a temporary building that was overcrowded (pictured left at an unknown date). Below is the unpaved play area that was frequently muddy and weed-strewn. The students living south of the Frisco tracks had to walk over a mile to school before the district approved a school in Meacham Park.

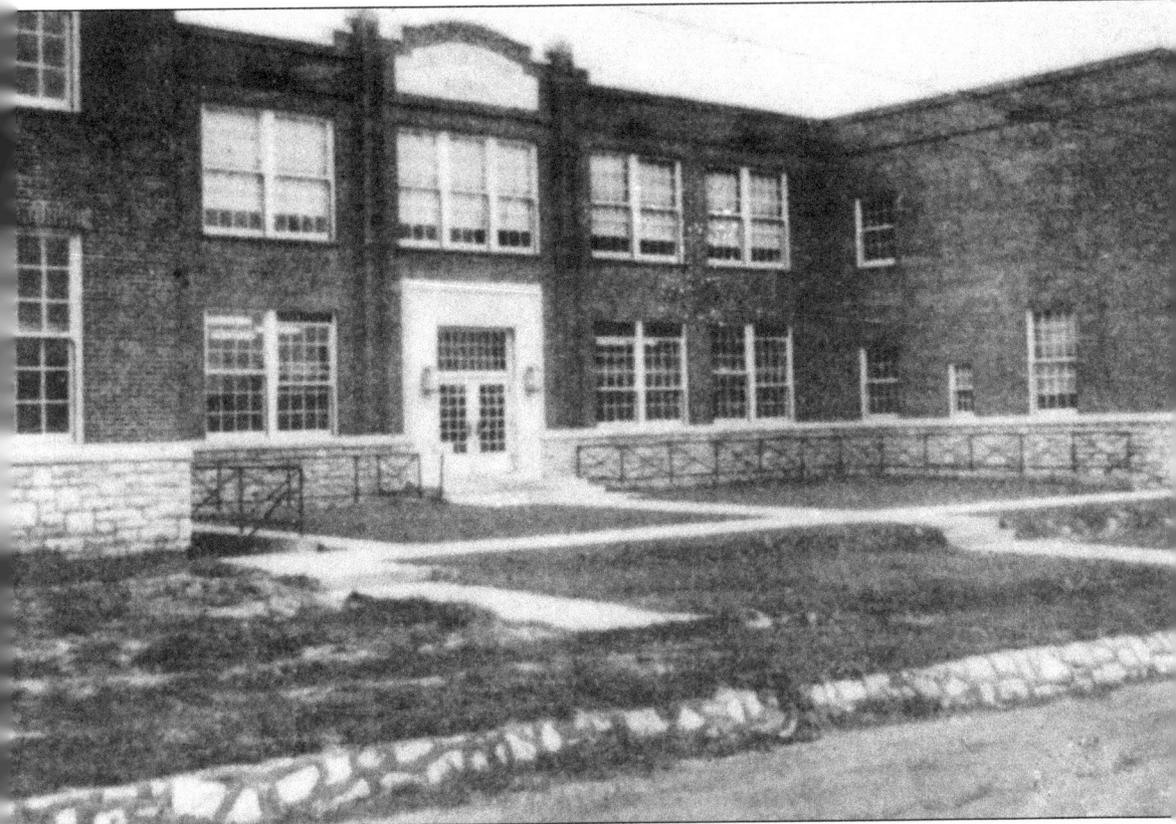

The issue of education for African Americans in Kirkwood has had a long and tortuous history. Initially, schools were segregated, with African American children in grades one through eight attending classes at Booker T. Washington School on the block denoted by Adams Avenue, Geyer Road, Jefferson Avenue, and Van Buren Avenue. No provision was made past eighth grade within the district until the school board agreed to pay tuition for African American students to attend high school in St. Louis. That lasted until 1955. In 1911, the district finally opened a school for black students in Meacham Park. The J. Milton Turner School (originally called Meacham Park School and renamed in 1932 in recognition of the man who was the American minister to Liberia at the time), pictured at an unknown date, was built in 1929. This school was closed in the 1970s. Kirkwood School District was one of the first county districts to sign up for the metropolitan voluntary desegregation program in 1982. This program bused St. Louis city students to county school districts and county students to city magnet schools in an effort to achieve integration that is more equal.

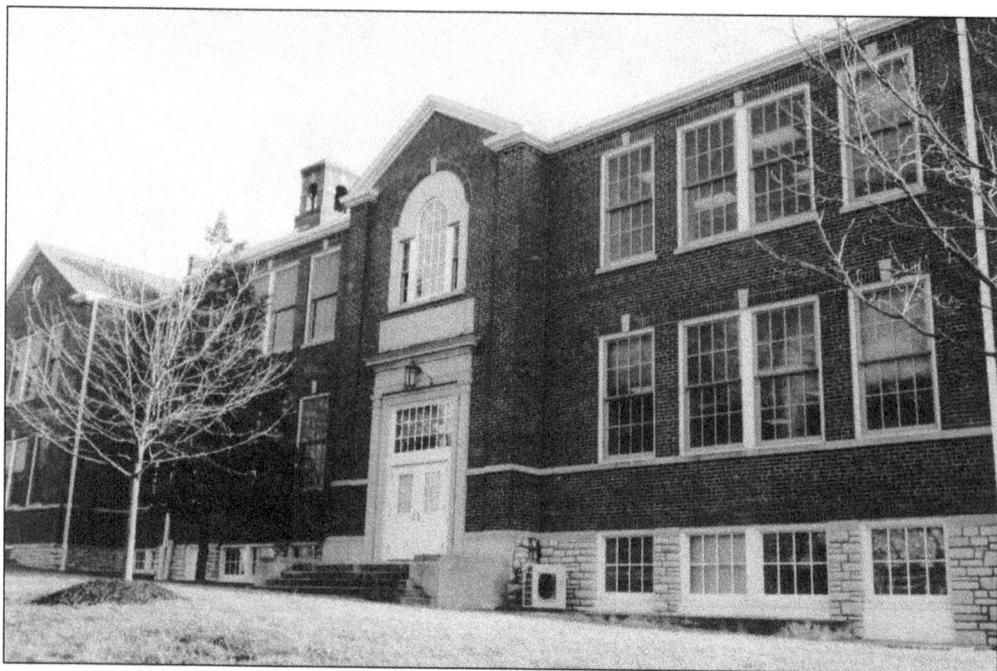

Henry Hough Elementary School was named after Henry W. Hough, who served on the Kirkwood School Board from 1879 to 1911. The school was originally housed in a building at the corner of Sappington Road and Lockwood Avenue (now demolished and the site of a condo development). A second building was constructed across the street and further down Sappington Road when Hough became too crowded. The school ceased operation as an elementary school in the 1980s and is now home to the Community Learning Center. This building is also in Glendale but part of the Kirkwood School District. (Author photograph.)

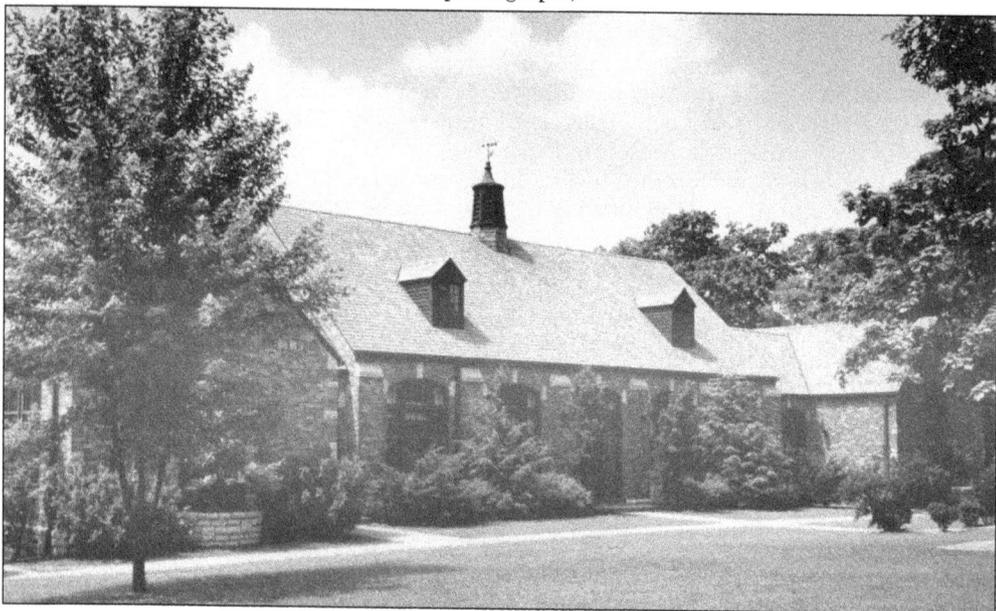

Kirkwood School District opened Osage Hills School in 1931. The school closed due to declining enrollment in the 1970s.

Pictured above is a group of unidentified Meramec School students around 1914. The Meramec Highlands School originally was its own district (Meramec Highlands District No. 5) until the Kirkwood School District annexed it. The school met at the general store, then moved to a building at present-day Barberry and Glenwood Lanes. Below is another group of unidentified Meramec School students around 1916.

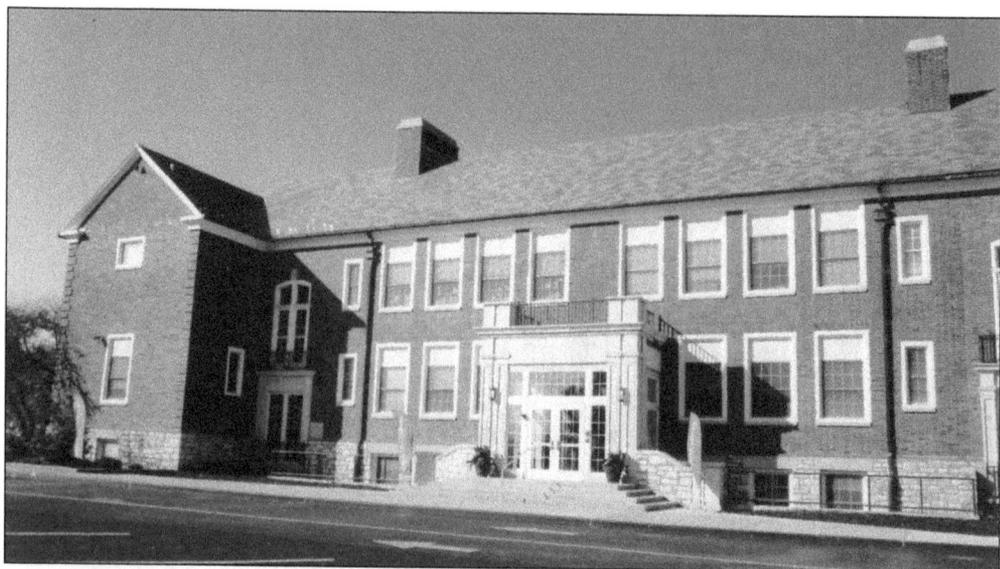

George R. Robinson Elementary School at Couch and Rose Hill Avenues was added to the district in 1929. George Robinson was a prominent St. Louis businessman who, with William H. Danforth, founded the company that ultimately became Ralston Purina. In addition, he was active in community affairs in Kirkwood, including those influencing young people. He lived at Woodlawn Avenue and Argonne Drive. When Robinson died suddenly in 1929, the Kirkwood School District honored him by naming a school after him. This photograph shows Robinson School after a 2012 renovation. (Author photograph.)

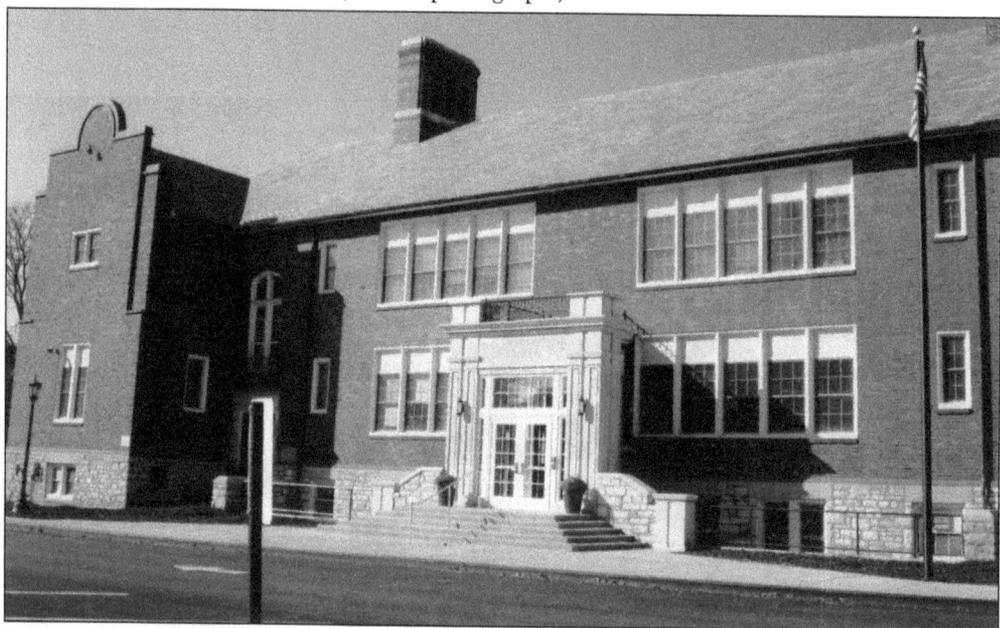

W.W. Keysor Elementary School, constructed in 1929–1930, is located on Geyer Road. The school was named after Judge William Winchester Keysor, who taught at the Washington University School of Law after retiring from the bench in Omaha, Nebraska. He moved to Kirkwood in 1902 into a home at Fillmore and Jefferson Avenues. His wife was also very prominent in educational and literary affairs in Kirkwood. (Author photograph.)

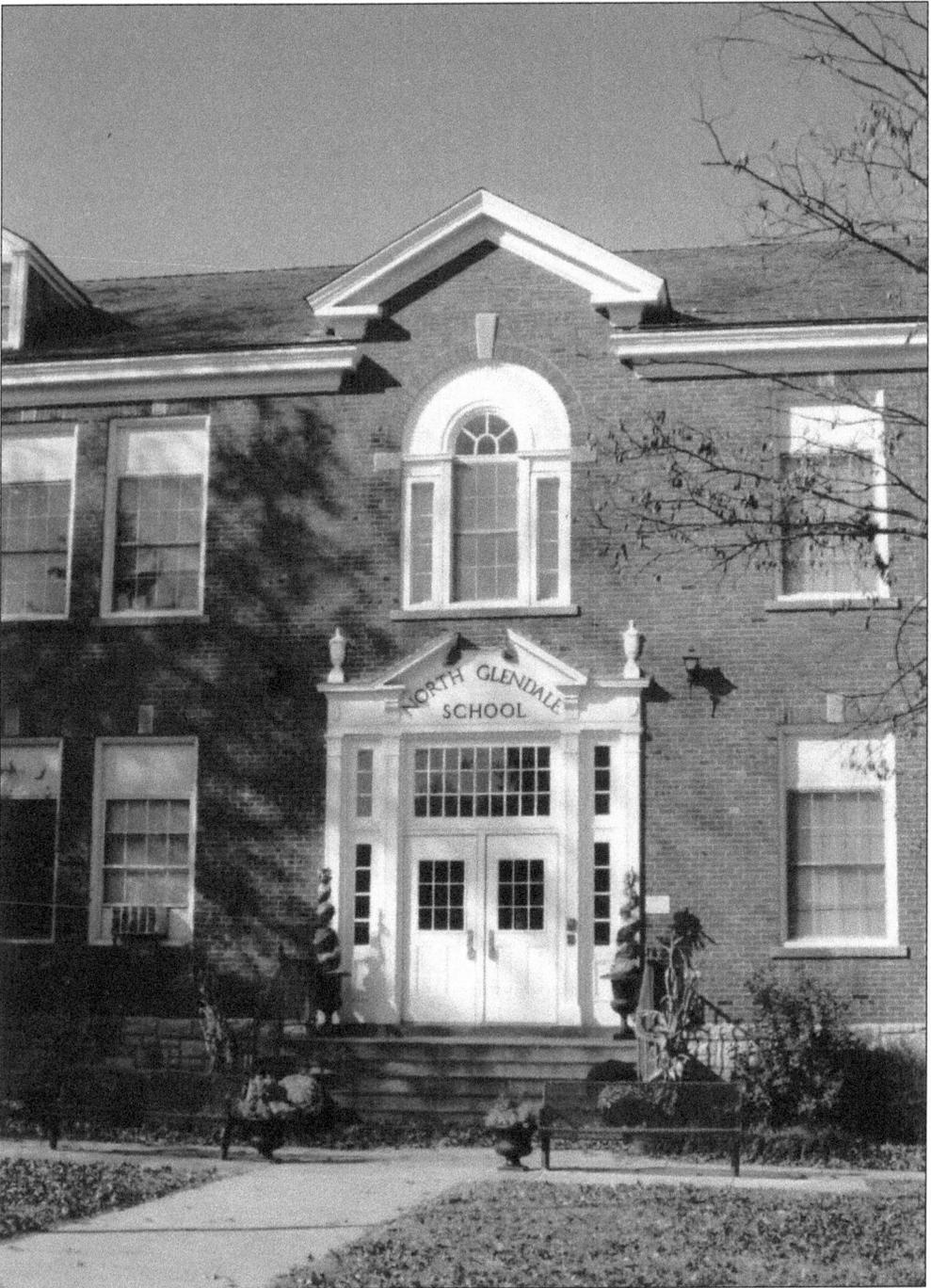

North Glendale Elementary School (actually located in Glendale but part of the Kirkwood School District) opened in 1938 at Sappington Road and Kirkham Avenue. Enrollment in the district peaked in 1967 but declined after, resulting in the closure of Des Peres, Osage Hills, Turner, and Pitman Schools in the early 1970s, Rose Hill in 1977, and Hough in 1982.

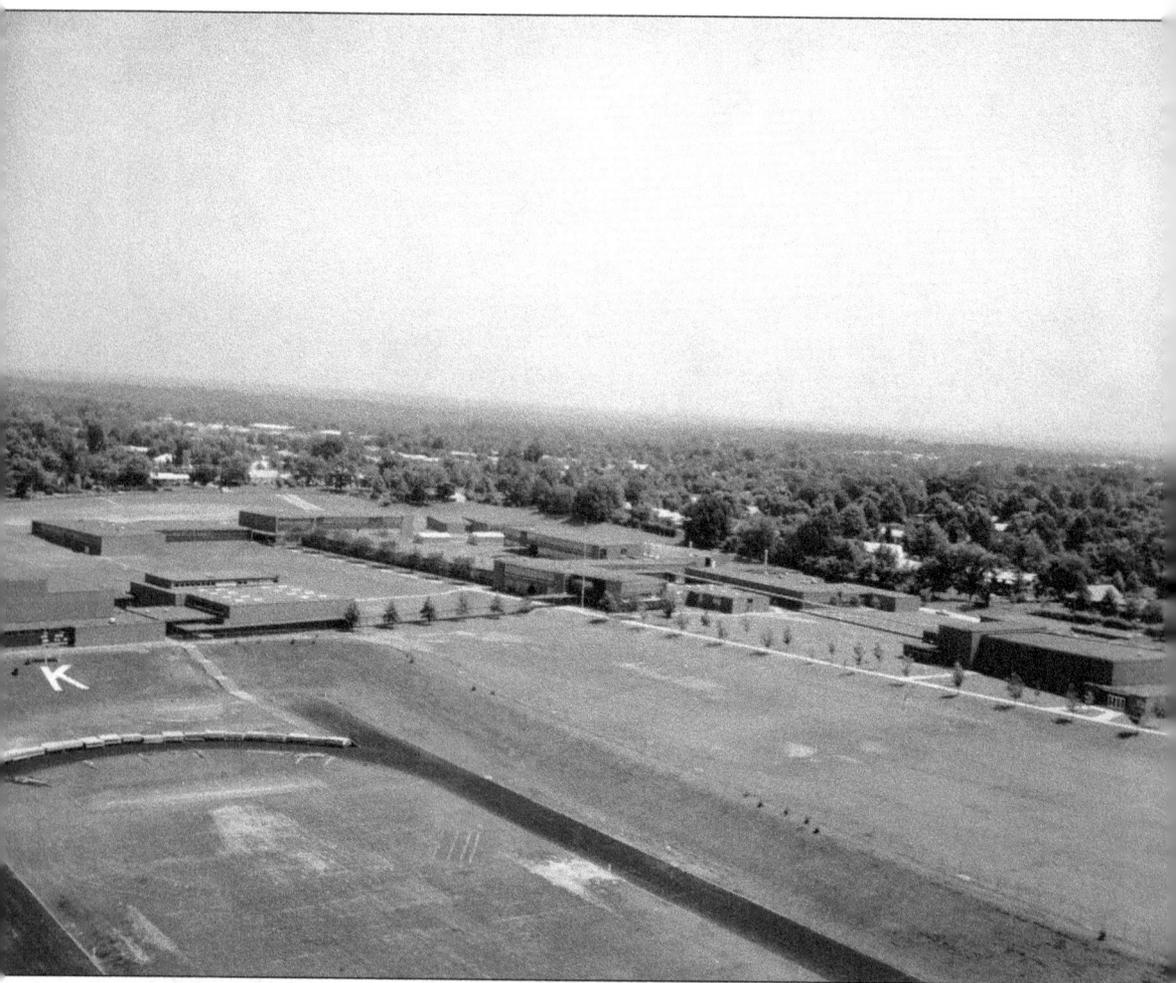

An early aerial view of the site of the present day Kirkwood High School shows the unfinished football field in the foreground with the buildings behind. When the new Kirkwood High School opened in September 1955, it was integrated for the first time. Elementary schools and faculty had been integrated in 1954. Kirkwood High School has recently added a new science building and a new gymnasium.

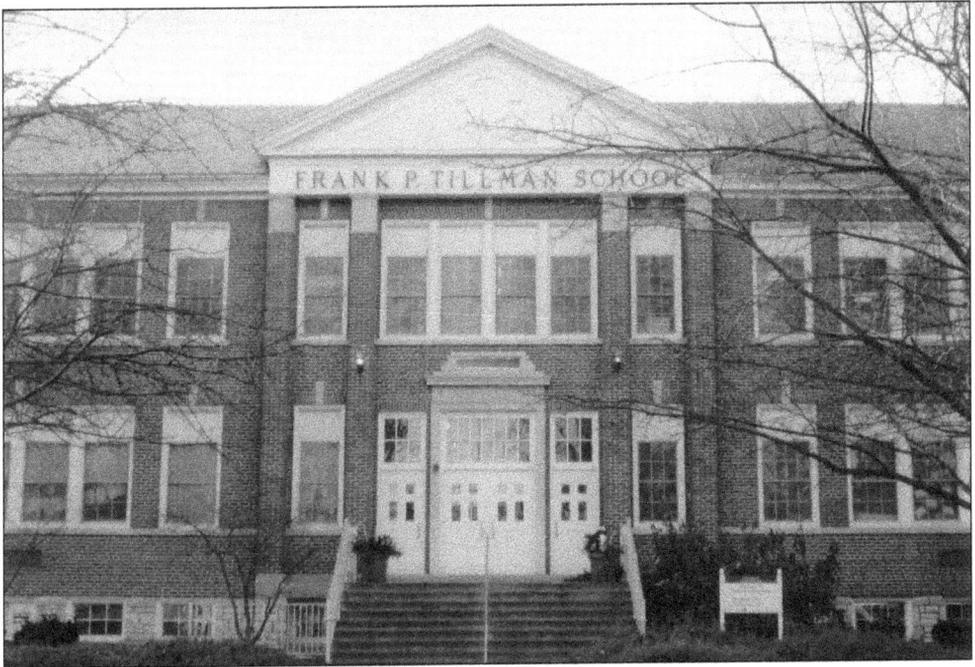

The property on Quan Avenue that would eventually be the location of Frank P. Tillman Elementary School was purchased in 1938, but because of wartime and postwar conditions, no school was built, even though citizens in north Kirkwood were pushing for one. Construction for on first section of Tillman was finally begun in 1946. The school was named for Superintendent Frank P. Tillman, who served the Kirkwood School District from 1924 to 1947. (Author photograph.)

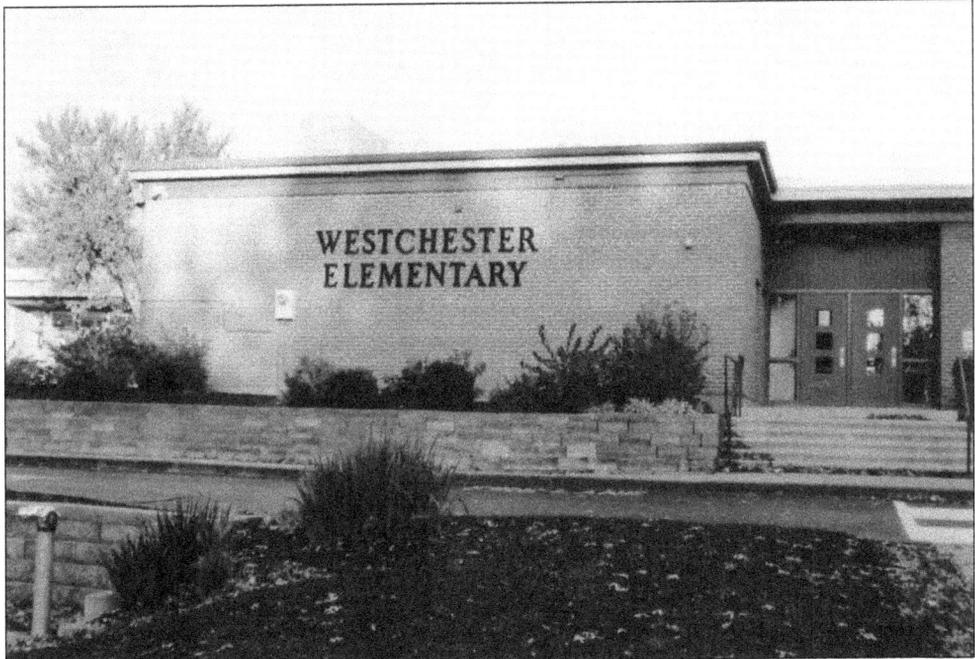

In answer to a growing school population, Westchester Elementary School was built in 1956, followed by Rose Hill in 1958. (Author photograph.)

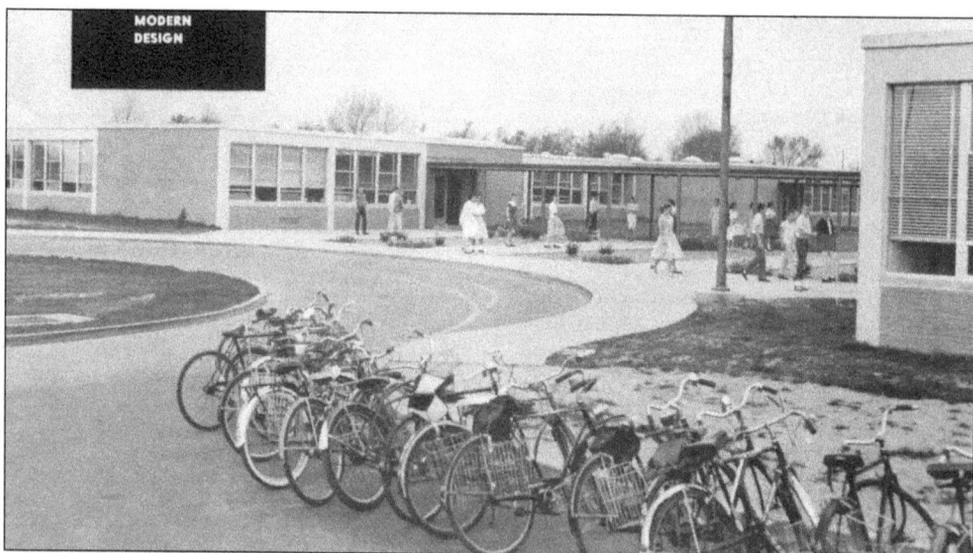

North Junior High School, the second junior high school in Kirkwood School District, opened in 1958. Located on Manchester Road, it is now known as North Kirkwood Middle School. The campus shares facilities with the district's administration offices.

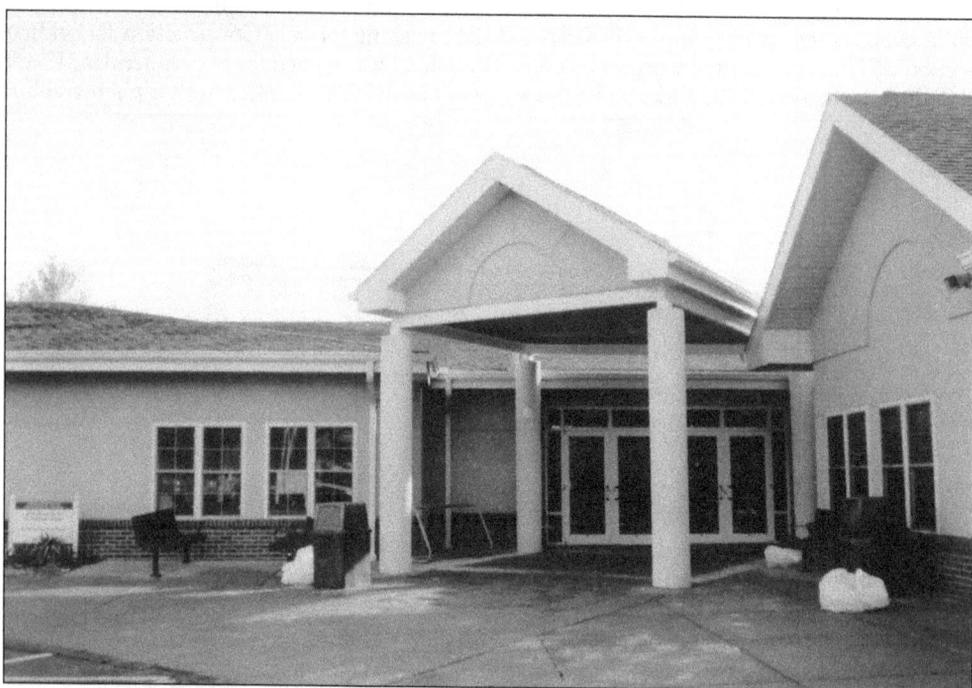

The Kirkwood Early Childhood Center (KECC) is also located in Glendale but is an important part of the Kirkwood School District. The center opened in 1991 and offers full-time and part-time preschool programs, early childhood special education programs, and a grade school camp in the summer. The program is funded by tuition and fundraisers. The Parents as Teachers program for the district is also housed at KECC. (Author photograph.)

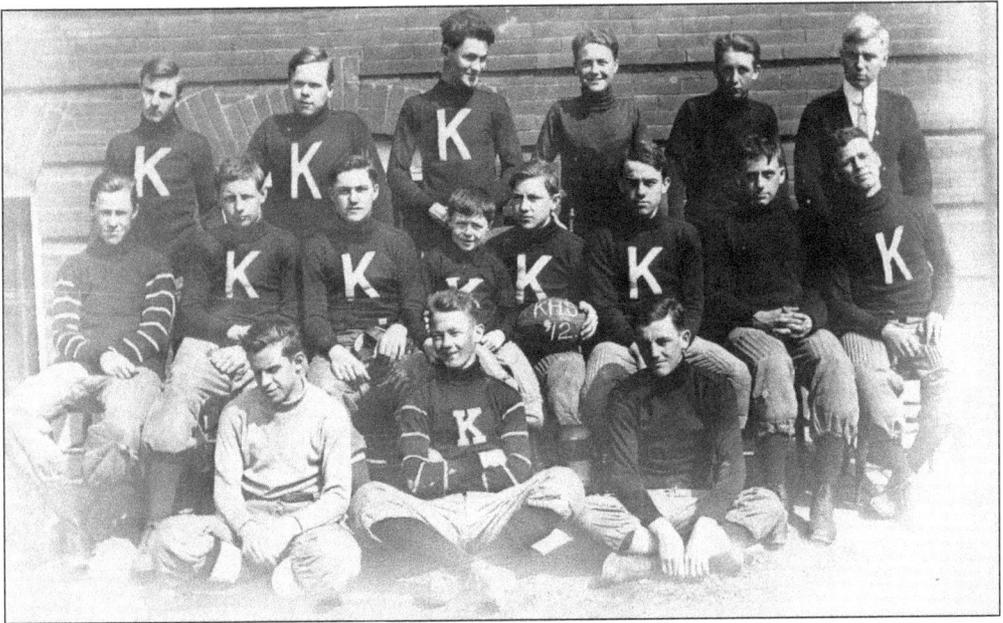

The first Turkey Day football game was played on Thanksgiving Day, 1907, between Kirkwood and Webster Groves, giving rise to the oldest high school football rivalry west of the Mississippi. A weeklong celebration precedes the game. The winner is awarded the Frisco Bell, and the loser receives the Little Brown Jug. The 1912 Kirkwood team, pictured here, lost by one point to Webster Groves.

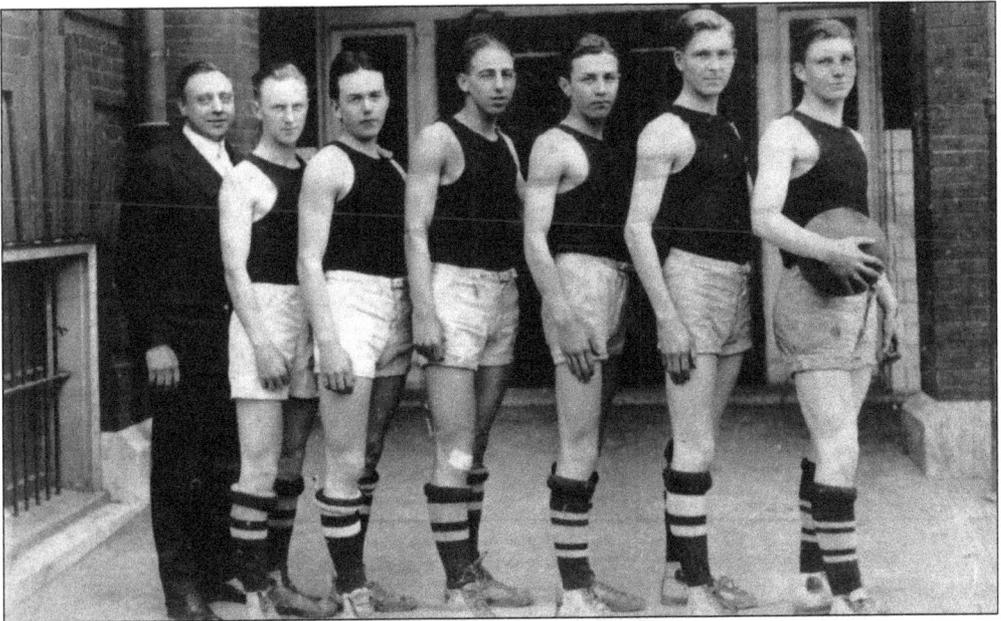

Kirkwood High School's first basketball team was organized in 1897, but the district did not provide either equipment or coaches. The boys raised money for their equipment and practiced on their own. There were no other high schools in the area, so they played in the Kirkwood Athletic Association against teams of men not in school. The team is pictured around 1921–1922, and by then, athletics were thoroughly supported by the school district.

Girls, as well as boys, played basketball in Kirkwood in the early 1900s. The girls' basketball team is pictured here at Kirkwood Train Station in 1917.

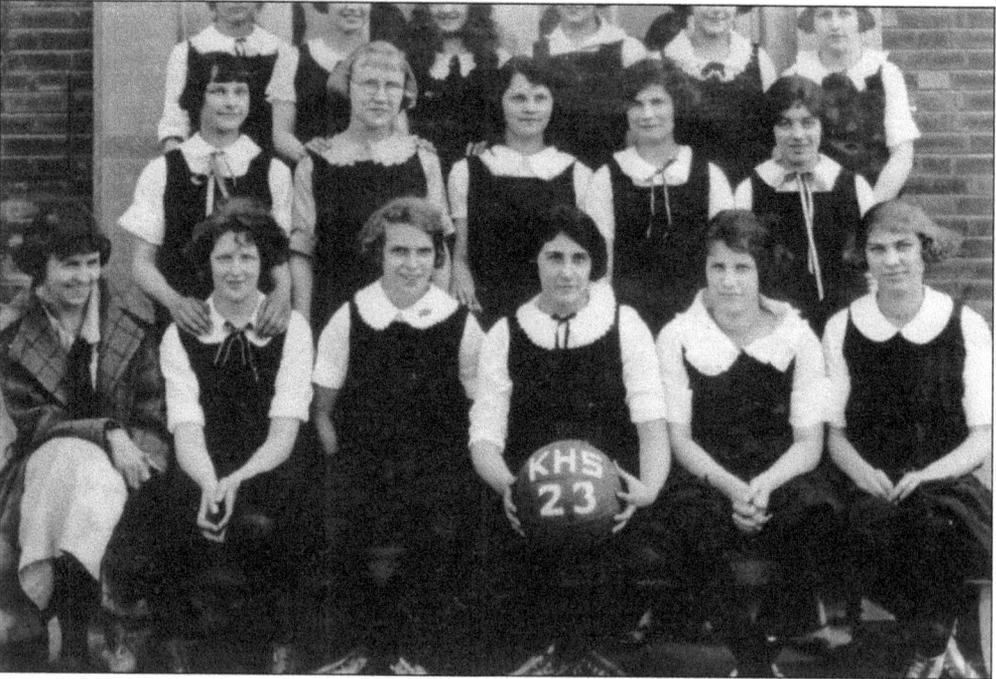

The Kirkwood High School girls' basketball team from 1923 is pictured here. Girls had great success on the court. An earlier Kirkwood girls' team (1918) defeated every young women's team in St. Louis County.

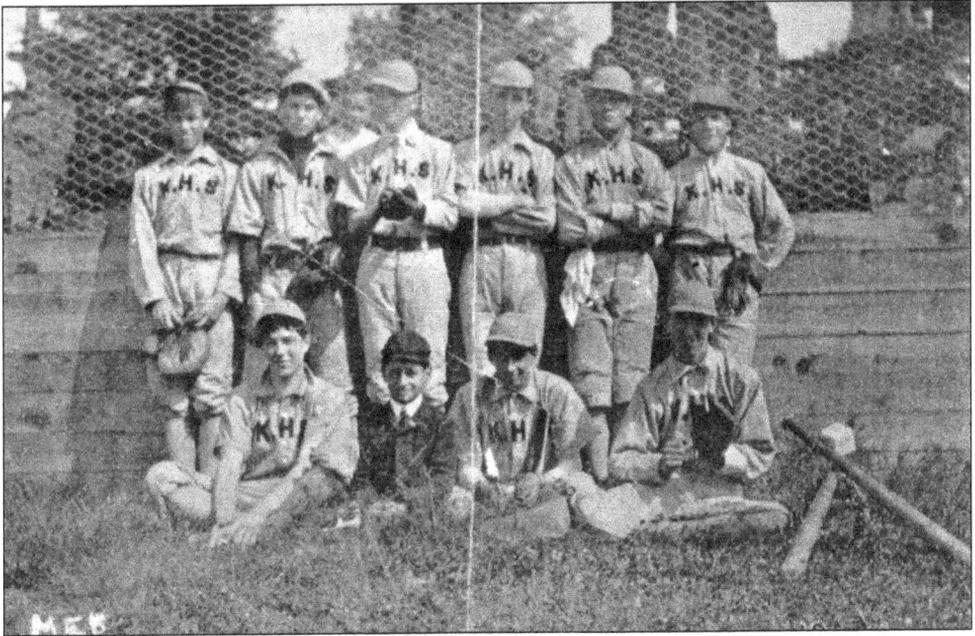

Kirkwood High School also fielded baseball teams early on. Pictured here is the 1902 team, made up of, from left to right, (first row) ? Taussig, shortstop; A. Brossard, mascot; J. Brossard, third base; and ? Votaw, second base; (second row) F. Young, left fielder; ? Brown, catcher; ? Monroe, pitcher; A. Logan, first base; ? Mudd, right fielder; and ? Leffingwell, center fielder.

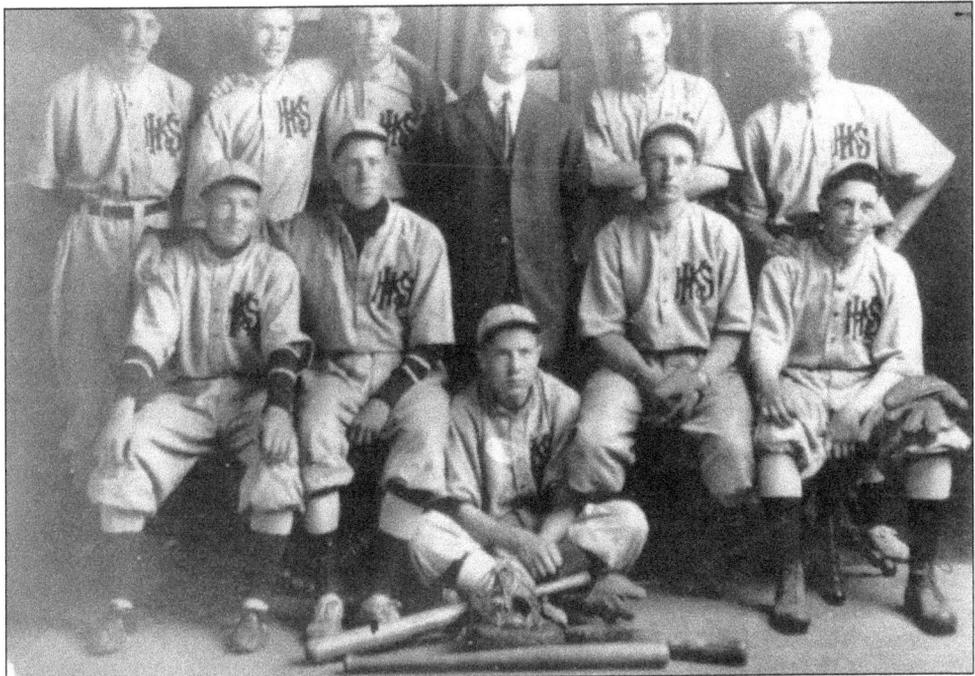

The 1912 Kirkwood High School baseball team poses in this photograph.

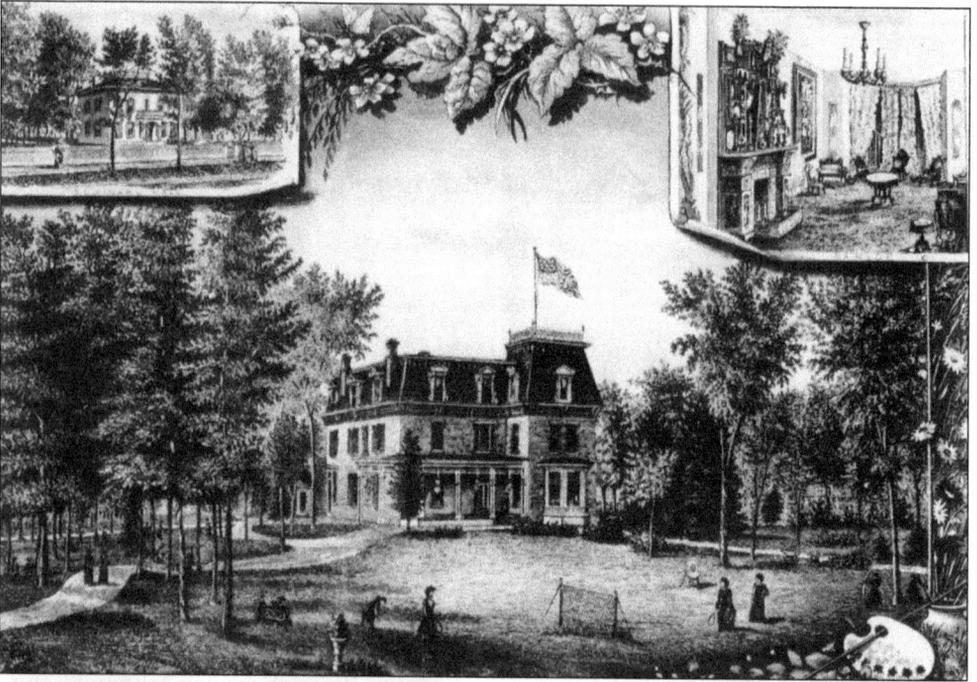

Anna Sneed opened Kirkwood Seminary on September 5, 1861, in a house at Harrison Avenue and Argonne Drive with a student body numbering seven. The numbers grew, and soon a group of local citizens invested in a building at the northwest corner of Kirkwood Road (Webster Avenue) and Adams Avenue. In 1868, a new building was added to house the increasing student body. The bulk of the student body was young girls from Kirkwood, but students commuted daily by train and came from surrounding states to board. The Kirkwood Seminary closed in 1889 after a dispute with the city over a drainpipe carrying waste from the school prompted a complaint from a neighbor.

Anna Sneed originally taught at a school in Lexington, Missouri, but that school closed at the outbreak of the Civil War. Sneed moved to St. Louis but decided not to teach in the city schools when she found out that religion was not a part of the curriculum, something she felt vital to education. She married the architect who designed the dormitory facilities for the seminary and became Mrs. J.G. Cairns. As the school grew, her sisters joined her faculty to assist. Kirkwood Seminary closed in 1889 after a lawsuit, and Anna Cairns opened Forest Park University in the city.

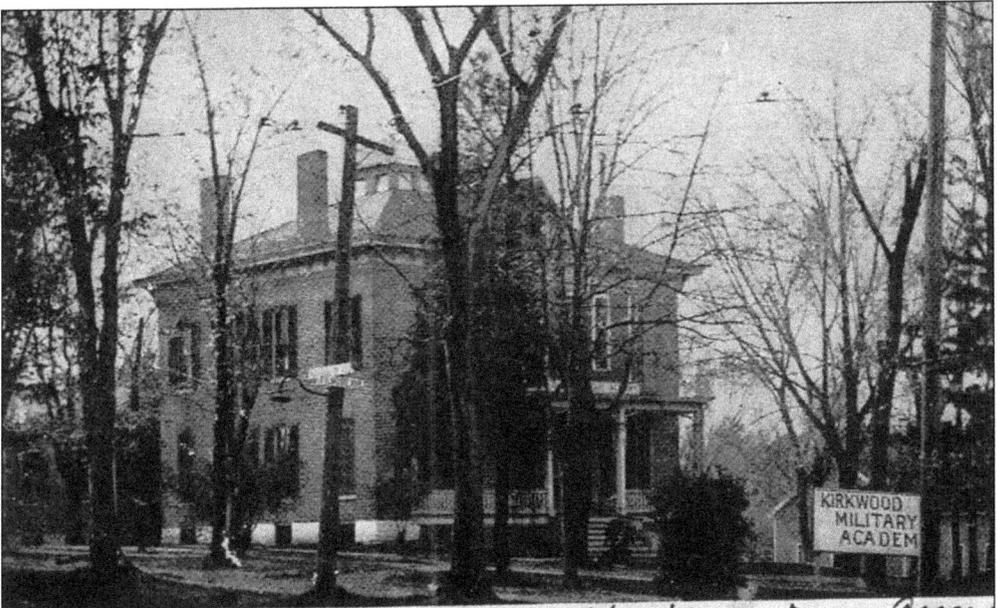

The Kirkwood Military Academy was established by Col. E.A. Haight in 1885 on Harrison Avenue. After a fire, the school moved to Argonne Drive and Taylor Avenue, then to Washington and Fillmore Avenues. The boys who attended the school were referred to as cadets and were subject to strict military discipline and standards. The institution was again destroyed by fire in late December 1910, and Colonel Haight did not reopen the school.

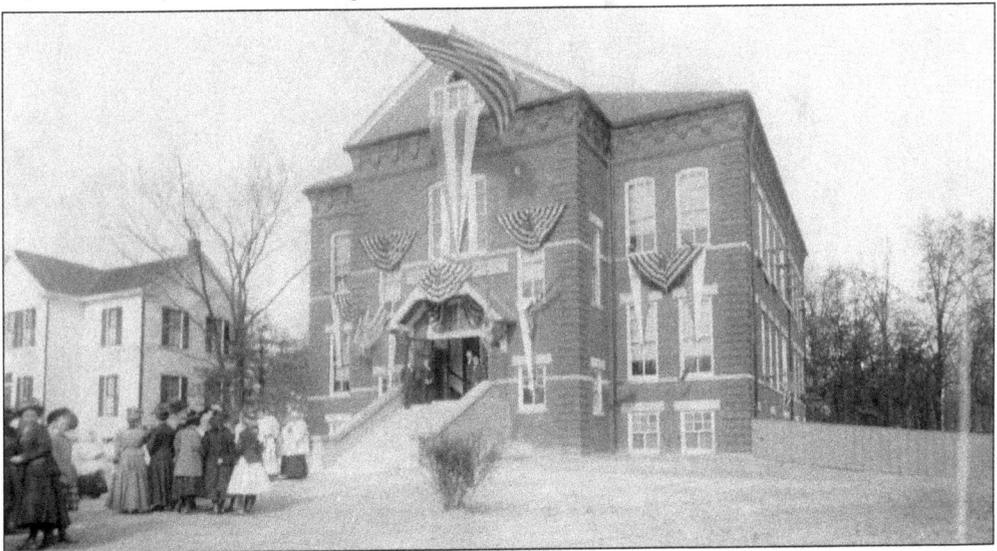

The first Catholic education was offered in Kirkwood in 1863 in a school near the original church on Jackson Avenue (now Geyer Road). Classes were taught by Franciscan nuns under the supervision of Fr. Henry Van der Sanden. School was held in various locations until 1882, when a two-room structure was built where St. Peter's School is today. The school building pictured was erected in 1907 at Clay Avenue and Argonne Drive (then Main Street) because of the growing number of students.

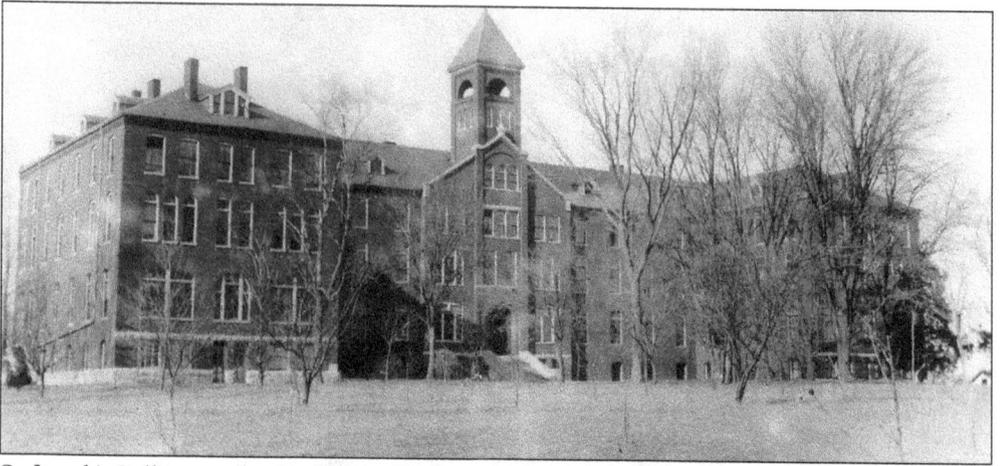

St. Joseph's College, run by the Order of Redemptorists, established a school for young men entering their order at the corner of Geyer and Big Bend Roads in 1889. The school offered four years of high school and two years of college. The college moved to Wisconsin in 1958.

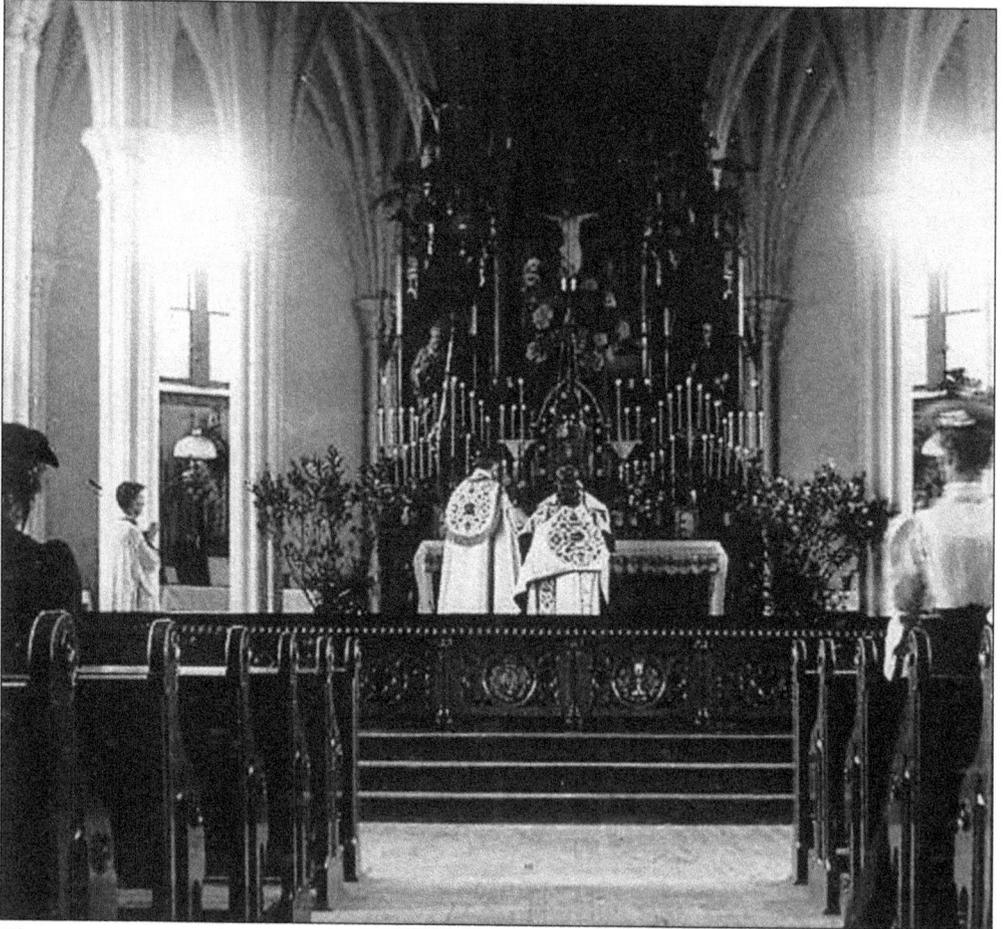

This is a view of the interior of the chapel at St. Joseph's College. The Redemptorists were primarily trained for missionary work. An average of 150 young men attended the school each year.

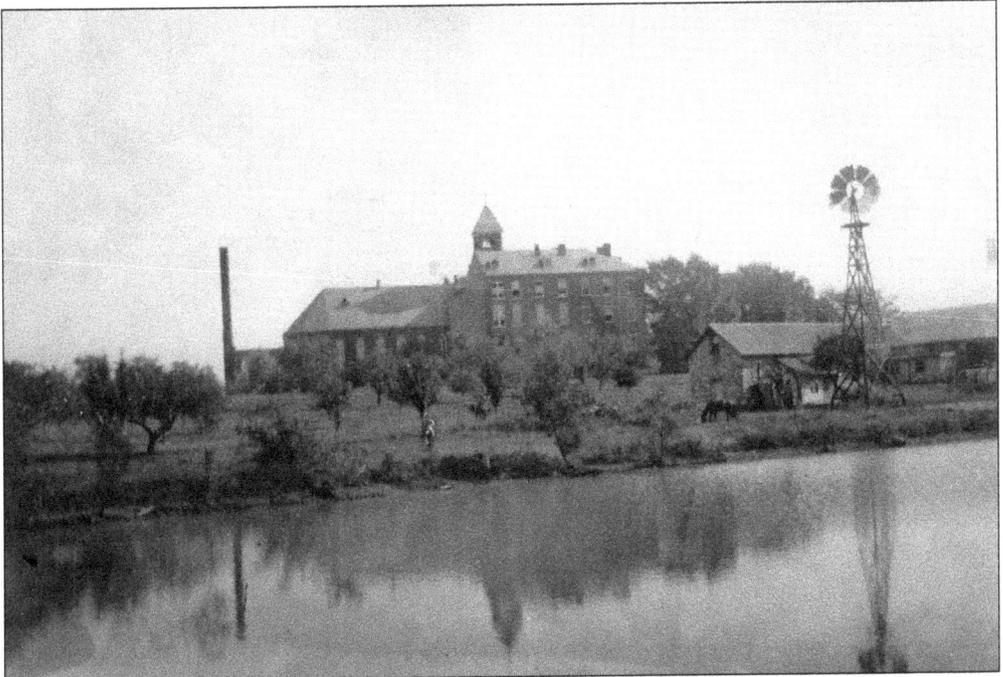

For a time, St. Joseph's College raised as much of its own food as possible for students and staff. This included a garden, orchard, dairy, and a supply of freshwater on about 80 acres of land.

Meramec Community College is located on the former grounds of St. Joseph's College. Meramec is part of the Junior College District of St. Louis and offers two-year degree programs. Classes opened at Meramec in January 1964. (Author photograph.)

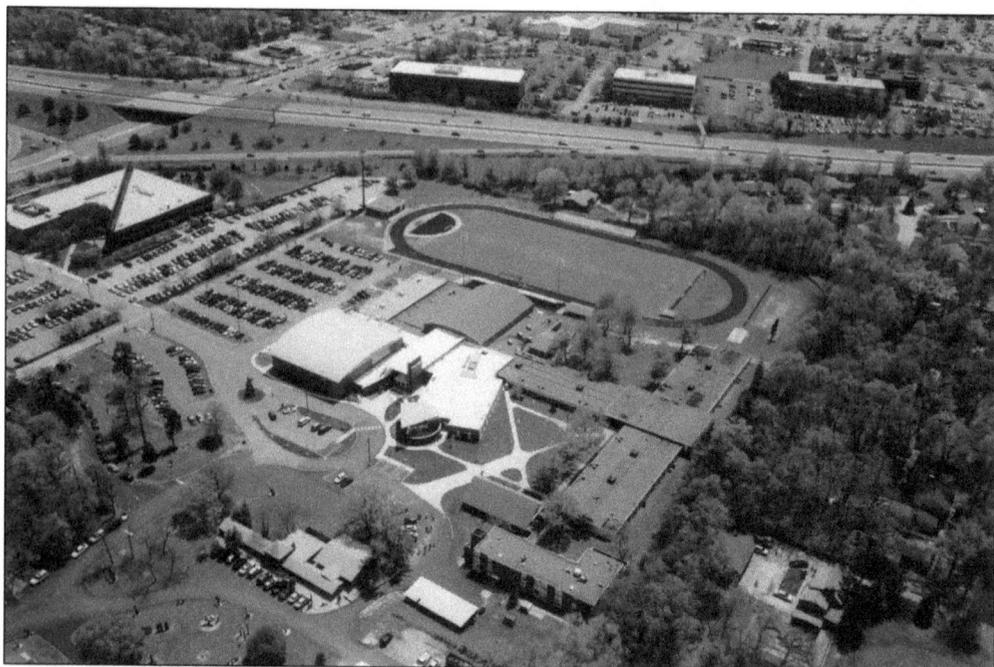

St. John Vianney High School, under the supervision of the Society of Mary, opened in 1961 offering area boys a Catholic secondary education. The Society of Mary had occupied the property (known as Maryhurst) at Lindbergh and Big Bend Boulevards since 1918. This is an aerial view of the Vianney campus in 2008.

The first classes were held at Concordia Lutheran School in 1875 in the church. Both German and English were taught. From 1882 to 1889, no classes were held, but once a permanent pastor was engaged in 1889, he held the dual function of pastor and teacher. Classes have continued uninterrupted since then. The school moved to its current location in 1948, when the new church was built. (Author photograph.)

Eight

MERAMEC HIGHLANDS

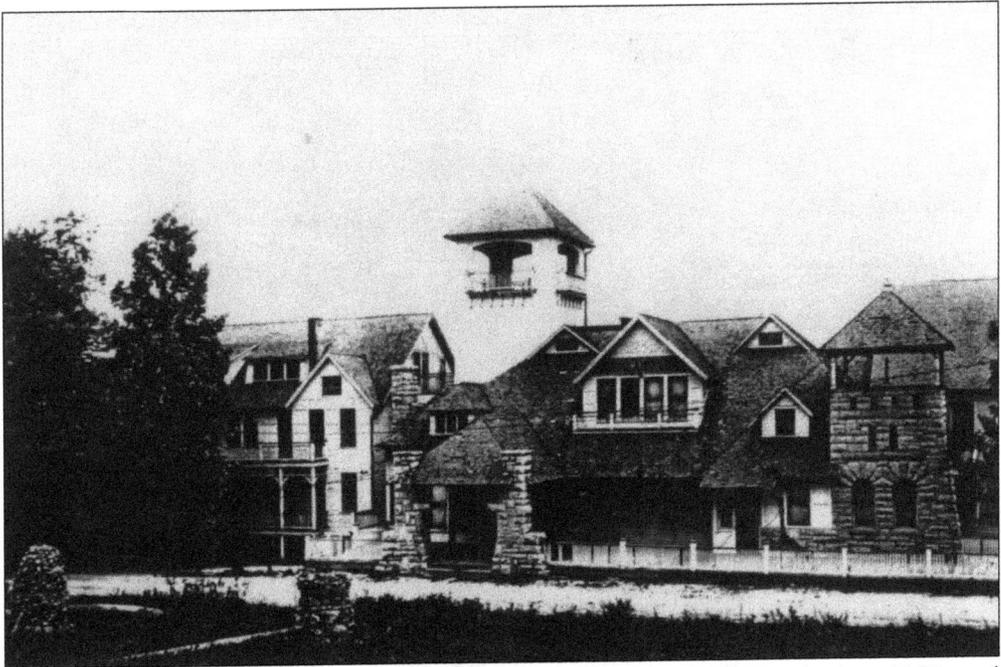

This view greeted visitors arriving at the Meramec Highlands Inn in the late 1800s and early 1900s.

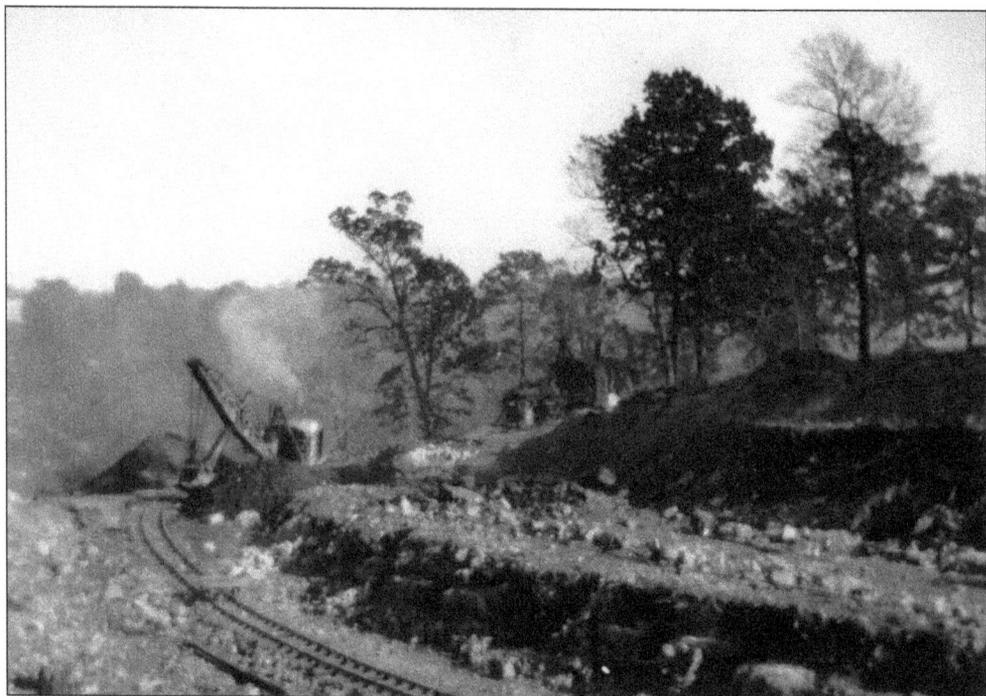

Without the Frisco Railroad, guests would not have had a way to travel to the Meramec Highlands in the early days (a streetcar line was added later). These undated photographs show the laying down of track to the Highlands. Originally, the Frisco Railroad leased track rights from the Missouri Pacific Railroad, but in 1882, the company added its own. The track was doubled in the early to mid-1920s.

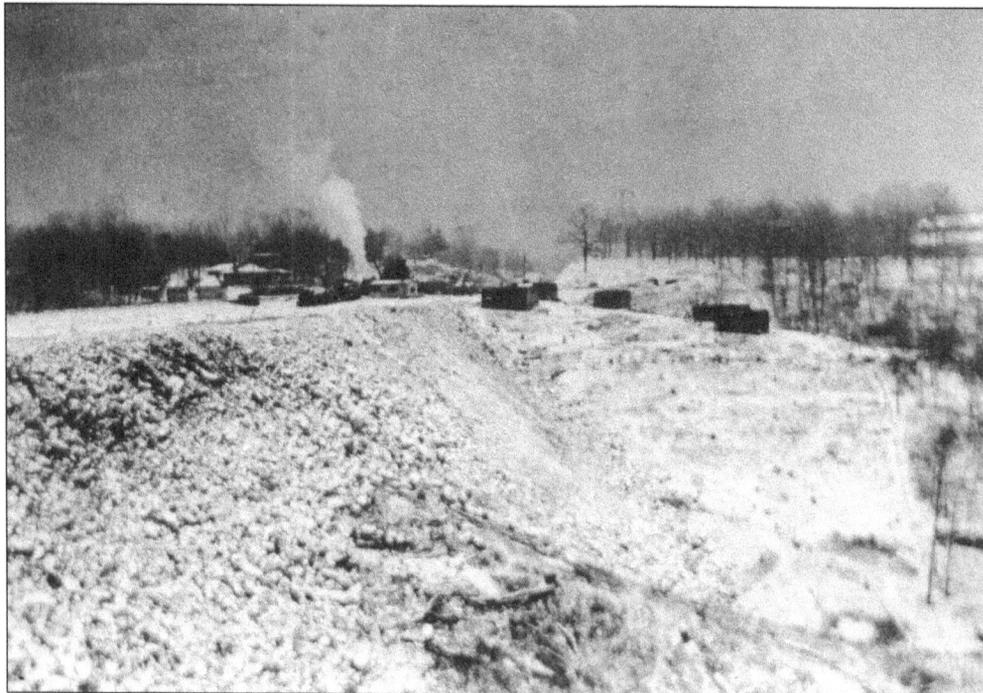

The Meramec Highlands Frisco Railroad tunnel was constructed through Sunset Hill in 1883. The 400-foot-long tunnel was on the Frisco line between Pacific and Windsor Springs (near Geyer Road and Big Bend Boulevard). The tunnel had many problems, including lack of ventilation, dangerous conditions for workers, and limited use due to the size of later equipment. In 1923, the track and tunnel were replaced by an open cut. The tracks were ultimately removed in 1929.

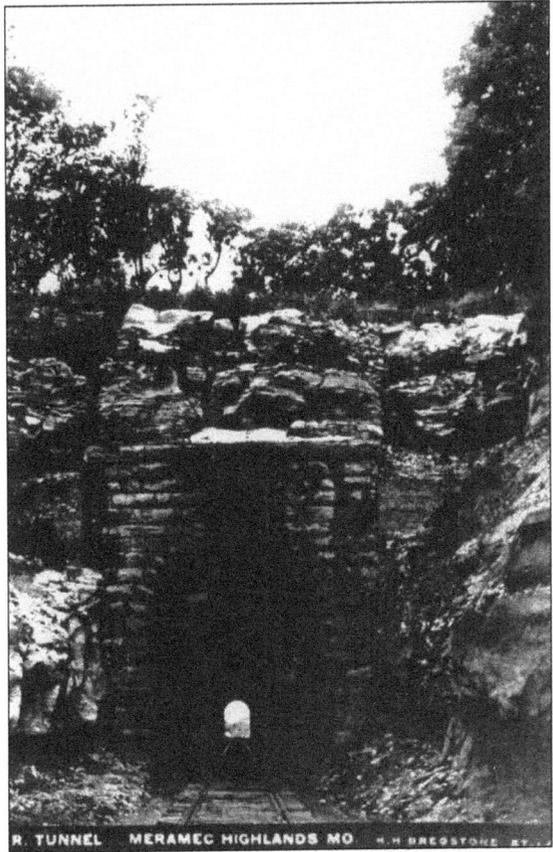

R. TUNNEL MERAMEC HIGHLANDS MO H. H. BREGSTONE ST. ?

Here is a clear view of the Frisco tunnel with an unidentified photographer setting up equipment to capture an image. The tunnel has always been popular with photographers.

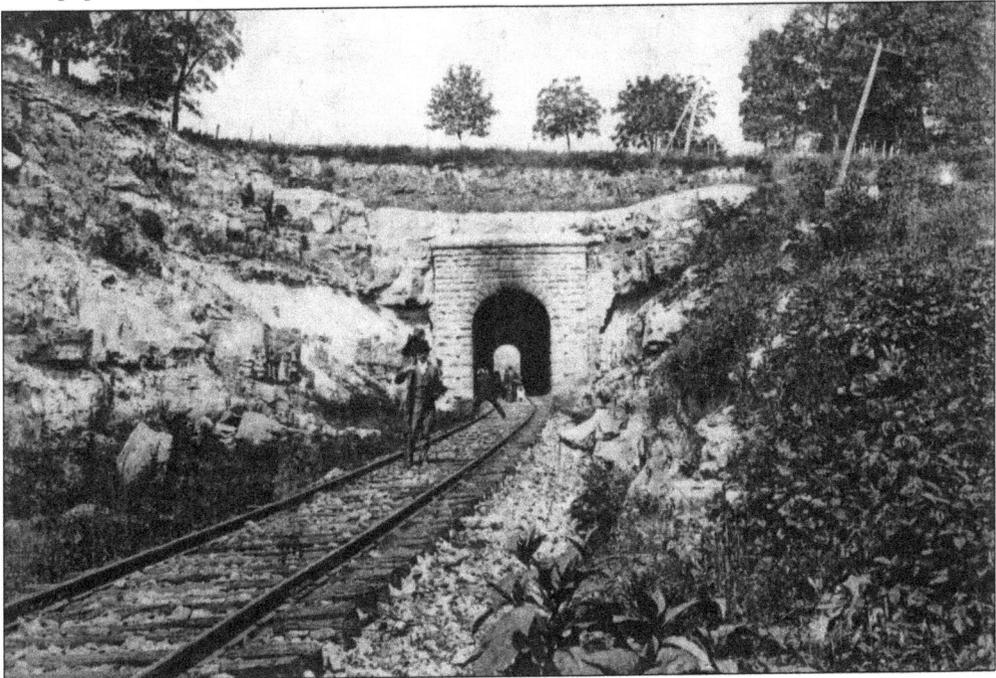

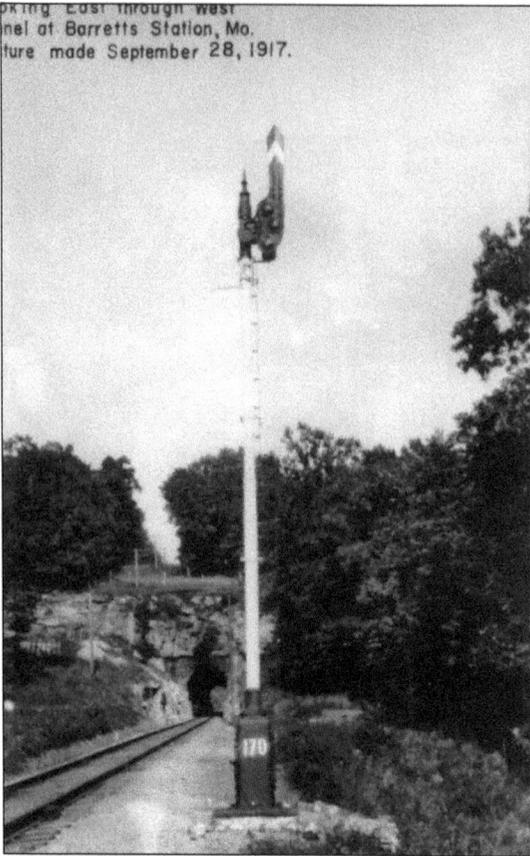

looking East through West
nel at Barretts Station, Mo.
ture made September 28, 1917.

This view looks west toward the railroad tunnel on September 28, 1917.

Visitors would arrive on a train much like this one, seen emerging from the tunnel at an unknown date.

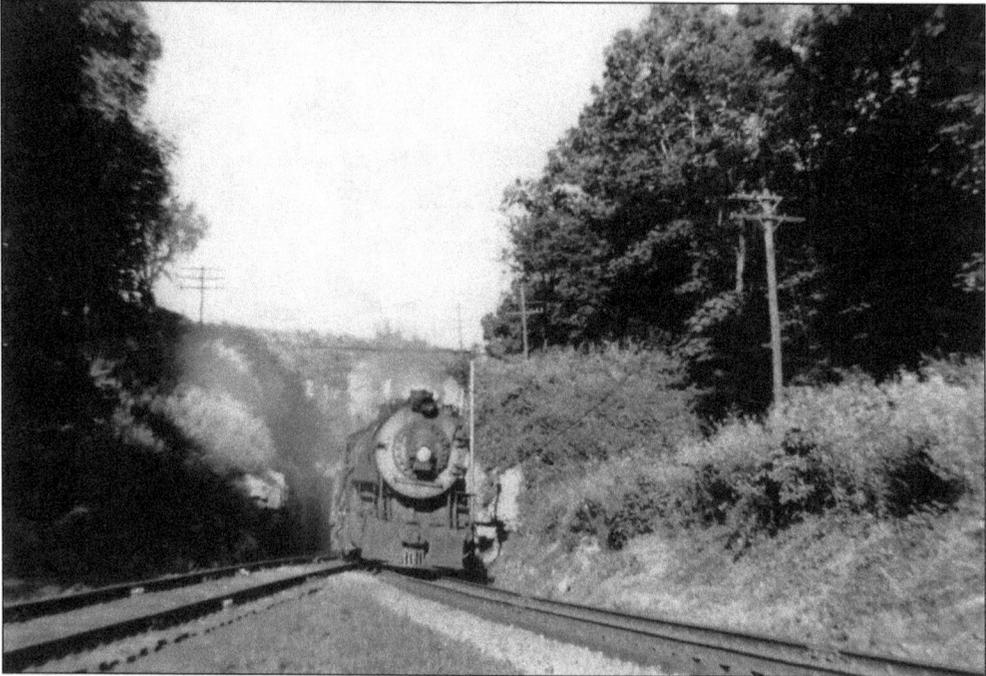

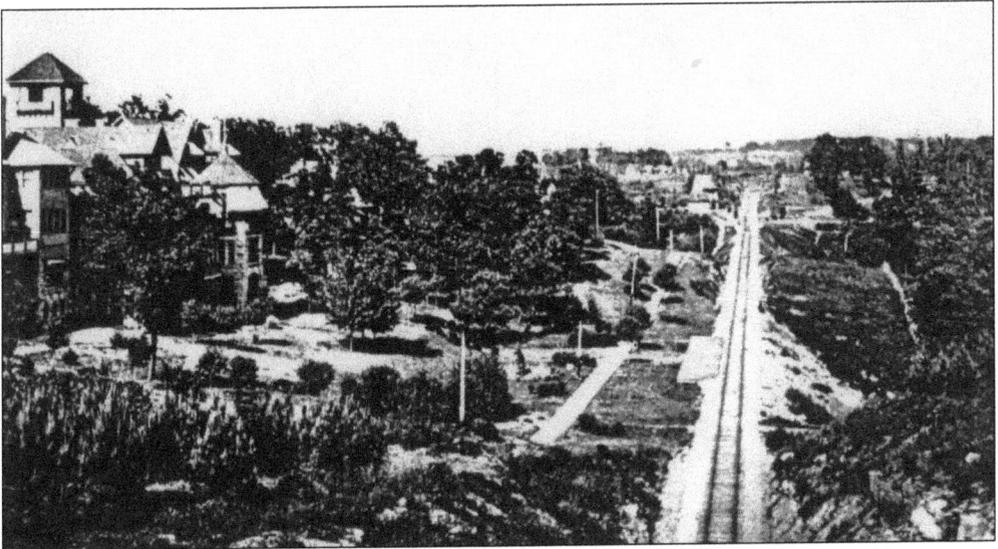

The Meramec Highlands Resort had a long and varied history. The inn, pictured here at an unknown date, sat above the railroad, offering ease of transportation to the site and a dramatic view of the surrounding countryside. The Highlands Inn and Cottages opened in the summer of 1894 under the ownership of Marcus Bernheimer. The inn was designed to be a local alternative for a healthy vacation spot away from the crowds of the city. By the time the inn burned in 1926, the building was vacant, and the resort had declined precipitously from its initial glory.

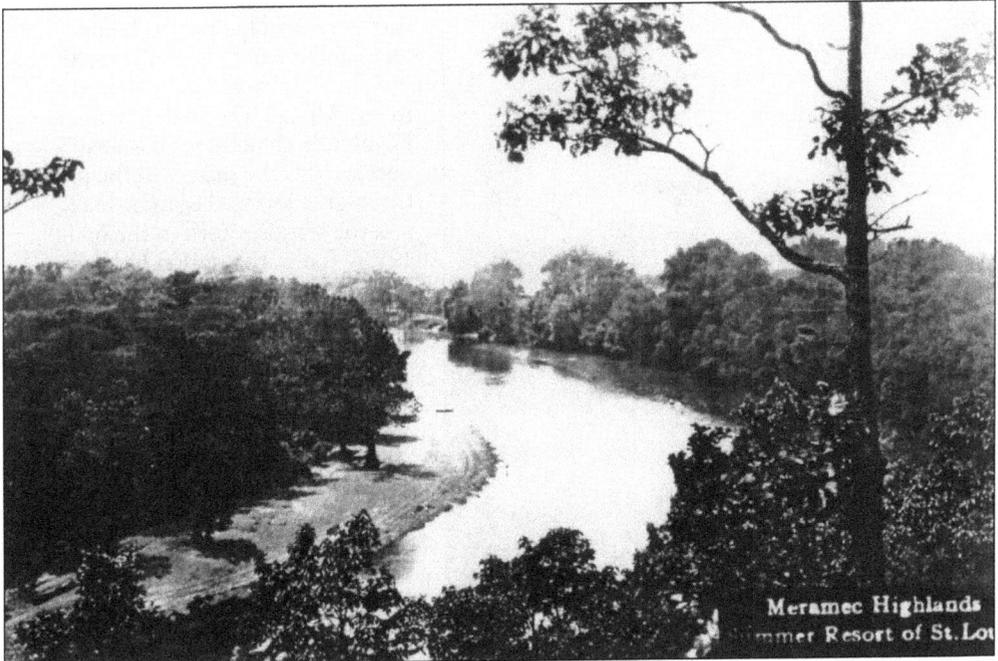

The resort overlooked the picturesque Meramec River, a point of interest for visitors. However, the more important source of water was the sulfo-lithia spring on Sunset Hill. The waters were promoted as having curative properties and were intended to be part of the allure of the resort. The water was bottled and sold but offered free to guests via a fountain on the grounds. It was also used in the alkaline-saline baths open to visitors in the mineral bathhouse, another service offered.

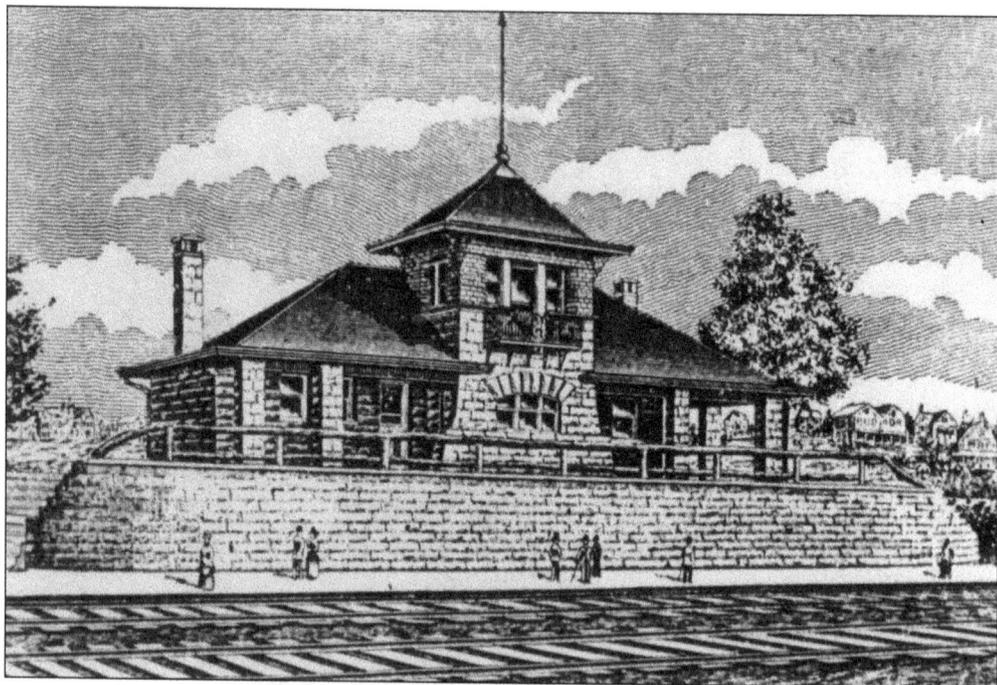

The Frisco depot was built by the Meramec Highlands Company, and then it was sold to the St. Louis and San Francisco Railroad for $1 in 1891. The railroad also agreed to provide rail service to Meramec Highlands, something that was necessary to the success of the project. Commuter service began in 1892, and the station closed in the mid-1930s. Today, the station has been renovated into a private residence. The drawing shown is from advertising for the 1904 World's Fair, and there are anomalies as to the actual appearance, including double tracks and buildings to the right of the depot.

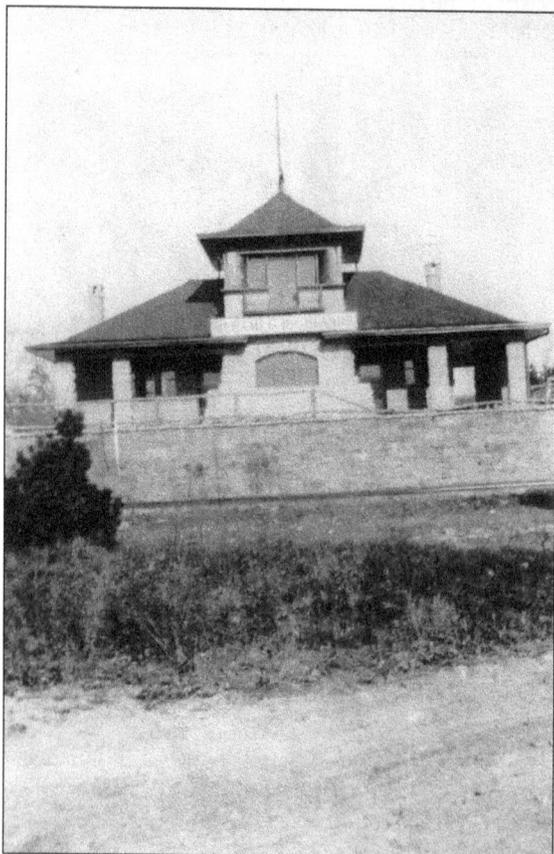

The Meramec Highlands station is pictured when abandoned. It was built in 1891 of quarry stone and neglected in 1972.

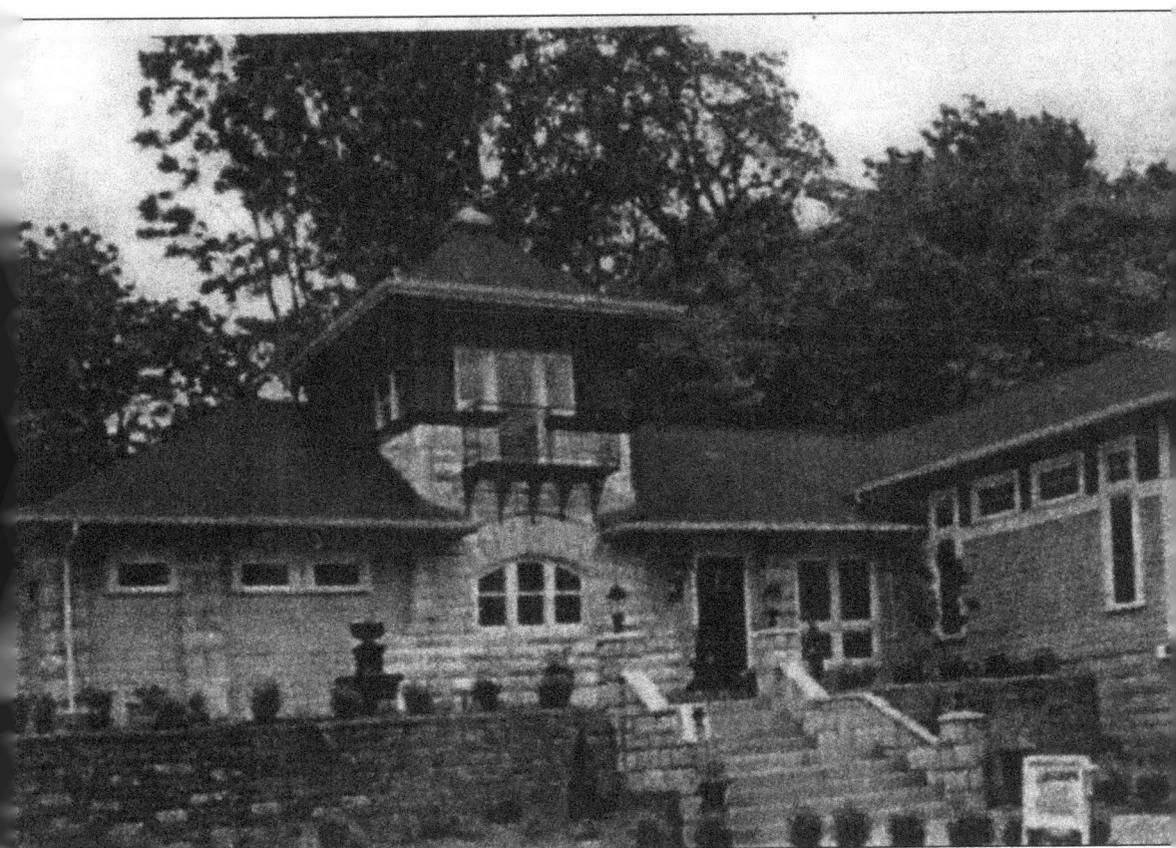

The Meramec Highlands station deteriorated over a period of years until it was repurposed into a lovely residence, pictured in 2008.

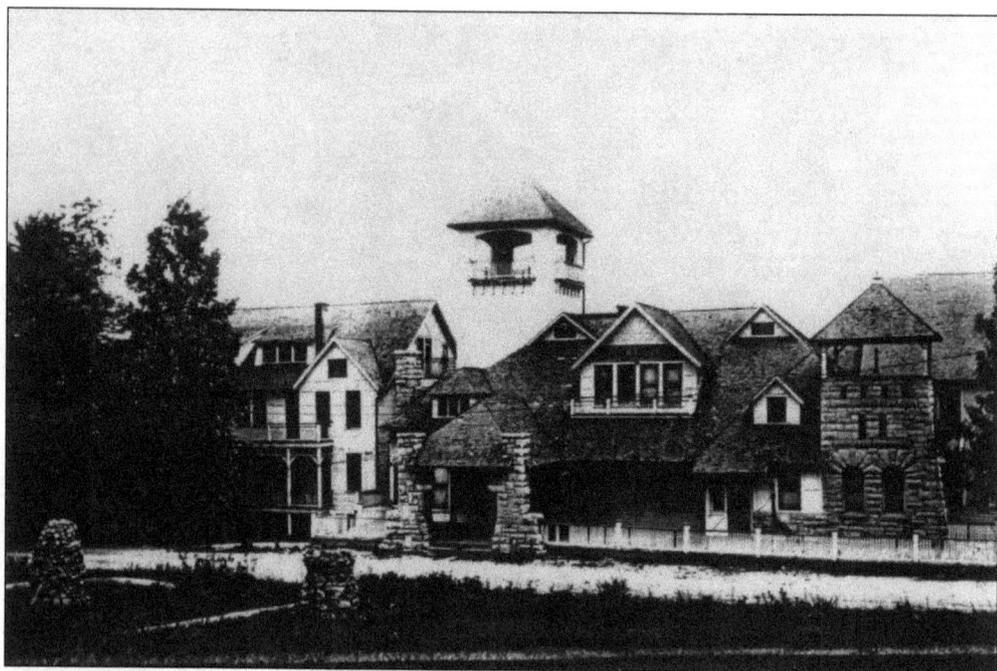

Pictured here are two views of the Meramec Highlands Inn, a beautiful four-story Victorian structure with manicured lawns and gardens. From its opening and heyday in the 1890s, it underwent a gradual decline. When streetcar lines opened up the possibility of a day trip to the resort, lower- and middle-income families flocked to the river on weekends. Other attractions in the St. Louis area also competed for guests. By 1911, the inn had closed. In the 1920s, an undesirable element was attracted to the site. In March 1926, the inn burned, most likely due to vagrants trying to stay warm by building a fire.

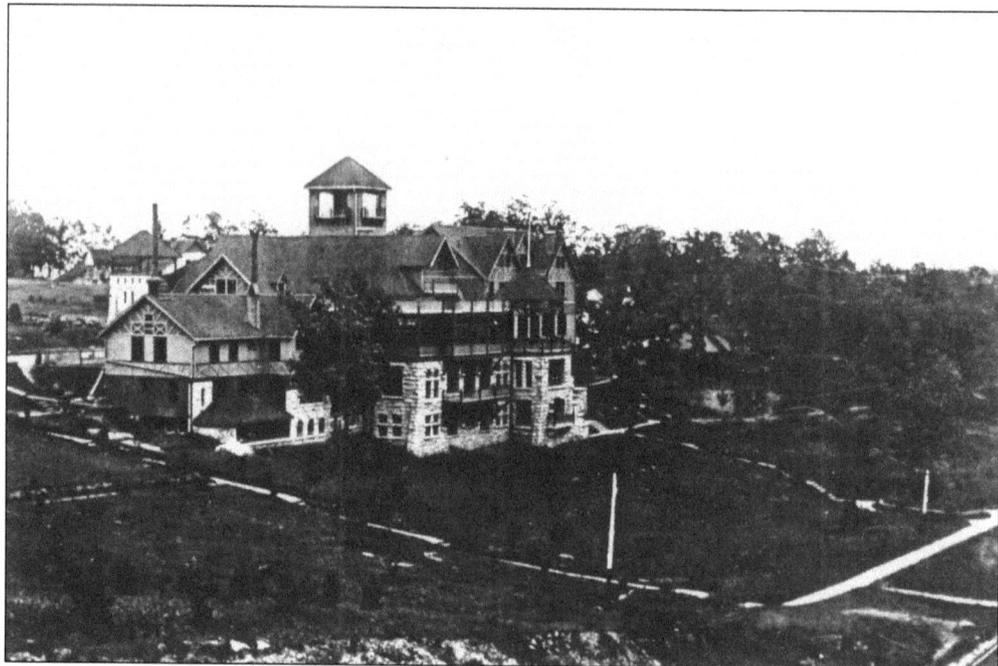

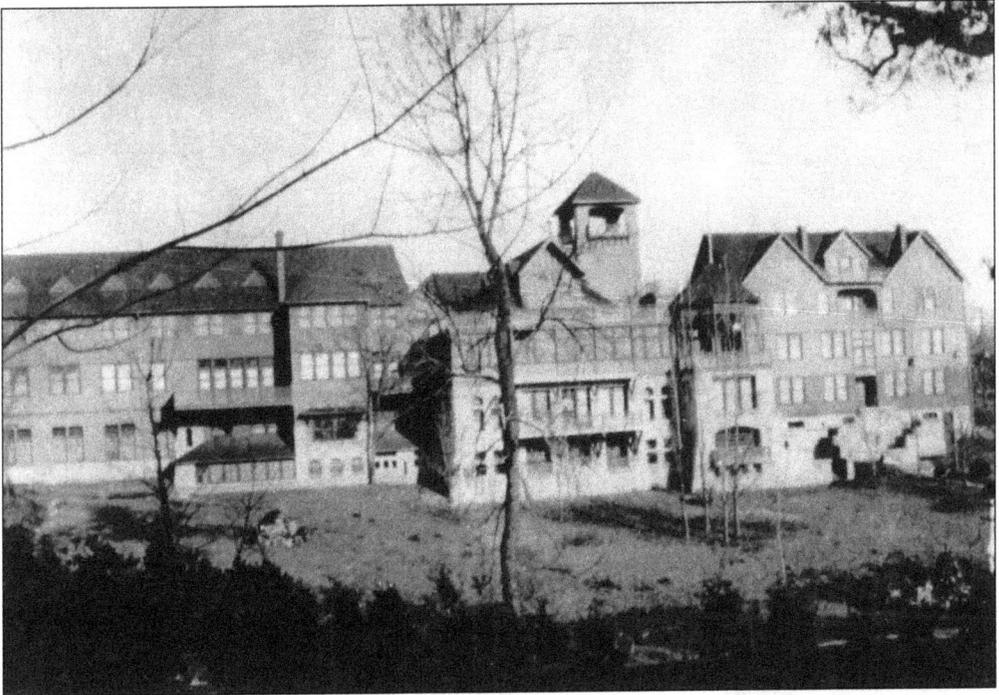

This is the Meramec Highlands Inn as it appeared around 1900, shortly before its resurgence as a lodging site for the 1904 St. Louis World's Fair.

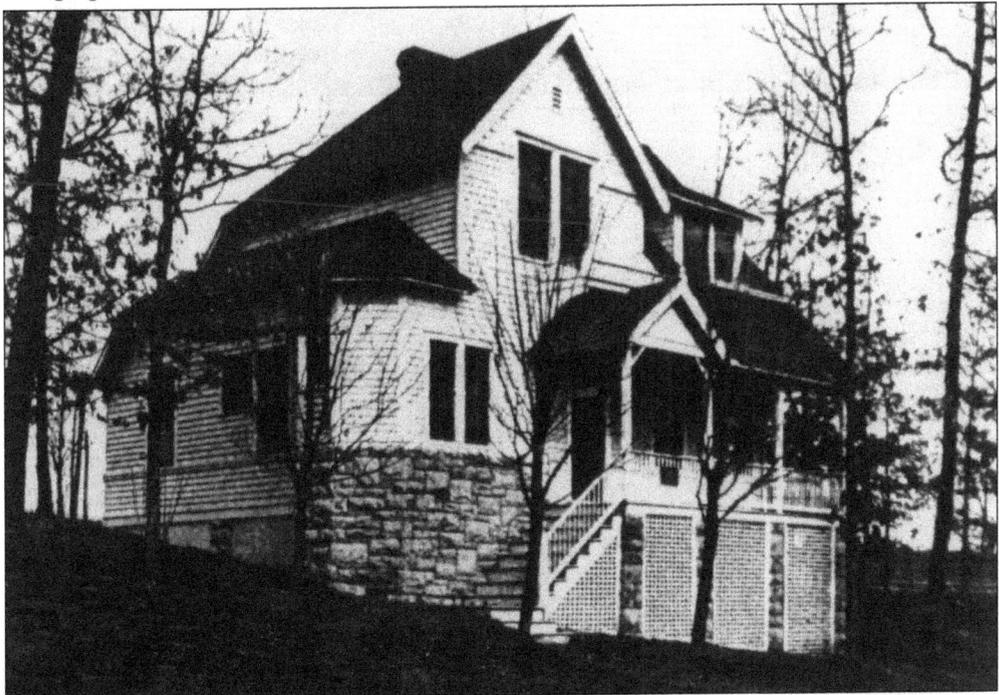

A series of cottages was built on the grounds of the Meramec Highlands Resort for guests (and later, for staff usage). The cottages had every amenity of the day and were available for vacation rentals. The cottages today are private residences and still line Ponca Trail.

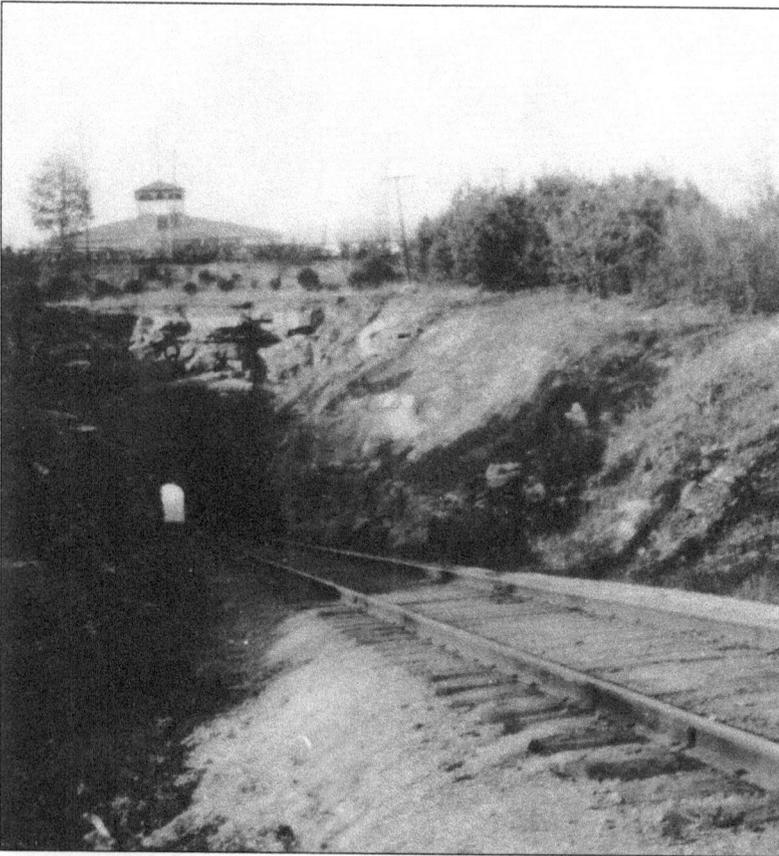

A dance pavilion called the Pagoda opened at the Meramec Highlands for the 1896 season. The pavilion was built on top of the Frisco tunnel. It was a popular dancing and beer-drinking spot for day visitors, as well as a site for special inn events. The pavilion burned down, allegedly as a result of arson, after a series of attempts to rebuild, relocate, and revive the popularity of the venue.

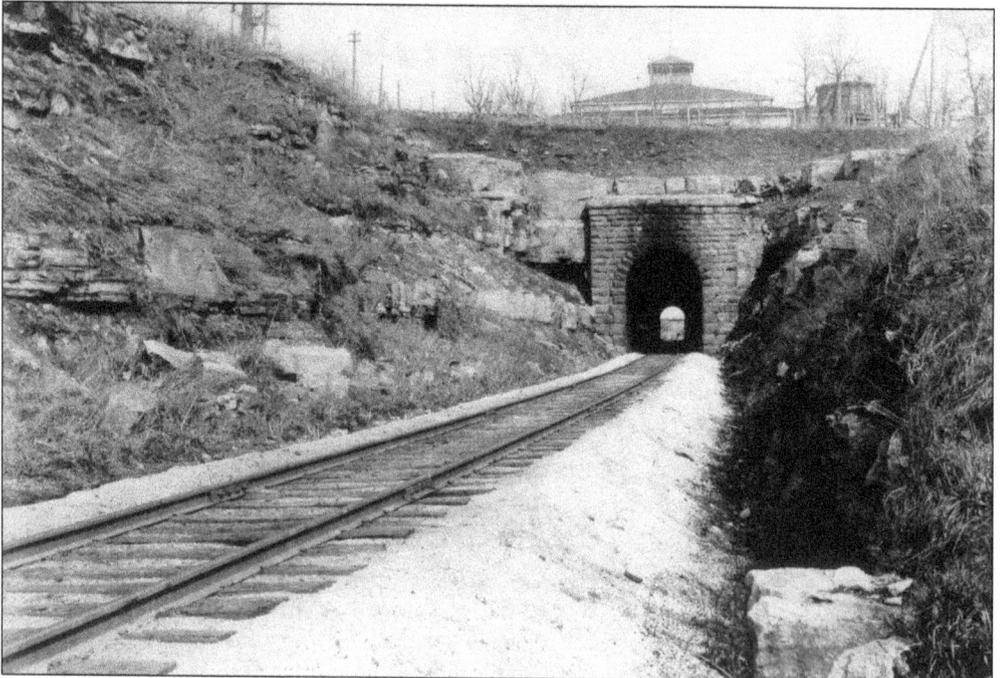

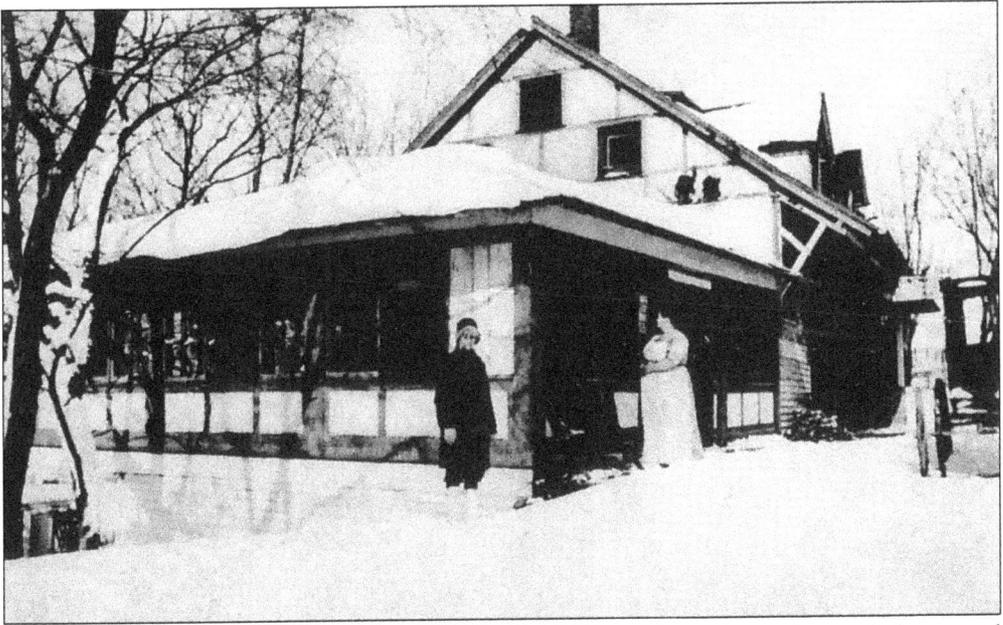

The general store at Meramec Highlands was located near the train station and also served as the post office from 1893 to 1907. This photograph is from around 1913. The Drier family lived upstairs.

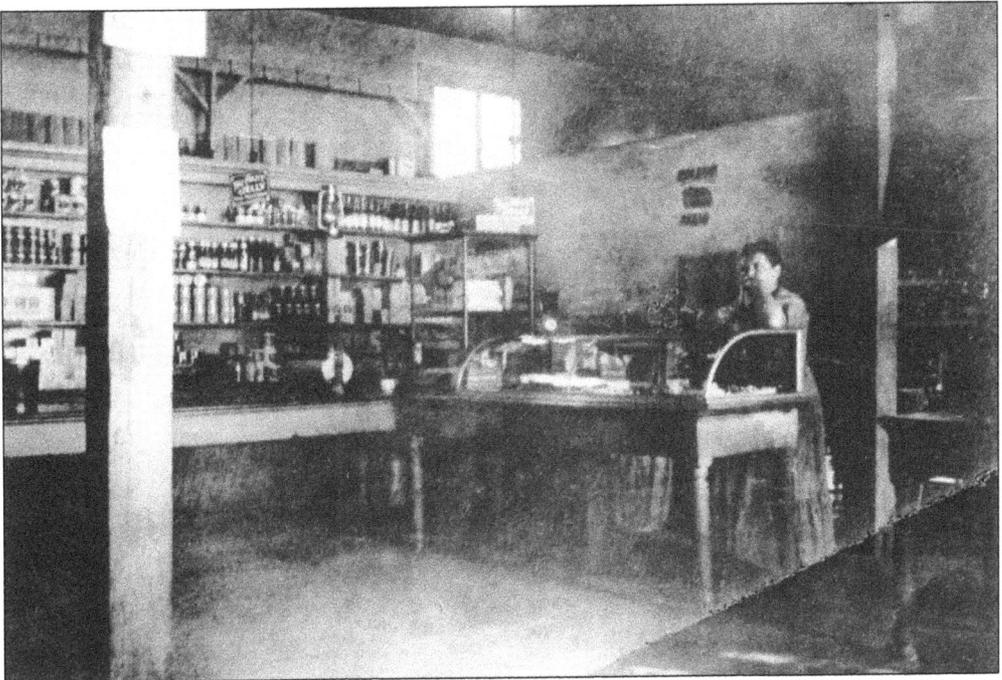

This is a view of the interior of the Meramec Highlands general store in 1913. Dora Drier, who ran the store with her husband, is pictured behind the counter. Gus Drier was formerly a St. Louis mounted policeman.

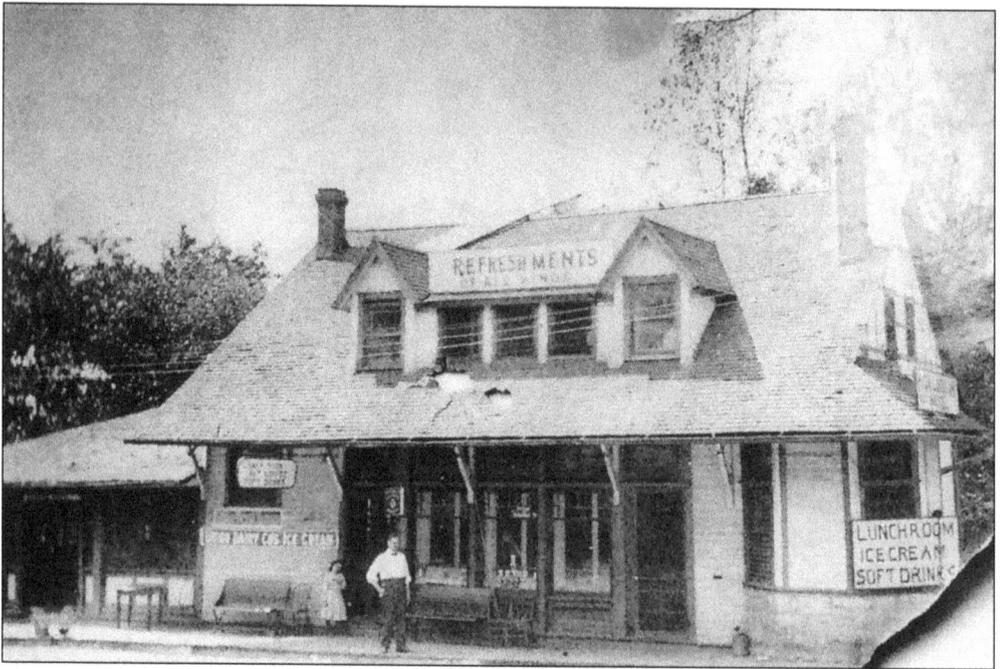

The general store serving Meramec Highlands was built in 1891. This photograph is from around 1913, when a lunchroom had been added to the facility. It was run by Gus and Dora Drier. The facility closed in the mid-1930s.

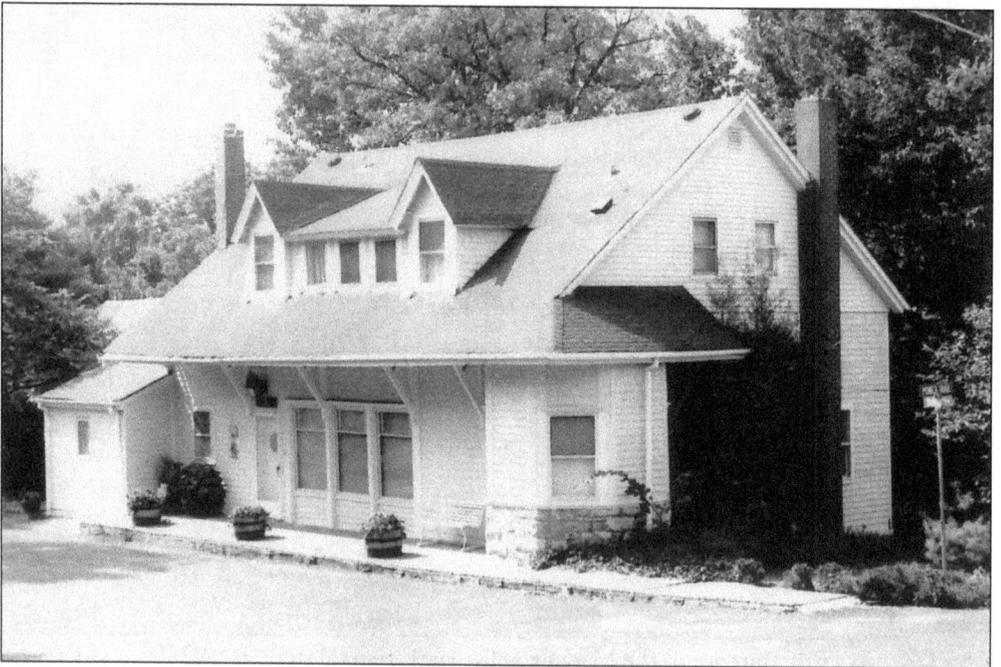

The Meramec Highlands general store was converted into a residence in 1953, pictured here in 1994.

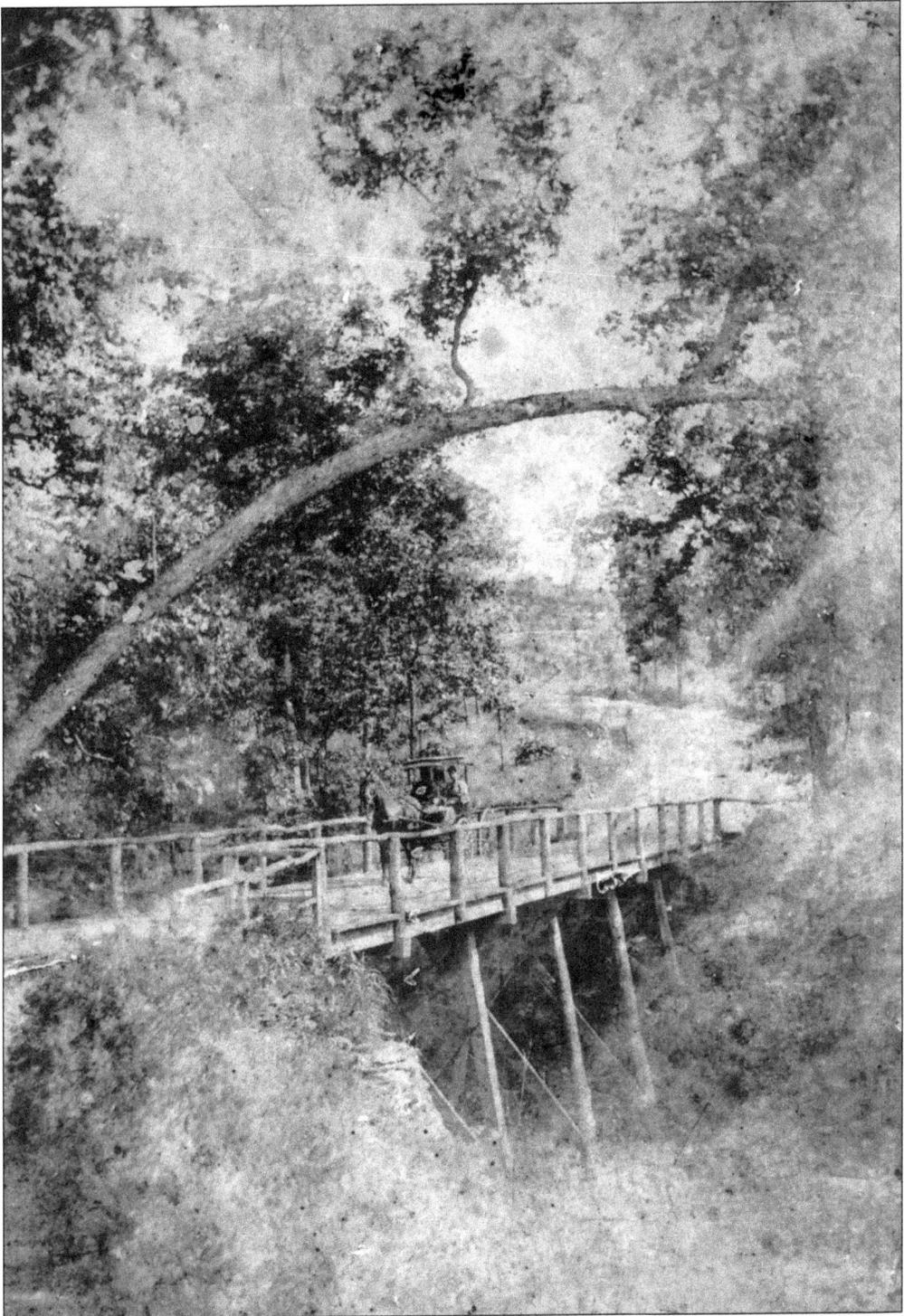

Pictured here at an unknown date is a bridge by the Meramec Highlands Quarry. The quarry was opened in the early 1890s as part of the plan for the resort by its founder, Marcus Bernheimer. It provided stone for the buildings and roads.

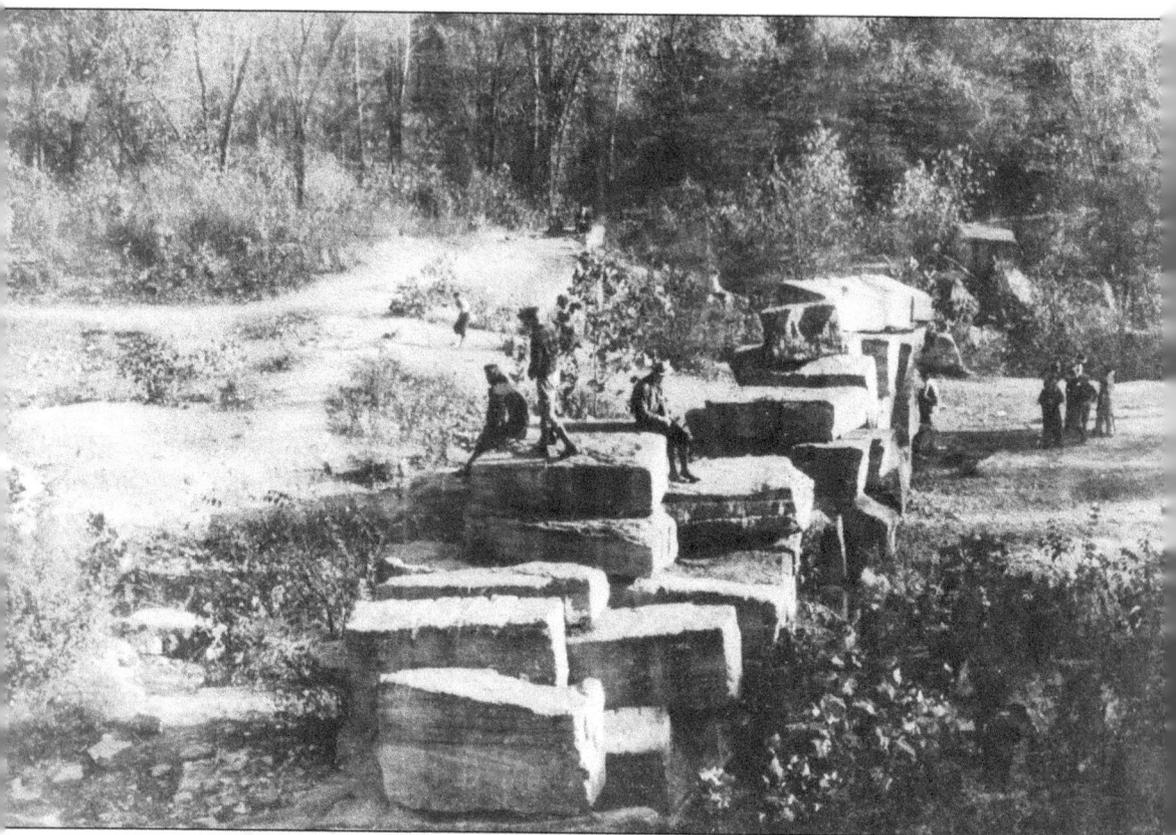

An unidentified group visits the remnants of the Meramec Highlands Quarry around 1938. Stone from the quarry was used in structures at the Highlands and around the metropolitan area. Even after a brief, intense demand for quarried stone for the 1904 St. Louis World's Fair, the quarry never proved profitable and was abandoned. After the closure, the huge slabs of rock and proximity to a streetcar line made the locale an attractive spot for recreation. Today, the area is private property, overgrown and difficult to access.

Nine

KIRKWOOD ENTERTAINMENTS AND ORGANIZATIONS

The Kirkwood Hotel appealed to city dwellers as a nearby option for a vacation, since it was easily accessible to the city of St. Louis. Pictured is an advertisement describing the reasons for a visit to the hotel.

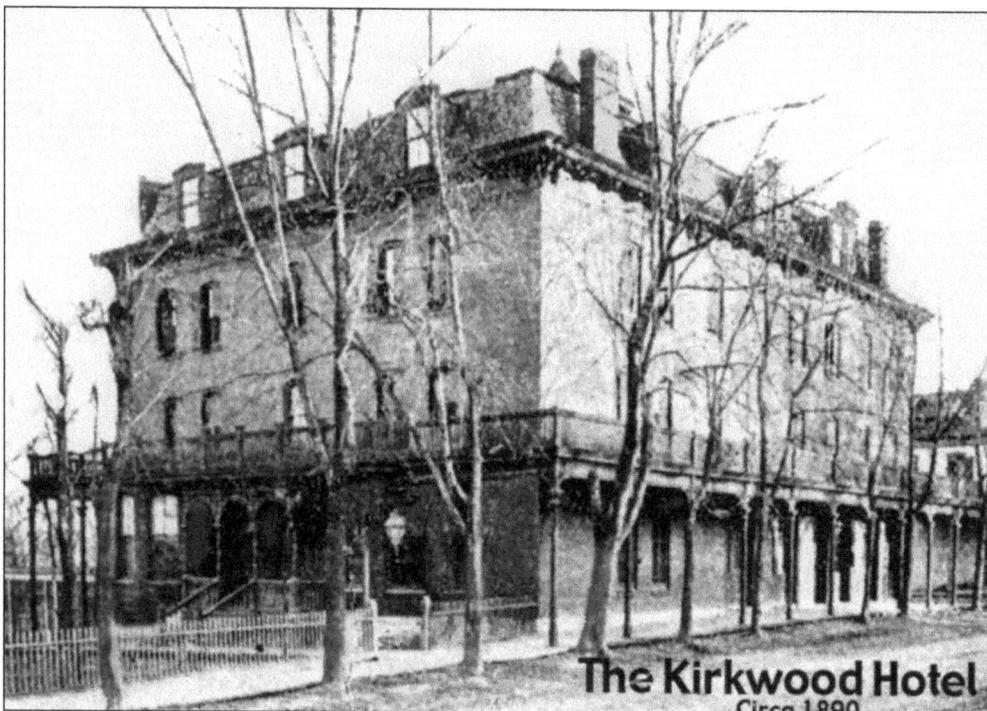

The Kirkwood Hotel
Circa 1890

The Kirkwood Hotel was one of the first buildings erected in the city, opening in 1853. Many social events and meetings were held in this venue. The hotel became a furniture storage facility and was eventually demolished to make way for a Target store.

Select Cotillon Party,

TO BE GIVEN

AT THE KIRKWOOD HOTEL,

(On line of Pacific Rail Road.)

On Tuesday Evening, January 24, '60.

Sir:
Yourself and ladies are respectfully solicited to attend a COTILLON PARTY, at Kirkwood, on Tuesday Evening, January 24th 1860.

Committee of Arrangements:

James Pierson. W. C. Crooker. J. H. Shook.

Floor Managers:

Thos. J. Magehan. Chas. O. Thomas. J. H. Temple.

Managers.

W. C. Inks, J. F. Antes, O. B. Purcell,
Jas. S. Phelps, Wm. E. Glenn, E. W. Wallace,
Charles E. White, Samuel Ray, James Way,
George Flangin, H. W. Leffingwell, James Warren,
Thomas Bacon, Harrison Long, John Ellise,
Arthur Brown, T. McKissock. M. G. Cary.

Train for Kirkwood leaves 7th Street Depot, at 4 o'clock, P. M.

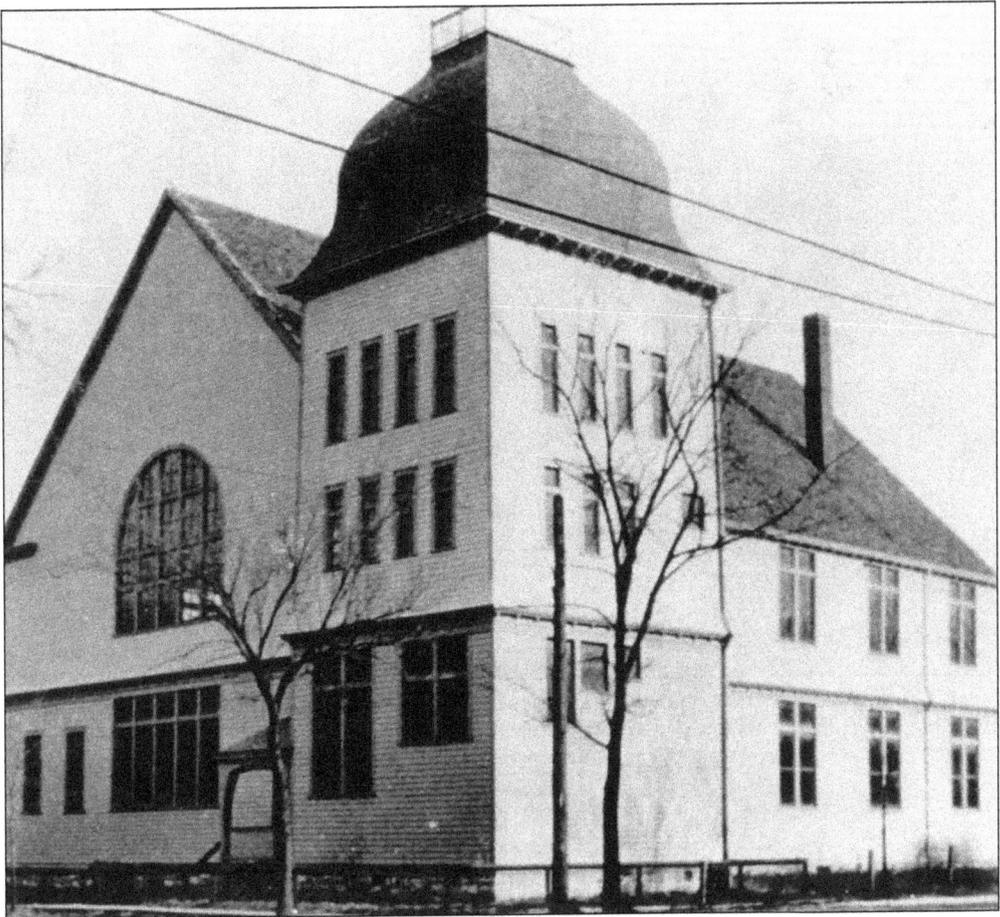

Because of the demand for space for social, cultural, and community events, Kirkwood citizens first built the Athenaeum in 1874 on the corner of Kirkwood Road (Webster Avenue) and Adams Avenue. The building was a great success until 1889, when it was destroyed by fire. A replacement "town hall" was built in 1892 and called the Armory (pictured, date unknown) because it was used as an indoor drill area for Company C of the 1st Regiment of the Missouri National Guard. Unfortunately, this building also fell victim to fire on the opening day of the St. Louis World's Fair, April 30, 1904.

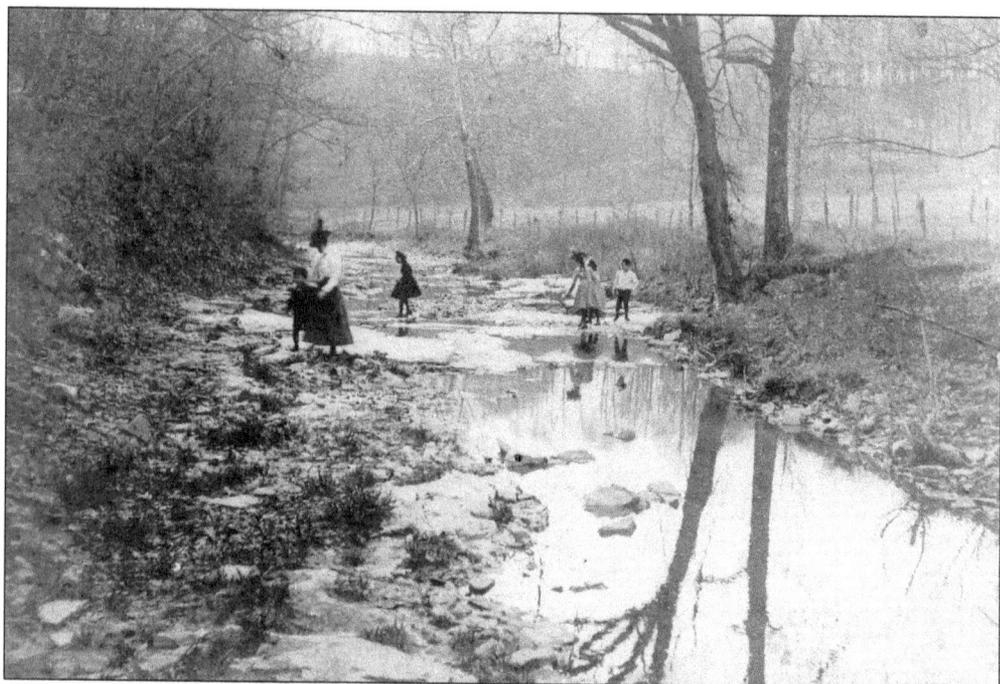

Sugar Creek offered recreational opportunities for Kirkwood families before formal parks were available. Here, the Byars family explores around 1890.

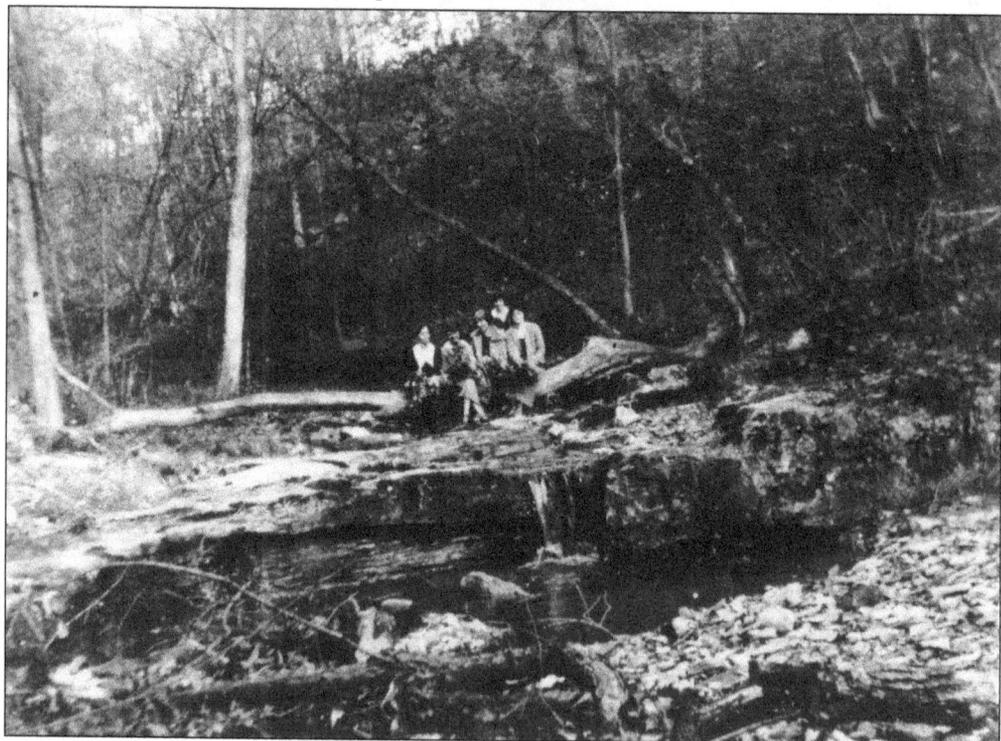

Another group visits the Sugar Creek to relax around the 1900s. Today, the area is still lovely, with many homes built into natural surroundings.

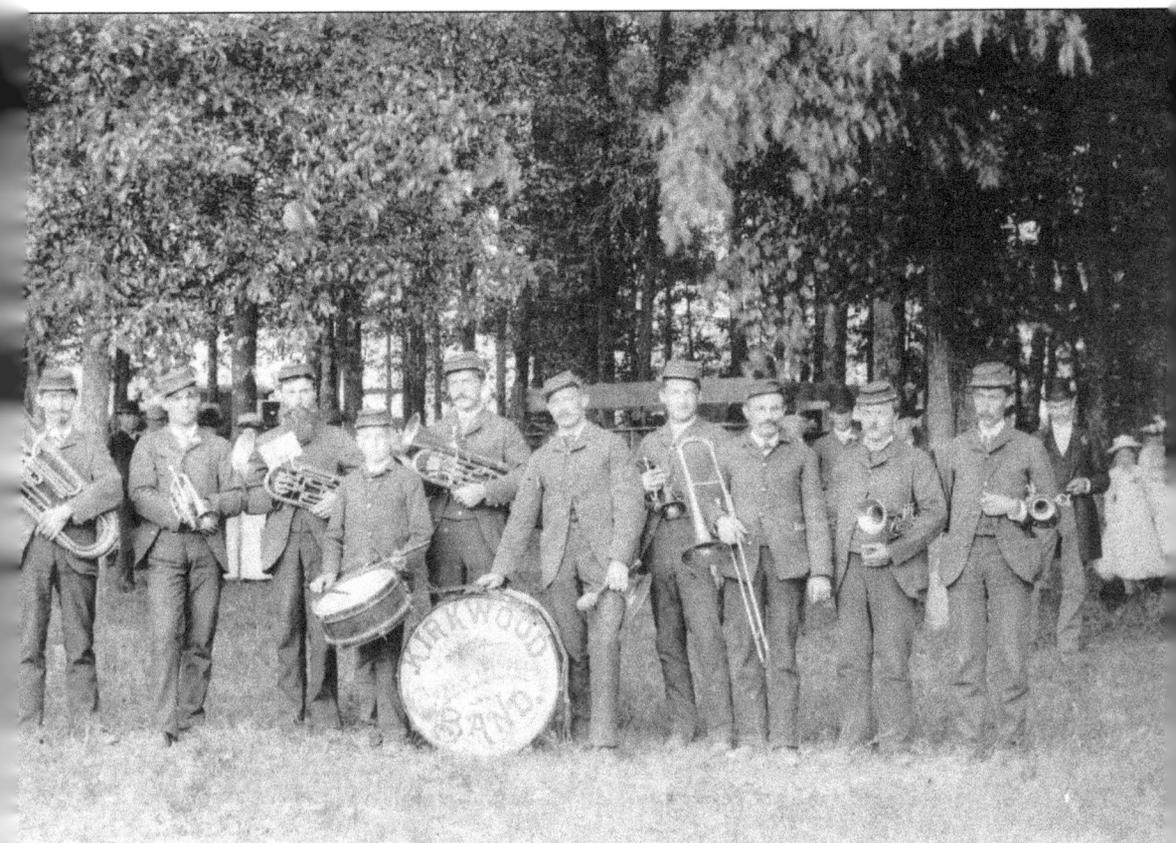

Before World War I, Kirkwood was home to the Kirkwood Brass Band. These unidentified men played engagements all over the St. Louis area.

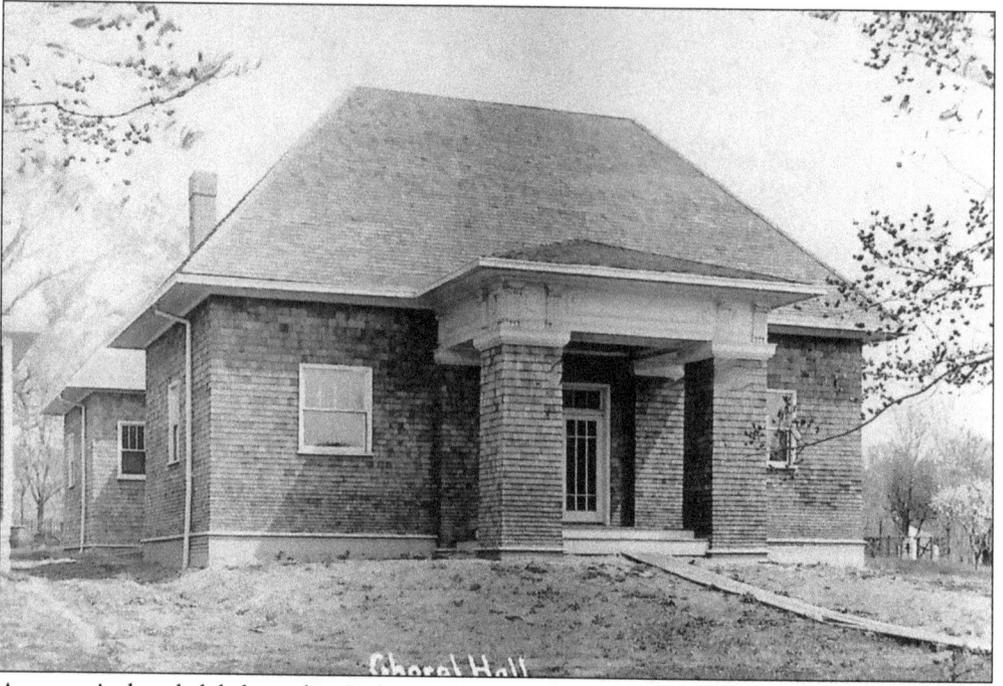

A women's choral club formed in Kirkwood in 1899 and built a choral hall in 1904 on the north side of Bodley Avenue between Kirkwood Road and Clay Avenue as a venue for performances. The group became coed in 1922. The hall was used for community meetings, high school graduations, and performances, such as the one pictured below at an unknown date; it was also the initial meeting site of the First Church of Christ, Scientist.

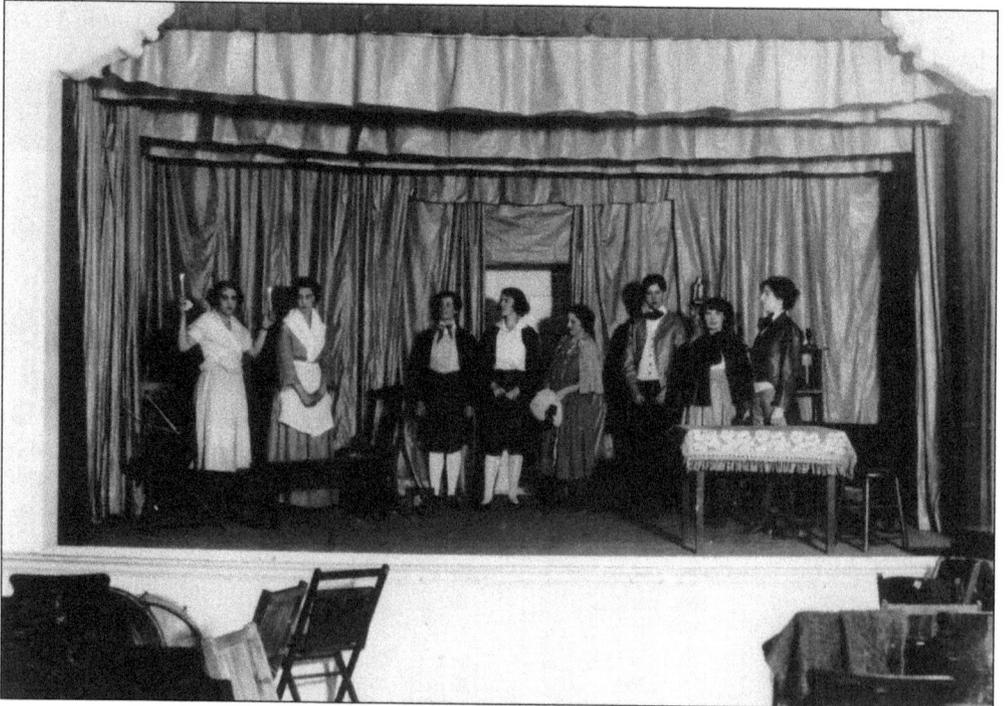

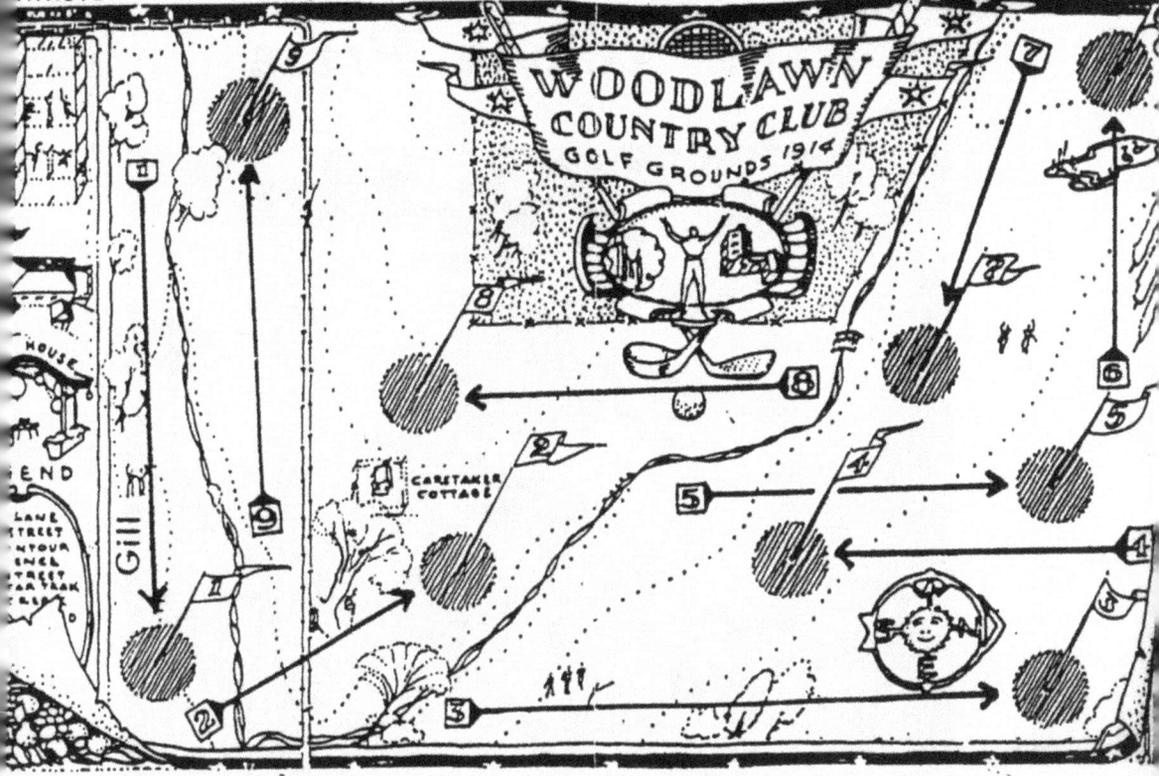

The Woodlawn Country Club was originally known as the Kirkwood Country Club (founded 1913) and featured a tennis club and a golf course. The Depression made it difficult for members to keep up with monetary obligations, and the club went into default on its mortgage. In 1937, a real estate firm purchased the land, and it was subdivided for homes. After a failed attempt to convince Kirkwood voters to approve funds to purchase the clubhouse and property south of Gill Avenue for a park facility, the clubhouse was razed, and the rest of the land sold for homes.

The Village Press

February Price 25c

Kirkwood was the home of the *Village Press*, a literary magazine founded in 1935 by Ann Rice Ludlow and Dorothy D.H. Suits. The short-lived magazine included poetry, prose, drawings, photographs, and book reviews. The mission statement was "The *Village Press* is taking its place in the line of march as a new kind of little magazine for women."

There was always room for fun in Kirkwood. This photograph shows Hollywood Mini Golf, located on the south side of Manchester Road near Woodlawn Avenue around the 1950s.

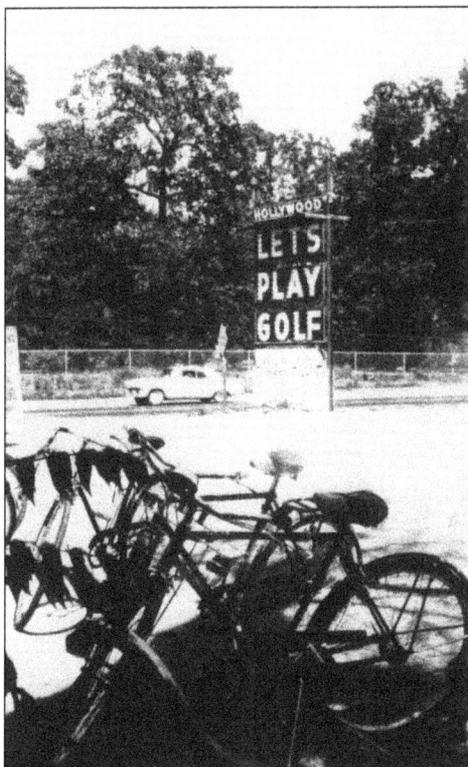

Mayor Robert Reim is pictured on October 11, 1971, at a ribbon cutting for Club 44, a local community service group. The program began with boys only but now includes girls as well.

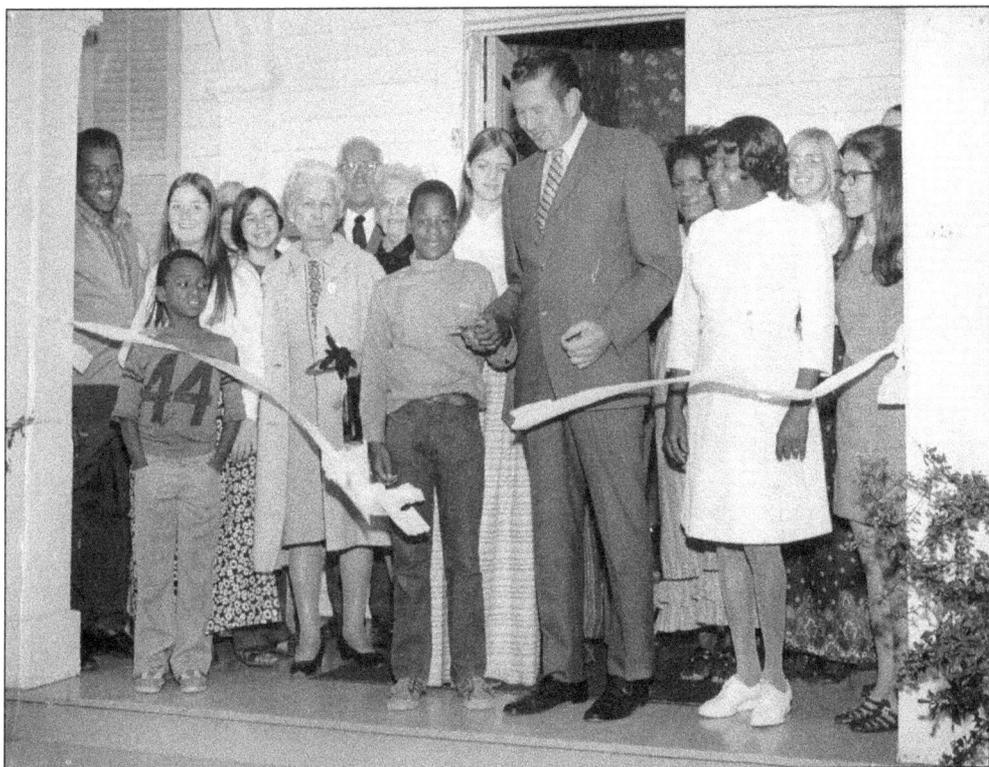

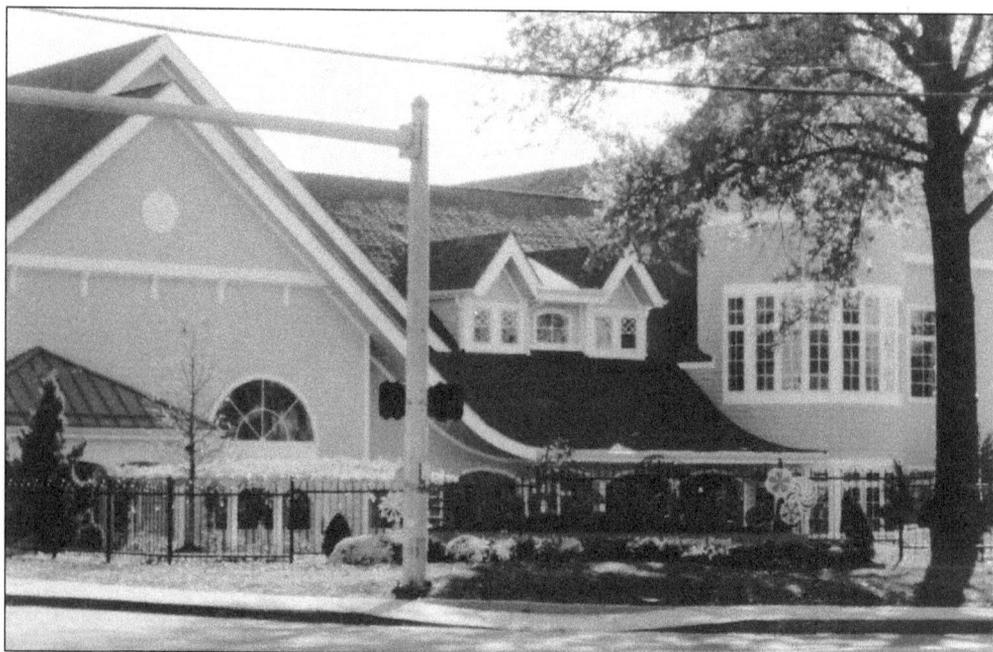

The Magic House, a children's museum, opened in Kirkwood in 1979. The museum offers hands-on activities for children of all ages. It has grown and is now one of the top tourist attractions in the area. (Author photograph.)

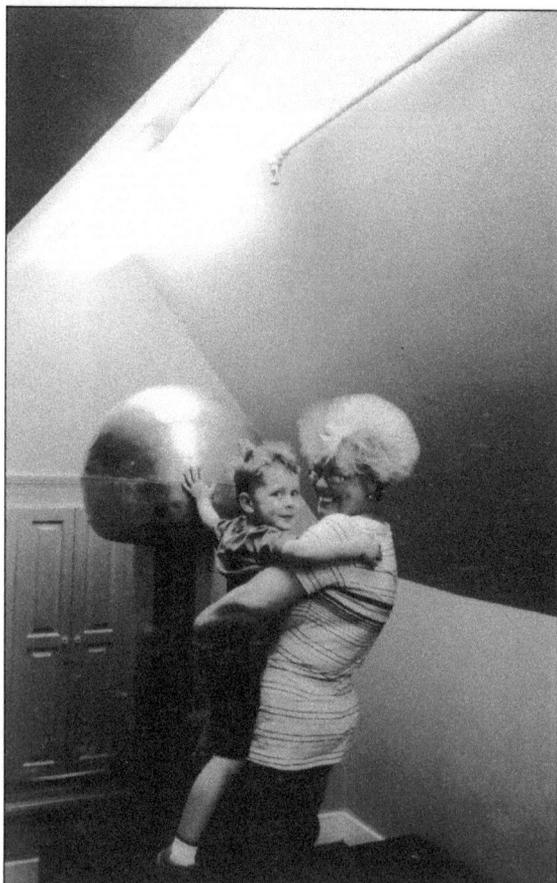

One of the favorite activities at the Magic House is the electrostatic generator. Shown here are Cameron Lauze and Vicki Erwin having a hair-raising adventure. Other favorite activities include the shadow wall and multistory slide. (Author photograph.)

Ten

KIRKWOOD PLACES

This is an artist's rendering of Homewood, where Harry Innes Bodley settled in Kirkwood and raised his family. The home no longer exists. The drawing is by William Bodley Lane.

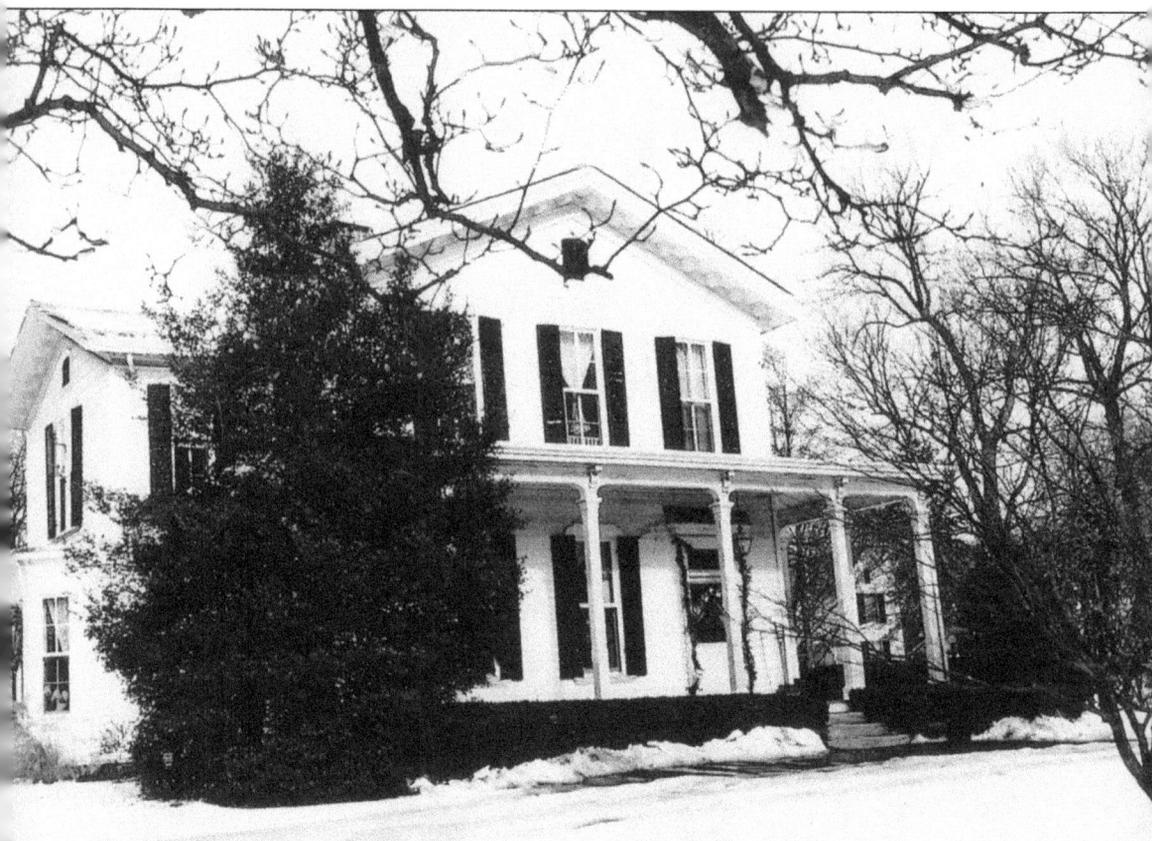

The Smith-Keysor house, located on East Jefferson Avenue, was probably built in the early 1850s by Spencer Smith, who was the original owner of the land. Smith was active in the beginnings of Grace Church. Judge William Winchester Keysor bought the home in 1902, when he and his wife moved to Kirkwood so Judge Keysor could teach at Washington University School of Law. Keysor Elementary School was named after him.

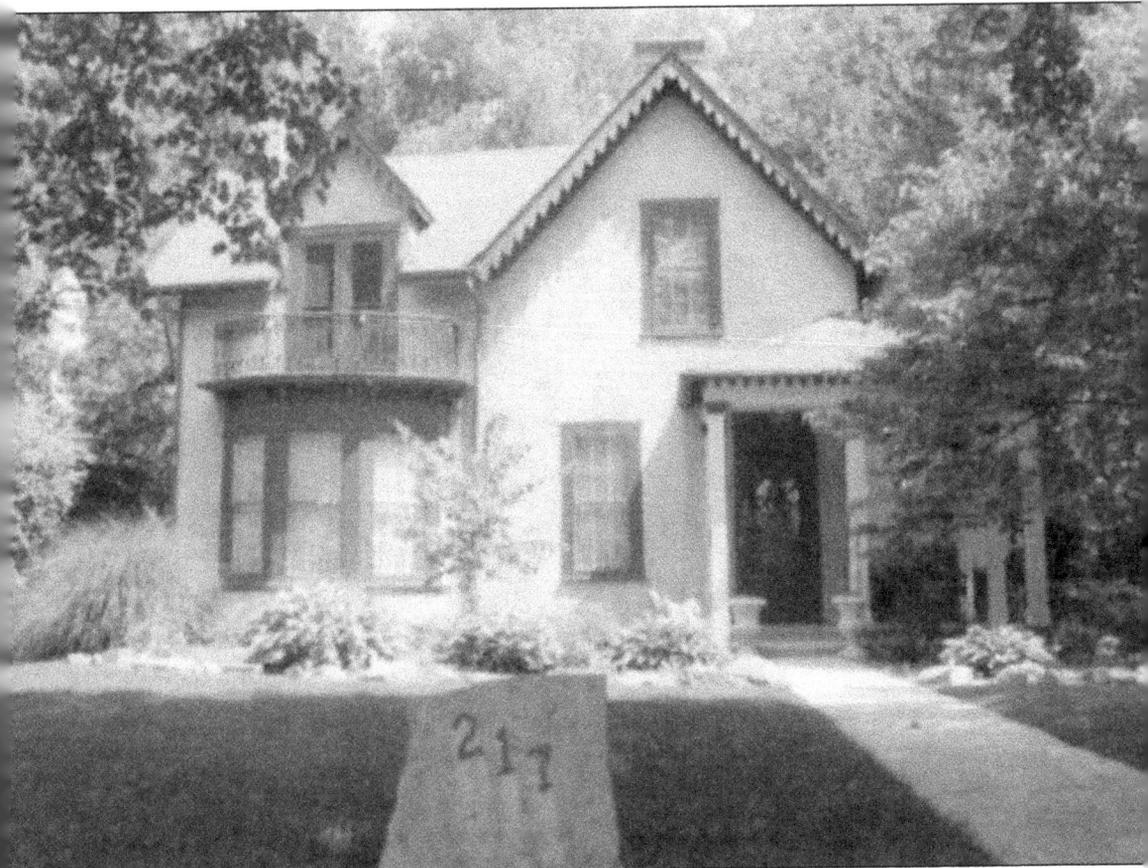

Henry Hough was an early resident of Kirkwood and served on the school board from 1879 to 1911. An elementary school was named after him. The Houghs built this house in 1859.

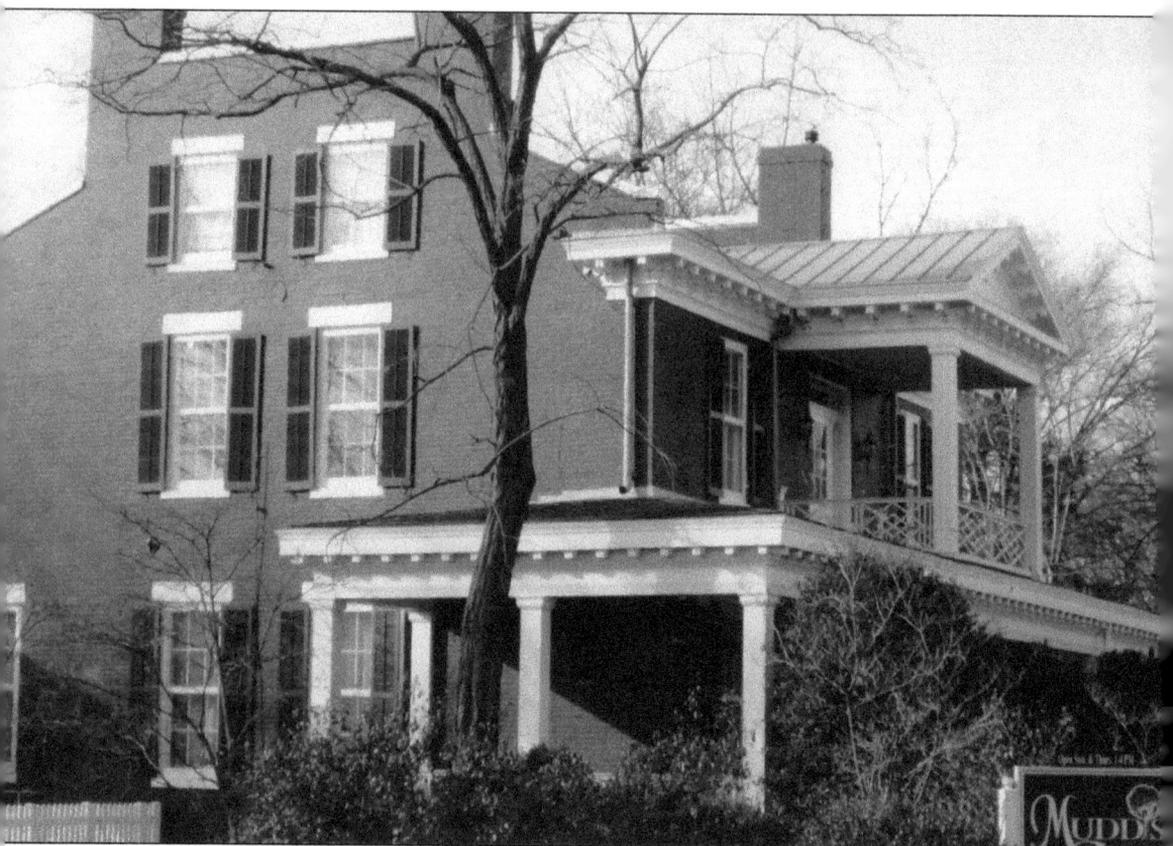

Mudd's Grove is the current home of the Kirkwood Historical Society. The house was built in 1859 by John Hoffman in a Greek Revival style. It is named after the Henry T. Mudd family, who lived there from 1865 to 1882. Henry Mudd was active in state and local government. The home is listed in the National Register of Historic Places. (Author photograph.)

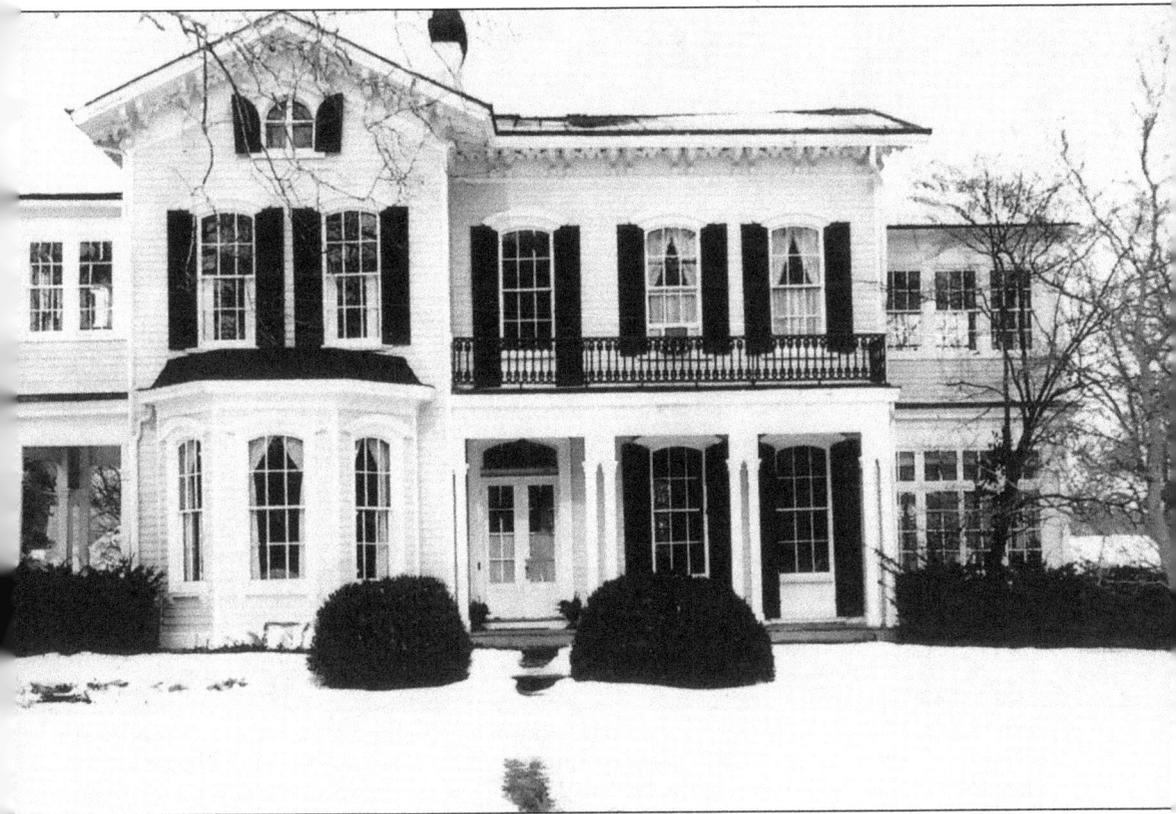

The Gill House, located on Argonne Drive, was built around 1858 and bought by George Gill in 1862. Gill owned land extending to Gill Avenue, which was named after him, and maintained an extensive garden. He was active in Kirkwood civic affairs, serving as a town trustee and as a member of the school board. He even lent money to Kirkwood when needed. Later, the home was owned by Edward Beecher, a mayor of Kirkwood.

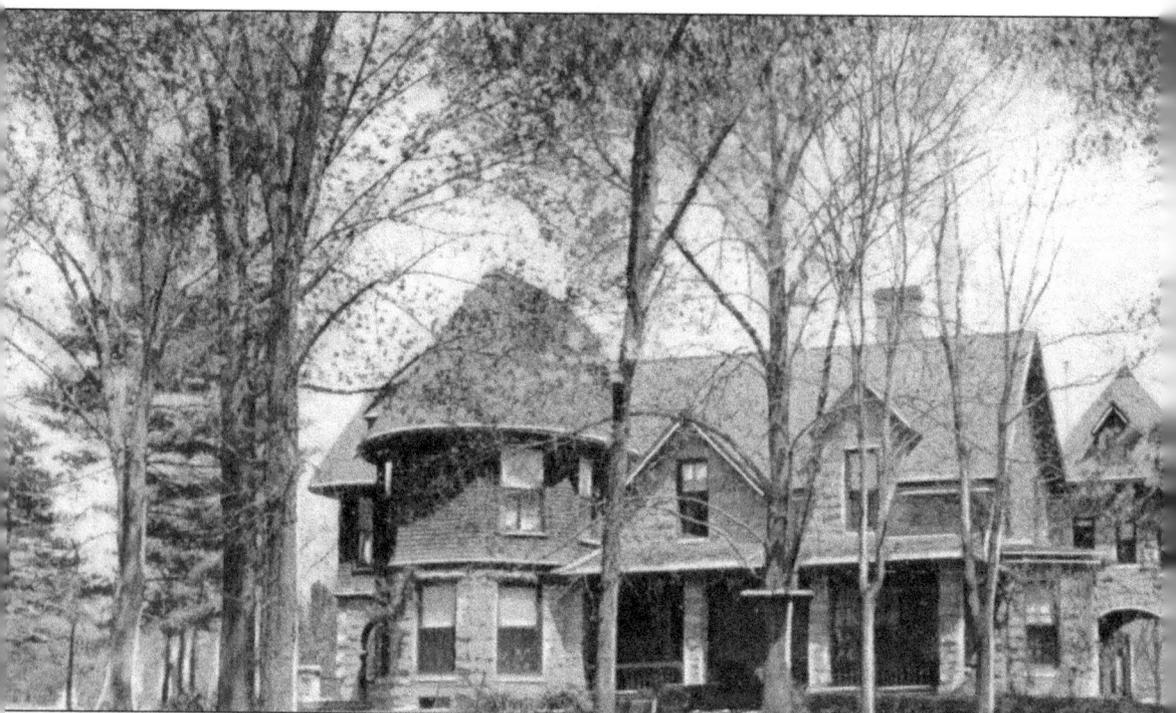

In the 1860s, William T. Essex built Ivy Lodge, shown here in the 1920s, at the corner of North Taylor and Bodley Avenues. Capt. Lorraine Farguhar "L.F." Jones purchased the home in 1881. The grounds were the location of the first swimming pool in Kirkwood, no longer in existence. The house in this photograph was torn down in the early 1940s, but the stone was used to build the house currently at the same location. The original pillar denoting the home as Ivy Lodge is still in place.

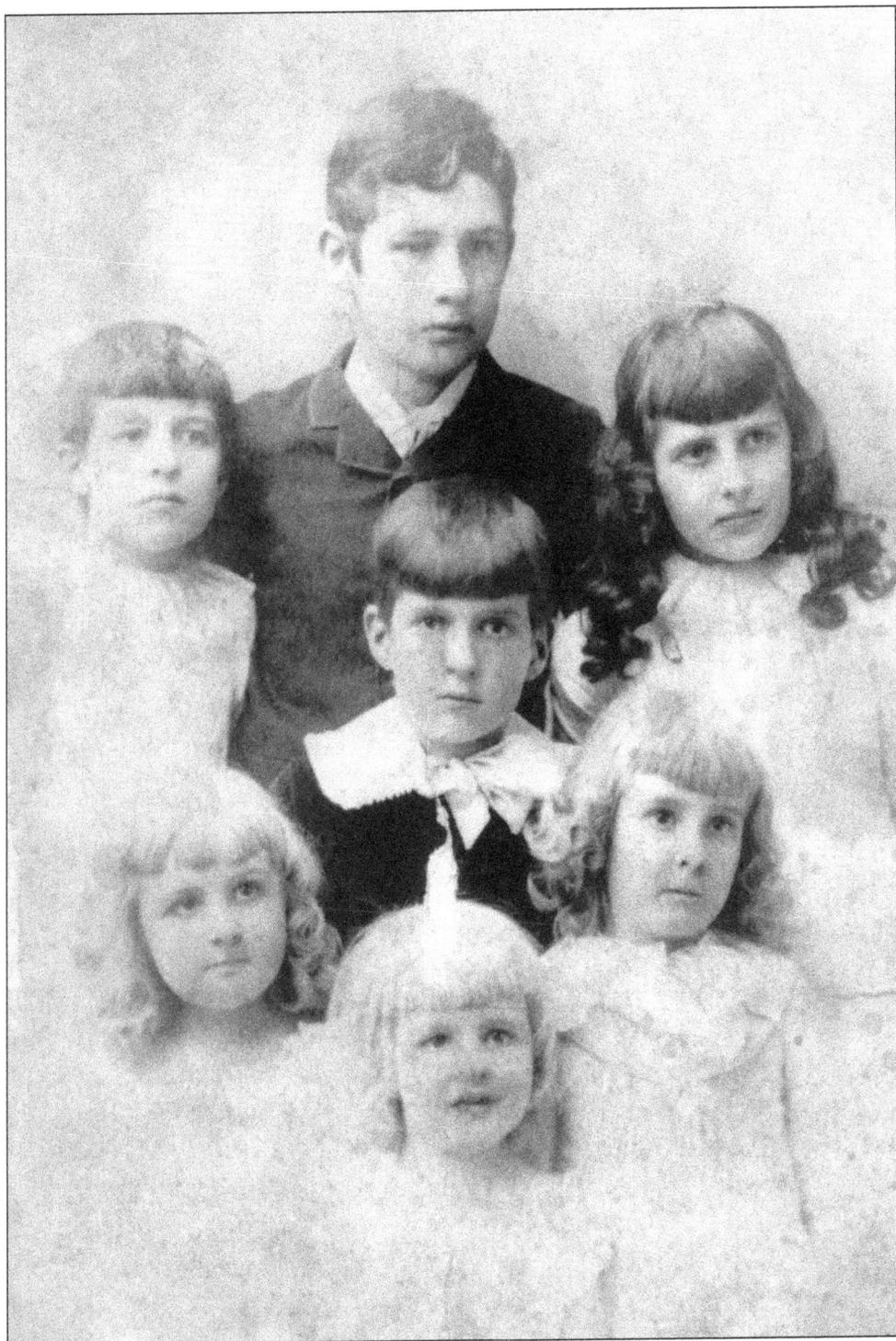

Captain Jones and his wife had nine children, two of whom died in infancy. Jones was close to his family, building homes for them near his own. He was a successful businessman, working in the cordage firm of Warren, Jones, and Gratz with Isaac Warren and Anderson Gratz.

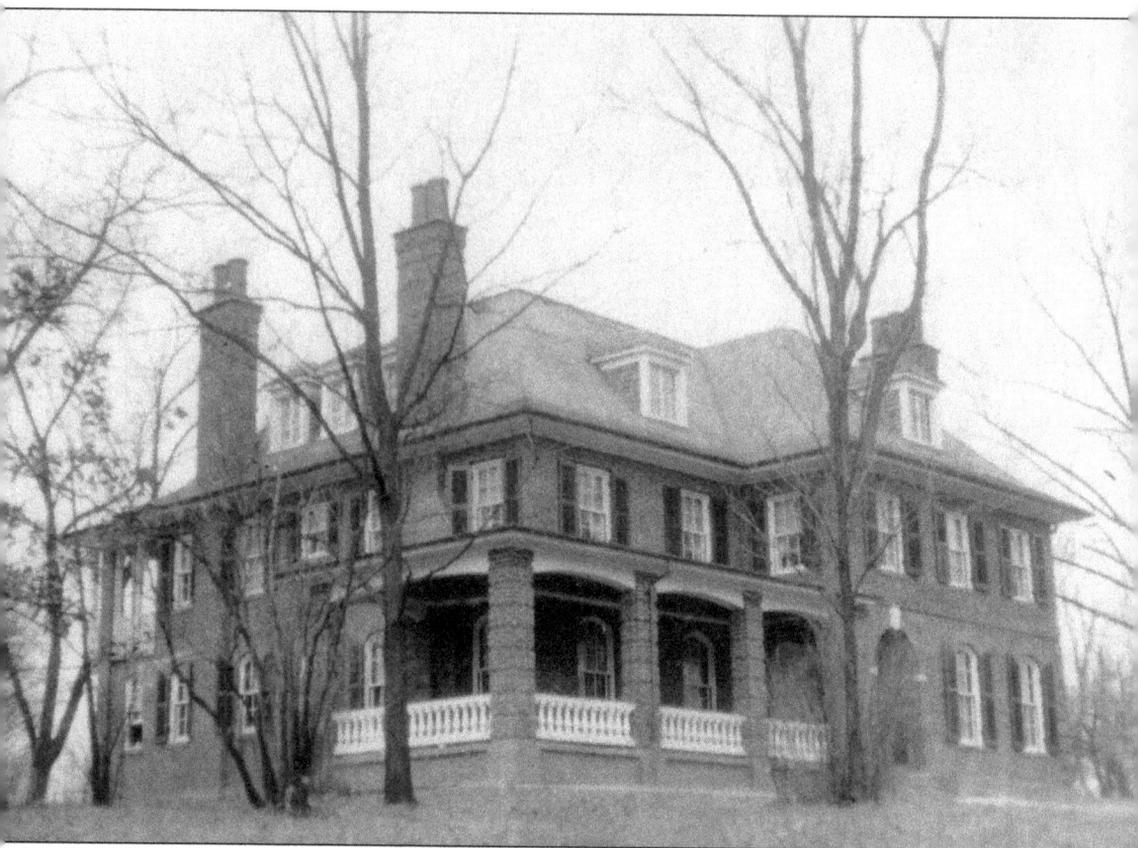

This was one of the homes Captain Jones built for his family using local contractors and materials, giving early meaning to the shop local movement.

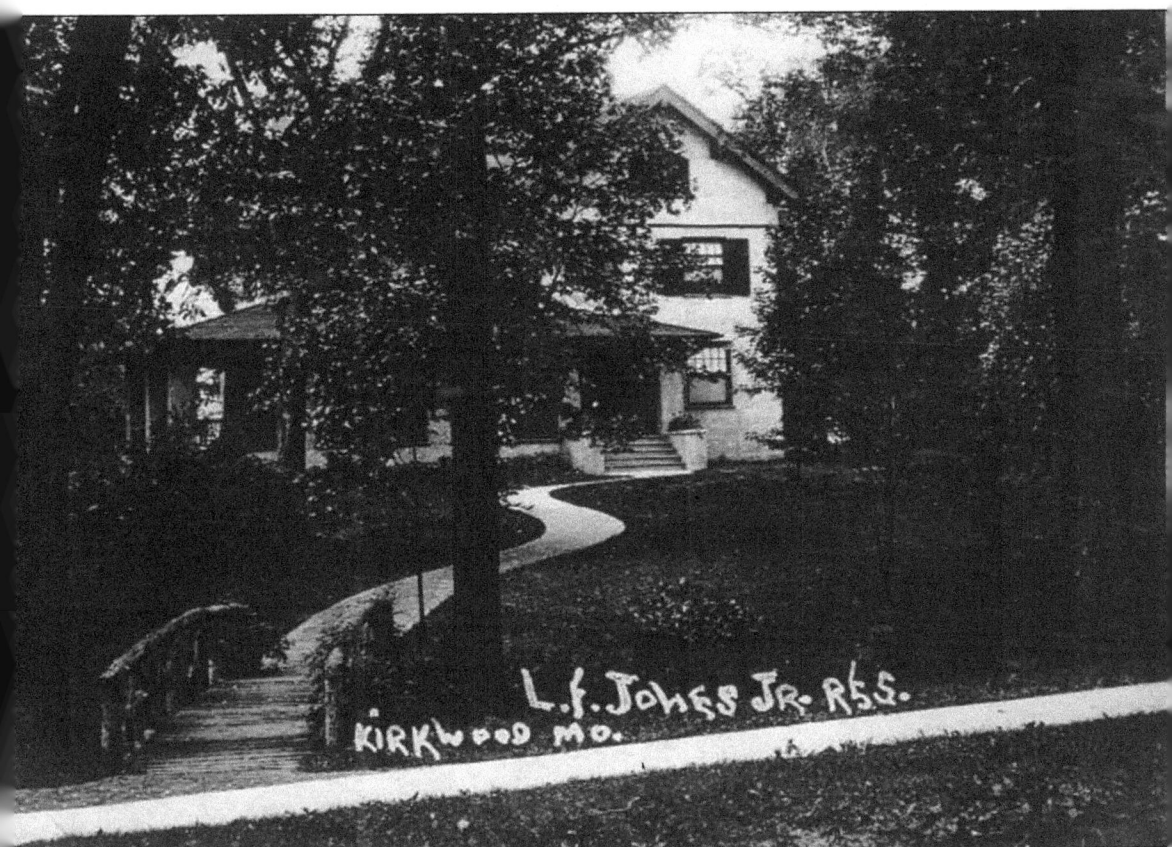

This was the home of Lorraine "L.F." Jones Jr., built by his father. Jones Jr. was a member of the 1897 inaugural Kirkwood basketball team and graduated from Kirkwood High School in 1900. He married a young woman from Arkansas, and they enjoyed this residence in his hometown.

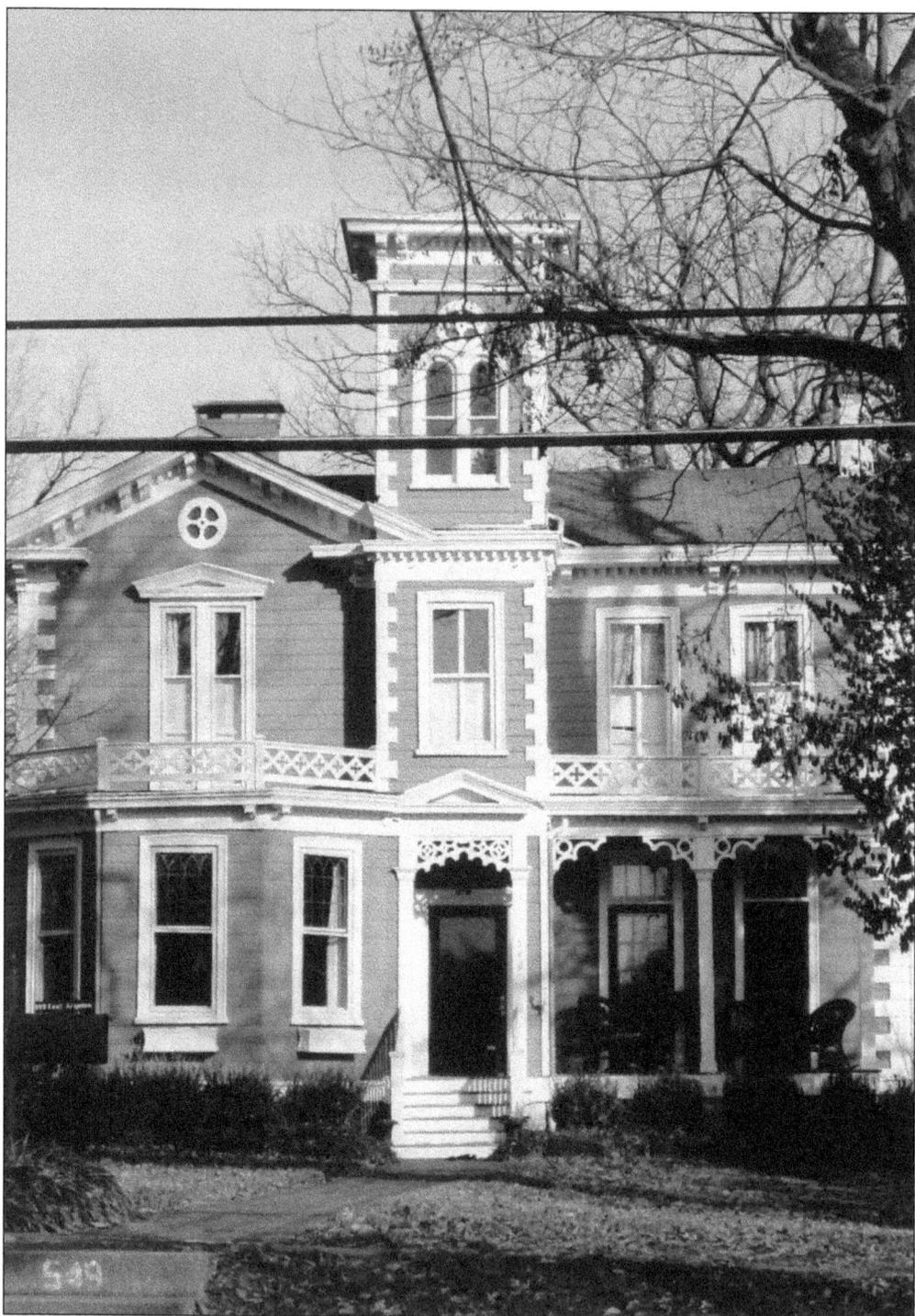

This lovely home in the Italianate style was built around 1865. It was owned by the McLagans, then the Charles Black family. Charles Black was publisher of the *Clayton Argus*, which contained a section focusing on Kirkwood. One of the outstanding features of this home is the tower. It also served as the home of the Kirkwood Historical Society from 1972 to 1992. (Author photograph.)

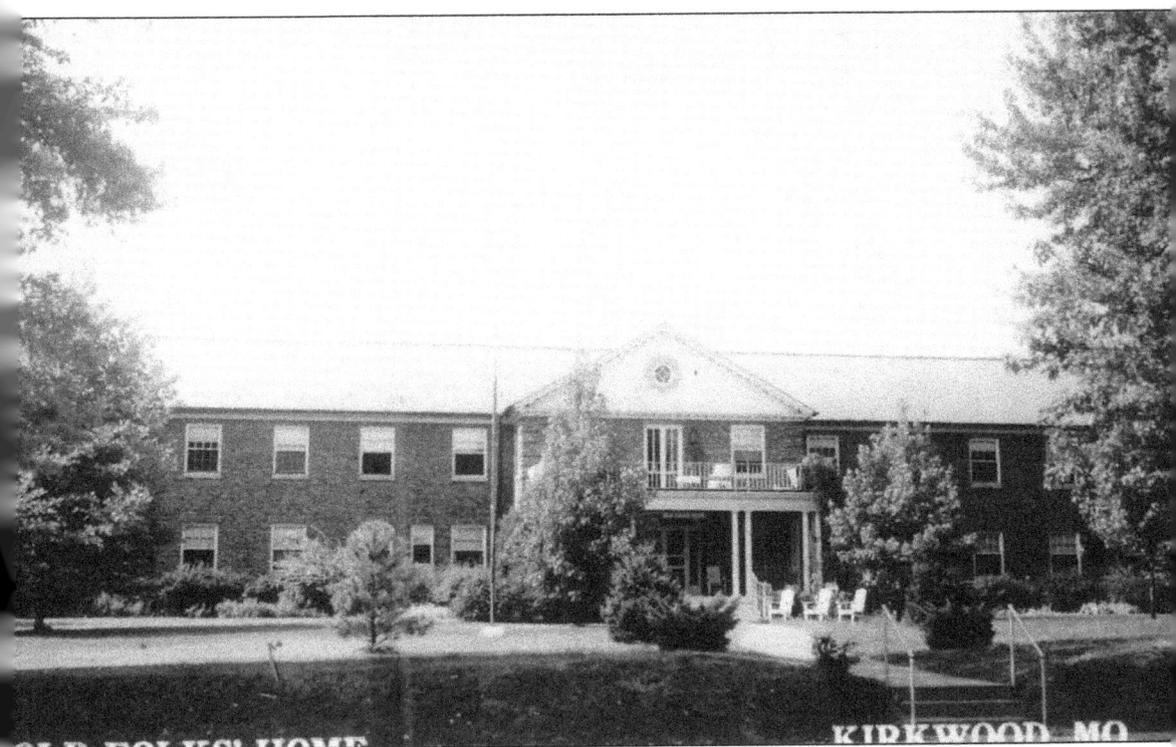

The Willing Workers Home for the Aged, established in 1907, was the first facility in St. Louis County for helping the aged poor. Originally located on Monroe Avenue, the home depended on donations and fundraisers. The name was changed to Old Folks Home, and it was moved in 1910 to a facility on the northwest corner of Taylor and Washington Avenues. The current facility on South Kirkwood Road was built in 1927 and is pictured here in 1942. Today, the home is known as Manor Grove, and it continues to provide excellent care to the elderly.

Cragwold was built in 1911 by Edwin A. Lemp, a member of the St. Louis brewing family. The family built a number of houses throughout the metropolitan area before Prohibition. This one, at the time, had a glass ceiling and hundreds of birds.

The home at the corner of Monroe and Woodlawn Avenues known as the Clarke House was built in 1913 by Judge Enos Clarke. The first home at this location burned, and this house, sometimes referred to as Seven Gables, replaced it. The home actually has 10 gables and, at one time, comprised an entire block with formal gardens, greenhouse, and a fishpond. (Author photograph.)

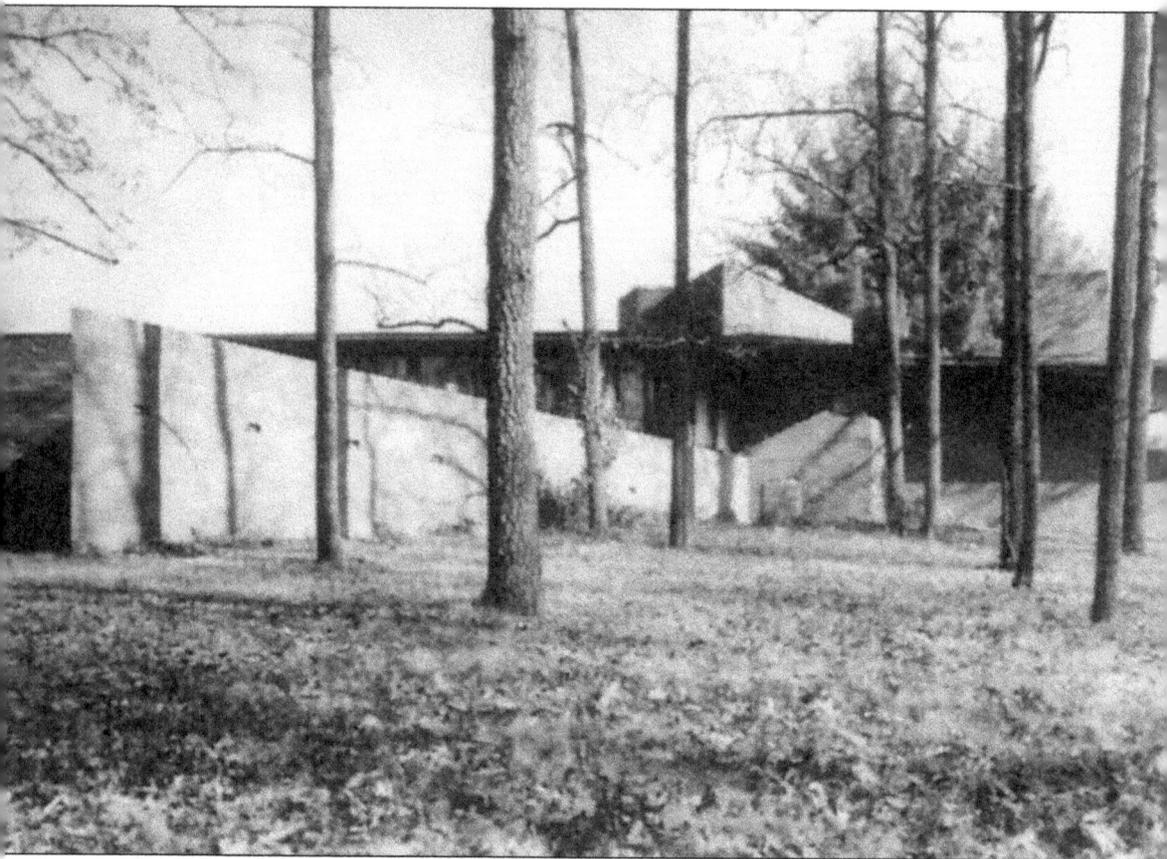

One of only two Frank Lloyd Wright–designed homes in the St. Louis area is located in Kirkwood. The home, built in 1955, was owned by Russell and Ruth Kraus. Russell was a renowned artist himself. The home has a geometric design with only one right angle. The furnishings were also designed by Wright. In 2001, the home became a museum and park.

BIBLIOGRAPHY

Baker, James F. *Glimpses of Meramec Highlands*. Kirkwood: Meramec Highlands Books, 1995.

Bamber, R.T. *A Pictorial Glimpse of Early Kirkwood, Volume II*. Kirkwood: Kirkwood Historical Society, 1988.

City of Kirkwood Landmarks Commission. *Historic Kirkwood Landmarks*. Kirkwood: City of Kirkwood, 2001.

Dahl, June Wilkinson. *A History of Kirkwood, Missouri 1851–1965*. Kirkwood: Kirkwood Historical Society, 1965.

Jones, David L. Jr. *A Pictorial Glimpse of Early Kirkwood*. Kirkwood: Kirkwood Chamber of Commerce, 1974.

Kirkwood A Pictorial History. St. Louis: G. Bradley Publishing, Inc., 2002.

Visit us at
arcadiapublishing.com

www.ingramcontent.com/pod-product-compliance
Lightning Source LLC
Chambersburg PA
CBHW050643110426
42813CB00007B/1897